D1442596

A Decade of Sculpture

A DECADE OF SCULPTURE
The 1960s

Julia M. Busch

PHILADELPHIA
THE ART ALLIANCE PRESS
LONDON: ASSOCIATED UNIVERSITY PRESSES

Associated University Presses, Inc.
Cranbury, New Jersey 08512

Associated University Presses
108 New Bond Street
London W1Y OQX, England

Library of Congress Cataloging in Publication Data

Busch, Julia M 1940–
 A decade of sculpture: the 1960s.

 Bibliography: p.
 1. Sculpture, Modern—20th century. 2. Form
(Aesthetics) 3. Art and technology. I. Title.
NB198.B86 735'.29 72-7855
ISBN 0-87982-007-1

To my parents

Contents

List of Illustrations

Preface

This volume surveys the many directions in which sculptors of the 1960s have employed their art. It is essentially an introduction to the surge of activity that has expanded the concept of dimensional creativity— creativity that can encompass two, three, and even four dimensions. By no means is it meant to function as a conclusive or comprehensive study, but rather touches on the multitude of possibilities that exist under the heading *sculpture*.

The reader is confronted with the notions that 1) sculpture as a contemporary label does not function, 2) traditional aesthetic limitations are no longer valid, and 3) the main classification, Visual Art, under which sculpture exists as a subheading, can no longer be called primarily visual since, in contemporary work, the verbal or conceptual many times takes precedence. The merger of art and science is ex-amined as the prime factor in these changes.

Arranged in three main sections, the volume deals first with what technology has provided on a manual level. This includes new industrial developments and materials that are available to the artist. The influence of scientific concept on the creative mind is the concern of section two. Included are thoughts of the Minimal artists, serial and modular works, cinetic, kinetic, and moveable art, and work with energy and light. The deliberate union of art and science in formal working situations such as exist at MIT (Massachusetts Institute of Technology) and at EAT (Experiments in Art and Technology) is reviewed in section three. Artists and educators express their views and critics contemplate the evolution of this new union.

Acknowledgments

A volume such as this owes its existence to the artists and galleries who have generously contributed photographs and information. These resources are listed under courtesy credits on the captions of illustrations and noted under Contributing Artists below. Special debts are owed to articles by artists and critics George Rickey, Sidney Geist, Mel Bochner, Margaret Buhler, Jack Wesley Burnham, Douglas M. Davis, Edward F. Fry, and Clement Greenberg, whose thoughts have shed much light on the material covered in this book.

I am especially indebted to Eugene Massin, Professor of Art, University of Miami, Florida, who for months acted as a sounding board for my thoughts, contributed information and photographs of his own works, and generally encouraged and facilitated this effort. To him and to my sister, Shirley Busch, whose "late night" photography added much, I give my deepest appreciation.

Special thanks are due to Dr. August L. Freundlich, Dean of Arts and Sciences, Syracuse University, for his encouragement and instigation of this volume. To Marilyn Hartson, to Joan E. Gill, and to the late Claire Miller goes my appreciation for reading, questioning, and editing. Also to Dr. Hans Müller, Cultural Counselor of the Embassy of Switzerland, Washington, D.C., and to Betty Chamberlain, Director, Art Information Center, New York, I give thanks for their efforts.

Contributing Artists

Carl Andre
Anne Arnold
Sol LeWitt
Frank Malina
Mike Bakaty
François and Bernard Baschet
Sondra Beal
Bruce Beasley
Larry Bell
Fletcher Benton
Ronald Bladen
Robert Breer
Anthony Caro
John Chamberlain
Judy Chicago (Gerowitz)
Ligia Clark
Tony DeLap
José De Rivera
Tom Doyle
Fred Eversley
Dan Flavin
Peter Forakis
Jane Frank
Charles R. Frazier
James Grant
Karl Gerstner
Robert Grosvenor
John Healey
Eva Hesse
Robert Hudson
Jasper Johns
Donald Judd
Lila Katzen
Lyman Kipp
Bernard Kirschenbaum
Gabriel Kohn
Peter Kowalski
Marisol
Eugene Massin
John McCracken
Robert Morris
Sadamasa Motonaga
Forrest Myers
Elie Nadelman
Louise Nevelson
Claes Oldenburg
Otto Piene
Peter Pinchbeck
Robert Rauschenberg
Martial Raysse
Ad Reinhardt
Bridgitt Riley
Nicolas Schöffer
George Segal
Jason Seley
David Slivka
David Smith
Tony Smith
Robert Smithson
Kenneth Snelson
Frank Stella
George Sugarman
Takis
Victor Vasarely
David Von Schlegell
Al Vrana
David Weinrib
H. C. Westermann
Audrey Corwin Wright
Wilfred Zogbaum

Introduction

Historically, three primary categories existed within the visual fine arts—painting, sculpture, and architecture. Occupying positions in which classification was clear-cut, sculpture and architecture stood distinctly apart from painting. Sculpture and architecture were three-dimensional, while painting incorporated only two dimensions. Sometimes cut in low or bas-relief, sculpture neared two dimensions, but still was not confused with painting because, although minimally utilized, the third dimension existed. Architecture and sculpture were also readily distinguishable; regardless of how sculpturally oriented, architecture was primarily intended for shelter or habitation.

Aesthetically, sculpture was concerned with carving and modeling—painting, with canvas and water color or oils. Ever since the Renaissance, one did not paint sculpture or sculpt canvas. Sculpture had to be made of materials that would endure; materials such as bronze, marble, and wood implied permanance. A philosophy of "truth to materials" demanded that the particular qualities of individual materials be fully explored. Wood grain was to be exploited, also the strata of stone. Techniques and methods relative to accepted materials were laboriously explored and refined, and camouflaging the identity of a material was considered aesthetically dishonest.

Today the boundaries of sculpture are not clearly drawn. The entire concept of two-dimensional and three-dimensional classification has undergone a drastic metamorphosis. Because the difference between painting and sculpture is frequently indistinguishable, such considerations as frontal orientation will sometimes enter into current classification. Still, the question frequently arises as to whether or not a particular work is painting or sculpture, since a substantial amount of work executed from the 1960s onward can be called neither painting nor sculpture.

A relationship exists, but many times it is a distant one.

Not only are distinctions between painting and sculpture difficult to determine, but the division between architecture and sculpture has also become blurred. Since good architecture has sculptural qualities, contemporary sculpture frequently resembles an architectural model. Today one may be led up to, enter into, and many times can look out from within a sculptural work that is in no sense sculpted or molded, but built up like architecture or constructed like a machine.

The modern sculptor is concerned with new forms and concepts that have greatly extended the traditional approach to sculpture. Examination of modern works indicates an upset in the whole notion of "medium." Traditionally, the material and the process were regarded jointly as the medium, as in wood-carving and bronze-casting. This concept is no longer applicable. No material is left unconsidered, and new processes such as plastic casting, contemporary welding, assembling and constructing are widely used. Traditional processes are combined with new materials, as in carving plastic; and traditional materials are joined with new processes, like plywood assemblages or wood laminations.

The once-dominant idea of "permanence" is no longer applied. New concepts have been extended to include the soft sculpture of Oldenburg, and works of artificial light that will eventually burn out. The ecological statement made by Frazier in utilizing dead fish on a beach is a far cry from "enduring" art. The notion of "truth to materials" is a notion that has been destroyed—for centuries color was not used in sculpture. Today it is used in many ways to disguise the material over which it is placed. Materials once considered not interchangeable in any one work are at present combined without challenge.

17

Sculpture, which once enjoyed definite guidelines, utilized the plinth or pedestal, a device that set the work apart as a precious object. Today's sculpture need not utilize this device. Instead, contemporary sculpture is sometimes extended to include the gallery or exhibition space as part of the "medium" or formal consideration of the work. The once well-defined visual fine arts under which *sculpture* was a self-contained classification now involve numerous means and indistinguishable boundaries. A ferment of activity took a strong hold in the sixties and still continues. Science and technology have been instrumental in effecting these changes; advances in industry have been reflected in artistic production.

A Decade of Sculpture

Part I

Technology for the Hand

1

New Images, Methods, and Materials

The most easily comprehended scientific and technological influences that have directly affected sculpture are: 1) the use of new materials, 2) the use of new tools and methods, 3) the appearance of a new imagery, and 4) the union of man and machine in the creation of art objects.

In the simplest form, science and technology may offer a new material such as plastic or simplify a traditional process. Donald Schon, in his *Technology and Change,* considers technology as *"any* tool or technique, *any* product, or process, *any* physical equipment or method of doing or making, by which the human capacity is extended." Artists who have traditionally used available materials, tools, and methods have availed themselves of a wider choice.

By perpetually seeking to upgrade the function and appearance of products through advancements in technology, our consumer society has added impetus to the artists' assimilation of new methods and materials. Because of this, the artist can utilize the new materials and methods relatively inexpensively, and can, in turn, satisfy a growing mass market for art by supplying an increasingly aware public.

The variety of materials is vast. Wood may be obtained in a wide range of forms. Metal may be acquired in ingots, bars, sheets, tubes, rods, mesh, and wire. Many degrees of hardness and malleability are available. Colored, opaque, and transparent synthetics can be obtained. Materials to be molded, machined, glued, bolted, carved, and assembled are readily available. Basic structural materials that are treated or surfaced can be acquired. Gabriel Kohn uses laminated wood to make cleanly shaped objects with a mechanical look. George Rickey utilizes stainless steel sheet, rods, bars, and pipe; also silicone bronze and brass.

A very different material, plaster, is used by George Segal, also by Peter Agostini, who forms his material, without using color, while it is still wet in a plastic bag.

Methods may range from the silver brazing, acetylene and heliarc welding, riveting, and bolting used by an artist such as George Rickey to the soft, stitched sculpture of Claes Oldenburg. Tools formerly found in the industrial arts—shears, sheet-metal bending brakes, and drill presses are employed as needed. In 1965 a piece of metal sculpture was "formed" by underwater explosion when Peter Kowalski joined with North American Aviation to undertake this endeavor. Charles Mattox has constructed a machine that is photoelectrically activated by means of color, and that also incorporates electromagnetic resonators.

By using industrial methods and materials, the artist of the sixties has achieved unusual effects and, as a result, new images. An example of this is the use of styrofoam—a soft synthetic material developed by the Dow Chemical Company. This material can be shaped and carved into complex forms that may or may not be cast. Foam casting is at present widely used and its use will no doubt increase as industry develops new foams and processes.

The contemporary artist has experimented and at times innovated techniques and modifications that are potentially useful outside the realm of art. Some of this work is being done in areas not before investigated by industry. Larry Bell, for instance, has extended a wide variety of techniques beyond industry's present interest. He is working with a *high vacuum optical coating machine,* which was originally commissioned for the United States Air Force. This machine

can lay an exceedingly thin layer of color onto glass.

In process, connotation, and expression, technology is used in varying degrees by different artists. In process, Larry Bell is one who uses technology to the maximum. He is identified with a specific industrial process. On the other hand, Donald Judd employs technology minimally, using a tinsmith for the execution of his metal sculpture. In connotation—historical connotations of cast bronze and carved wood and stone are not found in new synthetic materials that are utilized by many of the young sculptors. Anthony Caro has been trying to eliminate references in order to make a truly abstract work; he wants a material that eliminates art historical references and associations. And in expressive function, the use of new materials and methods varies from artist to artist. Vasa states,

> I am working with mechanically applied industrial finishes, because no classical medium can give me this fine surface. Through this process, I am eliminating the presence of the artist in his work, leaving only the idea and the concept to be experienced by the viewer without other distractions.[1]

But whether owing to process, connotation, or individual expression, the final appearance of a work often seems to negate the creative process or the "hand" of the creator who brought it into being. This appearance is found in works of Smithson and Andre, and in McCracken's irreducible slab. McCracken's work, like Bell's, represents the ultimate visualization of an idea. His work is covered by as many as twenty or thirty coats of sprayed paint, which leave no clue to the creative process.

It is interesting to note that this negation of the creative process is apparent in works that are dominated by the material or process rather than the form. Infinite emptiness is seen in Bell's coated boxes of glass; Flavin's light boxes look sterile; and McCracken's work looks like a section remaining after a construction job.

The new products and concepts in research have suggested new images and new subject matter. Since artists, as creators, have always sought the new and vital, there is nothing anti-traditional in the fact that a new imagery has been advanced. The new images, radical in themselves, are to be expected. Anti-traditionalism is to be noted, however, in the creative process where man and machine function together. The most sophisticated example is just now being explored—the computer. In this sense, technology has become an extension of man's central nervous system.[2] More and more, technology has become the method of the modern artist, as vital as his own hand or brain.

Artists of the sixties could employ and have employed any means necessary to accomplish an aesthetic solution. Masters and students alike have tried new methods of merging physical possibility with creative probability—have worked to impose order on the materials and to allow materials and techniques to stimulate directions in form and space. Pieces can be made to fly, float, suspend in the air, and radiate odors. The artist's limit is his imagination.

1. "New Talent USA," *Art in America,* no. 4 (1966), p. 61.

2. Marshall McLuhan and Quenton Fiore, *The Medium is the Massage, An Inventory* (New York, London, Toronto: Bantam Books Inc., 1967), p. 40.

2

Plastics

Plastic, a varied and flexible family of materials primarily created for industrial purposes, has made a great impact on the art world. Lacking artistic precedent and possessing qualities that are, many times, unparalleled in nature, the artist has *carte blanche* in the use of this material. Results have been unique and highly individual.

Readily pliable, plastic offers a wide range of artistic and scientific effects and experiences. Polyester resin alone ranges from free-form castings to intricate chemistry and the sensitivity of a gem-cutter in preparation. Acrylic sheeting, rods, and cylinders offer linear and constructional possibilities. Vinyl and plastic cloths provide material for "soft" and "inflatable" sculpture, while the transparent and translucent properties added to the "bendable" and "formable" properties allow for unlimited experiments in optics and light.

The contemporary artist has at his disposal polyesters, epoxies, acrylics, silicones, vinyls, polyethylenes, polystyrenes, urethanes, and foams, among other types of plastic. The material may be cast, machined, sanded, polished, carved, painted, glued, or stitched. Fillers can be added to resins, which may be water-white or dyed with transparent or opaque colors. Sheets of acrylic may be heated, bent, reheated and rebent, and light may be piped through linear etchings or projections.

Indicative of the wide range of possibility, artists Al Vrana and Eugene Massin utilize different forms of plastic to different ends. Since styrofoam carves easily and melts on contact with molten metal, Vrana uses the foam as a burnout material in bronze casting. Styrofoam is also employed as a waste mold, which Vrana uses in casting concrete architectural reliefs.

Easily transported to the building site, the lightweight foam readily tears away from the set concrete, leaving the finished sections to be set in place by cranes. A recent use of this technique was at Florida International University, where his three-story facade also serves as load-bearing walls.

Eugene Massin works with polyester resin and acrylic sheet. His interest is in reflections, refractions, multiple-surface viewpoints, color blending, and various other optical phenomena, which he combines with kinetics and light. In his polyester sculptures, color and interior images blend and bounce before the viewer's eyes, while in what he calls "three-dimensional paintings," acrylic lines are cut on a scroll saw and affixed to a transparent background sheet, which is then suspended and flooded with light to create what appears to be a drawing in space. In the early 1960s, Massin created an acrylic painted on acrylic sheet mural in the Cafritz Building, Washington, D.C. Here he utilized the viewer, who was reflected in the plastic glass, as an integral part of the composition. A recent example of his work is a mural executed for the City National Bank of Miami Beach, which functions by means of the reflective quality of the material and its transparent colors, which are overlaid and projected onto the wall. In this work, light, material, color, reflection, and projection fuse in a display of color and light.

On the West Coast, James Grant casts polyester resin in colored layers; Harold Paris works with vacuformed translucent silicones; and Bruce Beasley works with acrylic resin, which he forms in a "giant pressure-cooker," the autoclave. He created, with the support of the Dupont Company, a monumental transparent work. His clear sculptures, like Freda Kob-

lick's, seem to be concerned with flawless transparency and interior mass with refractions and exterior surface reflections.

Fred Eversley's "gems" are faceted cylindrical sections in which color and space constantly change as the viewer changes his vantage point. Space is modified by the sheer bulk of DeWain Valentine's architecturally scaled pieces. Jane Frank's acrylic constructions cast brilliant stained-glass shadows through the play of light and color.

Other artists employing plastic are David Weinrib and Leo Amino. Frank Gallo combines plastic with fiberglass; Sadamasa Motonaga fills plastic sleeves with water; Otto Piene and Charles Frazier use plastics for their "sail" in kites and inflatable works; while Oldenburg and Bill King "weld" soft vinyl with needle and thread.

The creative use of plastic is on the increase and the results are as varied as the individuals who use them and as flexible as the material itself.

3

The Trend to Monumentality

Closely tied to technology and of great concern to recent sculptors is scale. The sculptor, once singularly conceived of as a human possessing great strength who undertook manual feats requiring physical endurance, may now be an engineer whose sculptures are understood in blueprint form. Today's artists can turn over sketches of works to factories for mechanical production—pieces that could not be produced in the studio. Eugene Massin's acrylic murals, for instance, are first worked up as sketches on paper, then transferred to full-size cartoons that are turned over for factory production. Simultaneously a scale model is worked up by the artist in the actual materials. The model is then handed over to lighting engineers, who utilize computers in order to obtain the maximum illumination and projection of color. The artist works with and supervises the activities so that the end result will be that which he originally conceived. Al Vrana, who works also with scale, produces monumental works of concrete, metal, and stone. But he, on the other hand, hires his own crew, employs cranes for installation, and personally attends to whatever is necessary for his operation from the first sketch to the final touches.

Works involved with scale may be viewed as environmental (Tony Smith, David Smith, Jane Frank), monumental (Tony Smith, Al Vrana), or as works made for modular amplification. Environmental sculpture is never made to work at exactly human scale, but is sufficiently larger or smaller than scale to avoid confusion with the human image in the eyes of the viewer. The monumental works or sculpture dealing with scale encounter a different situation. It is one of classification. When a work reaches a size so large that it fills the exhibit area or gallery or can no longer be contained within the exhibition space, then the problem is one of definition. The work is no longer purely sculpture, even if planned in relation to human size, but has crossed a boundary and enters into the realm of architecture. Certain works, such as those of DeLap and McCracken, made for "modular amplification," exist in a variety of sizes. The work, in part, is *about* scale—calculations having to do with the meaning of the work itself. Through these calculations, the various degrees of enlargement contain a built-in control. Although these works can be readily understood in the model, it is not until the viewer is confronted with the completed work in full size that he is assailed with their power.

Grosvenor and Doyle share an interest in Environmental Sculpture that can be walked over and into—Grosvenor builds large cantilevered diagonals, painted bright yellow or red and blue, that sometimes hang from the ceiling or wall, almost touching the floor. Sugarman and Weinrib are not interested in monumentality per se, but their outsized constructions or disassociated structures require extended space. Marc di Suvero assembles giant wood, steel, and rubber-tire and rope constructions designed to let the viewer ride or swing on them. George Rickey's interest combines scale with kinetics—he creates monumental scissor-like shapes that are motivated by air currents.

Because of size, the monumental works shoulder their way out of the galleries and museums and take space in public areas. The work is frequently so large that it is considered or made specifically for the outdoors. Many monumentalists create civic works, thinking in terms of outdoor space and public enjoyment. Tony Smith and others want to create "architectonic mastodons" that would hold their own against city walls and streets and that would "command space-

age piazzas."[1] Al Vrana wants work that everyone can enjoy without having specifically to enter a gallery or museum. In the United States there is a feeling that the vastness of the country and the size of the architecture and cities need works that are suited to its size. It is felt that the new developments in architecture, engineering, and highway complexes demand large sculpture that is bold in concept, execution, and in the use of materials.[2]

Aside from civic reasons, "environmental" motives, and exploring scale for the sake of scale, the mode of monumentality exists for other reasons: Bladen and Grosvenor desire sculpture with a powerful impact; Sugarman works for a vivid dialogue between the piece and the space it creates:

> My involvement in sculpture outside of man's scale is an attempt to reach that area of excitement belonging to natural phenomena such as a gigantic wave poised before it makes its fall. . . .
> The scale becomes aggressive or heroic. The esthetic is a depersonalized one. The space is exploded or compressed rather than presented.[3]

Whatever the interests, the monumental sculptor is intrinsically involved in science and industry. Considerations such as weatherproofing require the investigation of surfacing materials: enamels, epoxies, and fiberglas, as well as metals like stainless steel. Stresses and tensions in monumental works must be calculated. Industry and technology have not only afforded artists the means of fabrication, but perpetuate interest in endless technical advancements.

1. "Sculpture: Master of the Monumentalists," *Time* 90, no. 15 (Oct. 13, 1967) : 80.

2. An international movement that recognizes both the need for scale and public enjoyment of the works has existed since 1959. Representatives have met in Austria, Yugoslavia, Israel, Japan, Italy, and Canada. The sculptors were provided with food and lodging, materials, and technical assistance. In return, they left a permanent garden of sculptural works in large scale. In 1962, David Smith, at Spoleto, created twenty-six pieces. In 1963, an International Symposium of Sculptors was formed to discuss a Highway of the Arts, which would incorporate monumental sculptures in materials representative of our civilization—stone, concrete, and steel.

3. Bladen, quoted from Barbara Rose, "ABC Art," *Art in America* 53, no. 5 (1965) : 63.

4
Surface Qualities

Surfaces of works of the sixties emphasize an optical rather than a tactile experience. McCracken's sensuous industrial finishes painted with a high luster exemplify this trend, as does David Smith's later work, which included polishing, burnishing, and grinding stainless steel.

Reflected in this new orientation is the contemporary feeling for materials; ambiguous and metaphorical implications suggested by qualities inherent in the reflection of polished or plated metal and the smoothness and precision of machine fabrication are utilized. Grinding and polishing, sculptor Audrey Corwin Wright produced a very personal interpretation of this trend. Through soaring, lustrous, metallic rhythms, she combined the tactile and the optical in "A Bird in Flight," a sculpture for the blind. Acrylics and polyesters, by the nature of the materials, lend themselves to artistic explorations in refraction and reflection of light and various other optical phenomena. This is witnessed in works by Beasley, Eversley, Frank, Massin, and other artists involved with plastics as a material.

Surfaces that are *put on forms,* such as colored plastics and epoxies on wood or metal, rarely seem so. Rather, they seem to be an integral part of the form.

Color and Sculpture

The new colorism is perhaps one of the boldest and most promising trends in contemporary sculpture. Bright colors have been more commonly encountered in the sixties than they have for five centuries, and their uses more varied than in late-Gothic polychromy.

An enormous amount of colored sculpture has recently been produced over which traditional values exert no influence. The modern maker of sculpture is allowed the freedom of his individual taste.[1] The trend is about twelve years old, and the uses of color are diverse.

All colors, as well as luminous and metallic finishes, are used; they draw heavily on advances in chemistry and manufactured materials. Appropriations are seen in works that are glazed, pigmented, coated, and sprayed; colored light is used, also colored plastics and other materials in which the color is not applied but inherent in the material.

The fluorescence of color directly and indirectly reflects the influence of technology. Steel, fiberglass, and aluminum, the natural color of which is relatively nondescript, suggest brightening. Plastic resins, enamels, and laquers which are almost impervious to wear are readily available to the artist.

The various uses of color, broken down into categories by Geist, are: 1) imitative naturalism, 2) stylized realism, 3) Cubist color, 4) color used as a formal element, 5) color used to demark and 6) create form, 7) color used as a unification element, 8) and as a surfacing medium used to neutralize the material, 9) color used to deny, oppose, absorb, and distort form, 10) negative color, and 11) color used for psychological effect.[2]

Italian religious sculpture is an example of *imitative naturalism.* This stylistic use is fairly rare in modern sculpture, requiring an imitative modeling of form plus an imitative color application to give the look of an actual subject frozen in time.

1. In the United States alone, sculptors using color include Arnold, Beal, Bladen, Campbell, Chamberlain, Daplines, Diller, Massin, Myers, Navin, Neri, Nevelson, Oldenburg, Tony Smith, Sugarman, Watts, Weinrib, Westermann, and the late Wilfred Zogbaum, among others.
2. Sidney Geist, "Color it Sculpture," *Arts Yearbook—8* (New York: Arts Digest Inc., 1965), pp. 93–95.

The most prevalent use of color in sculpture is classified as *stylistic realism*. Here the sculptor exhibits creative initiative rather than the display of imitative ability. The color functions within the sculpture. The application of color to figural sculpture may be according to any number of nonnaturalistic styles or configurations, and color usage may range from a descriptive to a decorative to a symbolic use.

Cubist color, as seen in Picasso's works, is color used to penetrate the surface of an object in order to create a more acute awareness of the interior.

In nonrepresentational sculpture, as in Neo-Plastic, Suprematist, and Constructivist works, color is used as a *formal element.* This concept is relatively new—color becomes like the form, a solid element that refers back to itself. The concept has given birth to sculpture independent of nature; these works are created of colored masses and planes. They are arranged in accordance with an invented logic.

McCracken's three-dimensional skins, created by layers of color, utilize this concept. The form is transcended and subsumed. Weinrib uses translucent and polychromed plastic; his color is used to produce a "play" of dissonant colors and lights.

Historically, the way in which color was most used was to *demark forms.* Closely allied to this is color to *create forms* that are not already indicated in the sculpture. Elie Nadleman used color in this way, also William King, and Anne Arnold—the use here is a sophisticated one, however; it is also found in folk art, where, for example, a nose and mouth are indicated on a smooth form by color where there is no sculptural indication for them.

In Louise Nevelson's constructions, the use of color to *unify the parts* is self-explanatory: these constructions are created through the combination of many different objects and components, and painted one tone. Caro, also, restricts himself to one unifying color per work, integrating color with structure, rather than superimposing pattern on form and segmenting elements.

Calder's stabiles may serve to illustrate the utilization of color as a *surfacing medium,* which has the capacity to neutralize the material in which he works. Tony Smith's color and also Caro's colorism are used in this way.

Color flooding over seemingly formal demarcations within the sculpture can *deny, oppose, or absorb forms.* Color can achieve a new form on a work where it does not exist sculpturally; a *trompe-l'oeil effect* is created when Robert Hudson covers his sculpture with shapes that make flat planes appear curved, protuberances flattened, and concave and convex shapes appear as flat planes. Various other optical illusions are added: the contradictory images include pop, op, hard-edge, and geometric forms.

Jasper Johns has also used color to fool the eye by denying the sculptural material in his *Painted Bronze,* where a bronze container and brushes are painted in imitation of the real article. Using Geist's classifications, one might ponder if this is color used as the aforementioned *imitative naturalism.* Or might it possibly be called a *surfacing medium,* since it certainly denies or at least neutralizes the material over which it is placed; or might it be the yet-to-be-discussed color used to create a *psychological effect,* since it certainly is jarring to discover that what looks like one thing is actually another? Perhaps the answer is all three—a *surfacing medium* that *imitates naturalism,* causing a *psychological effect.*

Negative color refers to works such as those created by Peter Agostini and George Segal, where white plaster objects and figures are cast. Oldenburg, too, jars the color sense with his soft echoes of everyday objects.

Color to create a mood, as in the work of Marisol, creates a *psychological effect.* For this artist, color is used to designate personalities. Tony Smith's color is neutral at times, not perceived as a hue, as in his sculpture entitled *Die.* The gray tone causes a psychological tension when placed in a natural environment. An artist such as Sugarman builds unrelated weighty forms, which he paints in order to augment the masses of his progression and clarify their specific positions; of prime importance to him is that the color create tremendous impact. But here, as with the Jasper Johns "bronze," Sugarman's colorism falls under more than one category.

The new use of color has created problems both practical and theoretical for the working artist. Sidney Geist has focused on the practical—it seems impossible to paint an object purple. This color is risky and must be used sparingly. Difficulties involve not only the color purple, but maroon, lavender, and Indian red. The ochers and umbers and dark greens are also

included. Even with these limitations, an artist such as Tom Doyle will use exotic pinks and grasshopper greens.

Difficulties of a more theoretical nature are also noted. Color in painting is always added color, whereas in sculpture color can be inherent in the material. This situation presents questions as to the definition of color in a given sculptural material. Geist asks:

> Does not all sculpture, by virtue of being material, have color? Does a touch of color, or the use of subtle or quiet color, qualify for the title of colored sculpture? . . . Is a sculpture painted all blue more "colored" than a white marble?[3]

Lucy Lippard reasons that

> obviously touches of color or quiet color do qualify and are often more important to the work than a large area or bright hue. Yet naturally colored traditional materials such as wood, bronze, marble, stone, no matter how much color they may provide, would not make colored sculpture in the strict sense, partially because of their long acceptance and consequent low level of visibility, but mainly because other characteristics of these materials, such as grain, reflectiveness, surface, texture, are likely to be more important than their color. Thus a sculpture *painted* gray is more

"colored" than a gray stone sculpture because the color is a positive, added factor, an agent of change that disguises or regulates all other properties of the material.[4]

The problem of a monochromed object is different from that of a polychromed object; unless the object is made of a material with inherent color, the added color may become an arbitrary envelope where it becomes nothing more than an eye-catching device. Clement Greenberg points to Anthony Caro, whose work, he feels, either transcends its color, or whose color combinations detract from the work. Greenberg considers Caro's use of color provisional, an element that can be changed at will without greatly affecting the quality of the work on which it is used.

Color in sculpture is more difficult to work with than color in painting. Painting in sculpture must "work" from more than just a frontal viewpoint; this means that far greater control is necessary. Painted or colored sculpture is at an earlier stage of development than color in painting. This makes judgment of a piece difficult, since there is not as yet a system or theory established whereby these works can be judged.

3. *Ibid.*, pp. 92–93.

4. Lucy C. Lippard, "As Painting is to Sculpture: A Changing Ratio," *American Sculpture of the Sixties*, ed. Maurice Tuchman (Greenwich, Conn.: New Graphic Society, 1967), pp. 33–34.

5

An Old Method Updated

Appearances in works of the sixties aren't always what they seem. While new images, materials, and methods are utilized by many, traditional methods, given new flexibility through technology, are also employed. In the area of metal, owing to industrial advances, a renewed interest in bronze casting has manifested itself. Industry's answer to the need for a casting process that would produce high-integrity, durable, and economical molds in a very short time is the Ceramic Shell Process. With this solution to the problem of casting precision instruments, tools, dies, and electric components, the artist has been provided with an inexpensive timesaving, and accurate method in which fine detail is not lost; rough textures as well as configurations can be obtained.

Three materials afforded by modern technology can be used in making the wax pattern: a heat-setting vinyl, used in the plastics industry; a cold vulcanized rubber, developed for use in missile systems; and a silicone rubber, developed for the electronics industry. Limitless quantities of wax models can be made from these patterns.

The molds to be fired are the most important part of the process. Extremely stable, heat-resistant ceramic materials are used instead of the old clays, brick dust, and plasters. Because these new molds are permeable, gases are able to escape through the mold itself, thereby eliminating the expensive gating systems previously necessary. With the fewer vents, there is less work "chasing" the pieces that have been cast. Resistance of the mold to heat dilation eliminates cracking in the mold, and the shrinkage or seepage of metal. Thus the artist is saved expensive and unnecessary repairs. The finished castings are clean because of the toughness and resistance of the mold; no mold particles are washed into the hot metal.

There is great advantage over the old lost wax process in the time saved in preparing and drying the molds and in burning out the wax. The entire mold operation has been cut from weeks to days—to burn out the wax alone would require nearly four days in the lost wax method; this can be accomplished in six hours with the Ceramic Shell Process.

Materials other than bronze, for example, stainless steel and aluminum, can be cast. Through these molds, the artist's vocabulary has been extended.

Al Vrana has cast in bronze for many years, incorporating anything from wax to *pasta* to styrene as a burnout material. Even when unorthodox materials are used in the model, the final work is orthodox in appearance.

David Slivka, on the other hand, after twenty years of stone carving, is casting in bronze. He works directly in wax, which he employs for its immediacy and spontaneity, and for the relative economy of casting costs. Bronze casting is one area where the old and the new have combined.

Part II

Scientific Concept for the Mind

Aside from the direct influences that are seen in Technology for the Hand, deeper and more subtle influences instigated by science and technology are also noted: the speed at which science has introduced new concepts, and the implications of a new metaphysic in a computer-oriented society, have been obviously reshaping our culture. Indirect influences infiltrate the art world so quickly that they are difficult to recognize and not easy to monitor. In the realm of physics, Einstein has upset the concept of time—his theories are reflected generally in the artistic and cultural clime, as in Happenings. Exerting no small influence, scientific concept has contributed to the breakdown of traditional aesthetics and classifications, and consequently to changes in sculptural prerequisites and visual reorientation.

6

Minimal Art

Utilizing anti-Newtonian concepts, concepts of "the object," of "nonsculpture," and of "*gestalt*" imagery, Minimal Art (also referred to as ABC, Reductive, and Primary Structures) is much more theoretically, intellectually, and verbally complex than visually interesting.

When carefully examined, Minimal Art not only indicates a breakdown in the classification *sculpture*, but also challenges the category of *visual* within the Fine Arts classification system. The object presented to the viewer as a visual experience is actually a mere reference to the thinking that brought it into being, and continues to be a monument to verbal explanations of the same.

Toward Nonsculpture and "the Object": A Brief History

Minimal Art is the evolutionary product of thought in both painting and sculpture that first led to "the object" and nonsculpture. The development toward "the object" and a nonsculptural sculpture is due to several factors. One was developed by Mark Rothko in the early fifties. He insisted that a painting was an "independent object." By making stretchers deeper than customary, omitting the frame and stripping, and painting the side edges, he stressed his convictions. This, added to the large size used by himself, Pollock, Newman, and Still, helped to force on the viewer the "presence" of the painting, which dominated the space in which it was hung. Also affecting a painting that was not merely decoration were Ad Reinhardt's stringently reductive program and black rectangles. Finally, the break away from easel painting helped create the new sculpture—the New York School's heroic era permit-

ted freedom of scale and a resultant conceptual freedom. Definitions of painting and sculpture were revised.[1]

Two concepts in painting have influenced the trend to nonsculptural sculpture: first, painting as a specific surface without connotation of volume and physicality—involving on the one hand, the rejection of illusionistic space in painting, and on the other, the present concern for surface qualities in the new sculpture; and second, painting as a three-dimensional "object."

The concept of "object" is equally double faceted. In the late fifties Rauschenberg and Johns, among other artists, began to add to the surface of their paintings objects that took up three-dimensional space. This notion of "object" is an additive one; it is associated with Dada or Surrealist or assemblage work, which is made of nontraditional materials or found items. Added to this, "specific objects," named by Judd, are of a different nature from the additive type. They encompass simple, single, or strictly repetitive serial or modular sculptures; the concept is a rejection of Cubist composition, which exists by the relationship and subordination of the formal parts to the entirety. Rather than being Cubist in connotation, the "specific object" is akin to the Dada object in this respect, that it is not only nonsculptural, but anti-sculptural as well.

Lippard feels that this new sculpture is also an anti-painting idiom because many of its creators were

1. Lucy R. Lippard, "As Painting is to Sculpture: A Changing Ratio"; Barbara Rose, "Post-Cubist Sculpture"; Clement Greenberg, "Recentness of Sculpture"; *American Sculpture of the Sixties*, ed. Maurice Tuchman (Greenwich, Conn.: New Graphic Society, 1967), p. 31.

former painters and their interests lie more in recent painting than in recent sculpture.[2] Because these three-dimensional objects were created as a reaction to the limitations in painting rather than in sculpture, and because their antecedents existed in the realm of three-dimensional "objects"—for example, Dada, Surreal, Assemblage, and "specific objects" —the new work appears to have little to do with conventional sculpture.

Another factor in the development of nonsculpture is the elimination of the base; many sculptors of the sixties have reacted against the convention that rooted their art in permanent, real surroundings that served as a twilight zone and allowed the work to stand apart. This base, this pedestal, this vehicle that helped create aura and distance around the precious object, has been forsaken; contemporary sculpture is set as a completely realized form in an open viewing space. Rather than aesthetic distance and the concept of sculpture as a rare and favored object, the heightened experience of direct contact is sought. Sculptures that occupy unexploited positions in space, for example works that come off the ceilings and walls, further emphasize this direction,[3] leading the spectator to contemplate the here and now.

Toward the Minimal Idea and Anti-Newtonian Concepts

The idea of shaping a form so that it exists in its own isolated space has developed in two directions, both of which differ from earlier Cubist traditions; they are: 1) the extended sculpture of Sugarman, Weinrib, and Doyle, and 2) the unitary objects of Judd, Morris, and others that come under various titles of Cool, ABC, or Minimal and Primary Structures, or Specific Objects. The extended, disassociated works of Sugarman and Weinrib juxtapose disparate, polychromed masses organized in sequence —the whole being subordinate to the parts. These off-axis, extended masses create a dynamic feeling, as though they were conquering space. The unitary works represented by Morris and Judd are the most discussed and controversial. Simple, massive, elementary geometric forms constitute these works, in solid or repeat units. They serve primarily the function of invasion or occupancy; the large inert "objects" seem to take up too much space, troubling the viewer with their presence.

Aesthetically, no problem is encountered, as in earlier sculpture, with regard to ordering the parts in a format or formal arrangement by establishing plastic relations with the work. The new works, constructed according to a different aesthetic, provide in unitary objects for the elimination of parts to emphasize the whole; in the dissociated structures the whole is subordinated to the parts.

Diametrically opposed to the relational basis of Cubist aesthetics, Minimal sculptors are making works that are integral "gestalts." These contemporary works—bold, aggressive, volumetric structures— demand to be seen all at once in one single image. They are held together with the energy of the gestalt.

> Characteristic of a gestalt is that once it is established all the information about it, qua gestalt, is exhausted. (One does not, for example, seek the gestalt of a gestalt.) [4]

Judd feels that a simple form, representative of neither order or disorder, should be used.[5] However, simplicity of shape does not necessarily mean simplicity of experience, according to artist Robert Morris. He feels that relationships are not reduced by unitary forms, but rather are ordered.[6] Judd is "getting rid of the things people used to think were essential to art. . . .It isn't necessary for a work to have a lot of things to look at, to compare, to analyze one by one, to contemplate."[7]

The Minimal idea is elaborated by artist Robert Smithson, who writes:

2. "Ratio," p. 31.

3. Among those who reject the traditional plinth, it has become commonplace to create works that cross broad expanses of floor (Andre), attach directly to a wall or ceiling (Grosvenor, Weinrib), lean against a wall (McCracken), or appear to defy the force of gravity and create the image of tremendous thrust (Snelson). See quotations from Snelson that accompany Figs. 63 and 82.

4. Robert Morris, "Notes on Sculpture," *Artforum* 4, no. 6 (1966): 44.

5. Bruce Glaser, "Questions to Stella and Judd," *Art News* 65, no. 5 (1966): 58–60.

6. Morris, "Notes," p. 44.

7. Glaser, "Questions," pp. 58–60.

Instead of causing us to remember the past like the old monuments, the new monuments seem to cause us to forget the future. . . . They are . . . built . . . against the ages. They are involved in a systematic reduction of time down to fractions of seconds, rather than representing the long spaces of centuries. Both past and future are placed into an objective present. This kind of time has little or no space; it is stationary and without movement, it is going nowhere, it is anti-Newtonian, as well as being instant, and is against the wheels of the time-clock.[8]

This nullification is labeled and likened to a City of the Future that hovers between mind and matter, having no natural function, and without the age-old concepts of space and progress. This city becomes visible only through strict perception rather than through the emotions.

Perception as a deprivation of action and reaction brings to mind the desolate, but exquisite surface-structures of the empty "box" or "lattice." As action decreases, the clarity of surface structures increases. This is evident in art when all representations of action pass into oblivion. At this stage, lethargy is elevated to most glorious magnitude.[9]

A Feat of Ideation

Unitary objects whose bareness forces attention to the irreducible limits of sculpture, seeming to be reduced by the logic of purest aesthetics, have been classified in Clement Greenberg's concept of "far-out."

In the Sixties it has been as though art—at least the kind that gets the most attention—set for itself as a problem the task of extricating the far-out "in itself" from the merely odd, the incongruous, and the socially shocking . . . the furthest-out usually lay on the borderline between art and non-art.[10]

He suggests that when painting could no longer be classified as nonart, since an unpainted canvas was stated as a picture, the third dimension was left to be explored as the area where nonart lay. The idea of mixing the mediums seemed to be the far-out thing to do, the purpose being to assemble objects that were barely art. This projection was the ostensible aim of the Minimalists, who offer the viewer a minimum amount of interesting incident. According to Greenberg, in concept it appears that a type of art closer to nonart could not be imagined or "ideated" at the time. Unfortunately, this is exactly the problem with Minimal Art. According to Greenberg, it remains primarily a feat of ideation and little else.[11] Greenberg is not alone in his criticisms. Sandler describes the pieces as matter-of-fact and mentally contrived rather than that which has been developed during the working process. Cool and intellectual, he feels that the works are the antithesis of art.[12]

Greenberg also notes that Minimal Art offers the viewer only one surprise, not unlike that of novelty art. The senses, he feels, experience conventionality, and aesthetically the work, he notes, goes only as far as "good safe taste . . . in the realm of Good Design." The works, Greenberg describes as "tokens," which convert the third dimension into a "mannerism."[13]

Artists Morris and Judd have written lengthy theoretical defenses of their work. They dislike having the terms *theoretical* and *reductive* applied to their work. According to these artists, their creations are being judged in terms that do not apply to the understanding of the new aesthetic.

8. Robert Smithson, "Entropy and the New Monuments," *Artforum* 4, no. 10 (1966): 26–27.

9. *Ibid.*, p. 27.

10. Greenberg, "Recentness," pp. 24–25.

11. *Ibid.*

12. Irving Sandler, "Gesture and Non-Gesture in Recent Sculpture," *American Sculpture of the Sixties*, p. 42.

13. Greenberg, "Recentness," pp. 24–25.

7

Serial and Modular Works

Another area greatly influenced by scientfic concept is that of serial and modular systems. The field is intellectually fascinating and verbally exciting. Resultant works are visualizations of abstract patterns of thought. Although these works are presently considered in the *visual* arts, listed below is a vocabulary adapted from Mel Bochner necessary for intelligibility.

ABSTRACT SYSTEM—A method or arrangement in which the physical members that are to operate as objects have not been stated.

BINARY—Made up of two components.

DEFINITE TRANSITION—A precept that requires, at some fixed interval before or after a given member, that some other member be demanded or omitted.

GRAMMAR—That phase of the method that regulates the allowable combinations of components belonging to that arrangement.

ISOMORPHISM—An arrangement between methods so that by regulations governing transformation each member of one system can be made to correspond to one member of the other.

ORTHOGONAL—Right angled.

PERMUTATION—Any of a sum total of mutations or changes in arrangement that are feasible within a group of elements.

PROBABILITY—The ratio of the number of ways in which a particular form of an event might occur to the total number of ways in which the event might happen in any form.

PROGRESSION—A discrete series that has a first element or component but not necessarily a last element or component in which every intermediate factor is related by a constant law to the others. An ARITHMETIC PROGRESSION is one in which a series of numbers in which succeeding terms are determined by the addition of a constant number (1, 3,7,9 . . .). A GEOMETRIC PROGRESSION is a series of numbers in which the succeeding terms are derived by the multiplication by a constant factor (2,8,32, 128 . . .).

REVERSAL—A method consisting of an upside-down turn or inversion within a series.

ROTATION—A method involving an axial turn or succession within a series.

SEQUENCE—State of being in a consecutive order.

SERIES—A succession of terms or set of sequentially ordered elements each derived from one or more of the preceding elements by a constant factor.

SET—The sum total of points, numbers, or other elements that satisfy a given prerequisite.

SIMULTANEITY—A relation or agreement of time or place in the happening of multiple events[1].

Immediately apparent, in concept and terminology, is the influence of the computer and scientific abstractions.

Both systems, modular and serial, are systems of order, yet modular concepts differ radically from serial ideas. Modular is based on the repetition of a standard unit, which may be anything from Andre's bricks to Warhol's soup cans. This standard unit does not alter in form, but may vary in the way in which the systems are adjoined. In this system, units may be added to modify a simple *gestalt* work. It is based on the simple repetition of forms. The series system is more complex. Basically, three operational assumptions exist:

(1) The derivation of the terms or interior divisions of the work is by means of a numerical or otherwise systematically predetermined process (permutation, progression, rotation, reversal).

(2) The order takes precedence over the execution.

(3) The completed work is fundamentally parsimonious and systematically self-exhausting.[2]

Artists exploiting aspects of serial and modular systems include: Sol LeWitt, whose two-dimensional orthogonal or rectangular grid placement is akin to the system used in mapmaking; Donald Judd; Dan Flavin, whose *Nominal Three to William of Ocham* is based on an arithmetic progression; Eva Hesse; William Kolokowski, who uses programmed asterisks; Bernard Kirschenbaum's crystallographic structures; and Robert Smithson's pyramidal glass stacks.[3] Modular concepts are utilized by Frank Stella, although in his concentric-square painting, a serialized color arrangement is employed along with the arrangement of black squares.[4] Donald Judd, interested in the realm of "specific objects," has used the modular and serial concepts. In one of his untitled galvanized iron pieces, which consists of four hemi-cylindrical parts projecting from the face of a long rectangular form, he uses the progression: 3, 4, 3½, 3½, 4, 3, 4½.

The first, third, fifth, and seventh numbers are the ascending proportions of the widths of the metal protrusions. The second, fourth, and sixth numbers are the widths of the spaces between. The numbers are not measurements but proportional divisions of whatever length the work is decided to be.[5]

Sol LeWitt also uses serial systems.

Sol LeWitt orders his floor pieces by permuting linear dimension and binary volumetric possibilities. Part of his eighteen-piece Dwan Gallery (Los Angeles) exhibition could have appeared at one of three height variables, in one of two volumetric variables . . . and in one of two positional variables, on a constant 3 x 3 square grid.[6]

Works employing these systems, as in Minimal Art, mark the absence of the artist in the creative process. Here one is reminded of Fry's progressive steps to a "Faustian" dream of a new art, one that "would be only incidentally tangible and would serve as witness to the presence of intangible systems," an art that would eventually create life and intelligence itself.[7]

1. Mel Bochner, "The Serial Attitude," *Artforum* 6, no. 4 (1967): 31.
2. *Ibid.*, p. 28.
3. *Ibid.*, p. 33.
4. *Ibid.*, p. 28.
5. *Ibid.*, p. 33.
6. *Ibid.*
7. Fry, "Sculpture," p. 28.

8

Kinetics and Light

The trends of Kinetics and Light, both concerned with energy, are deeply enmeshed in science and technology. Kinetics, involved with movement, utilizes energy in general; Light is concerned with specific energy—Light.

The Kinetic Stream

Kinetic Art has been defined by Reichardt as "the type of art which employs mechanical motion, and where this motion is introduced as a technical rather than ideological consideration."[1] A kinetic work, according to Rickey, one of the foremost kineticists, "moves within itself, changing the space relations of the parts; and this movement is a dominant theme, not an incidental quality."[2]

One definition places importance on mechanical motion, and that motion must be a technical consideration; the other stresses movement within and by the work itself. One element, however, is constant—kinetic works must *move,* whether mechanically or otherwise, and this movement must be *within* the piece.

Although bearing resemblances and sharing the concept of movement with other trends, kinetic works can be set apart. Optical pieces that stimulate movement and works that depend on spectator participation for actual movement bear a relation to kinetic art—optical creations employ static images or objects as stimuli. Although exciting the viewer to experience motion, this work can not be classified as kinetic by the afore-stated definition because, in kinetics, movement is considered the attribute of the object. The type of art that conveys the illusion of motion by optical phenomena, that dazzles the eye and causes boundaries to appear to shift is termed "cinetic."[3] Included in this category of *fixed* objects are moirage and paralax, which utilize juxtapositions of black and white tones. In the case of paralax, the relationship between the parts changes when the viewer moves.

Agam's painting and moiré effects of superimposed grids are indicative of cinetic pieces. Various types of optical phenomena are treated by Vasarely, Bridgitt Riley, Tadesky, and Apolino.

Another relative to the kinetic stream is the movable work in which kinship is created by the term *movable.*[4] This type of work requires a kinetic viewer to pull strings, turn knobs, move hinged objects or otherwise rearrange an object from one static position to another. The viewer is in motion, but the work only momentarily so at the time of manipulation. This can not be considered kinetic art, either, but rather movable art.

Ligia Clark, a Brazilian artist, hinges planes of aluminum to be moved by the viewer. Karl Gërstner, from Basel, has the viewer adjust superimposed lattices in tweed positions. Another Swiss, Paul Täl-man, also effects movement in this mode of manipulation.

1. Jasia Reichardt, "A Perspective of Kinetic Art," *Studio International* 173, no. 886 (1967): 58.
2. George Rickey, "Origins of Kinetic Art," *Studio International* 173, no. 886 (1967): 68.

3. Reichardt, "Kinetic Art," p. 58.
4. Rickey, "Origins," p. 68.

Strictly Light

Works produced within the realm of "light" include those by Dan Flavin and Cryssa, who use light as a material; light as a material is radical. Flavin works in a square format of four eight-foot fluorescent tubes that are frontally oriented. Neon works by Cryssa, although they exist in the third dimension, suggest painting with light.

Light is sometimes projected to form "Light Paintings"—Thomas Wilfred and Nicolas Schöffer, among others, are involved in this area. In this form, light is projected from programmed boxes or "light organs" onto a translucent surface. Otto Piene of the Düsseldorf Group Zero, creates an environment by projecting orchestrations of light onto the ceiling, walls, and floor. Light is also used to "play" on other materials—this is different from the above sense, which involves projection. La Parc, for instance, "plays" a ray of light on a curved and moving reflector in order to note the interplay and response.

Energy-Drawn Artists

The trends of Kinetic and Light clearly reflect alliances within science, technology, industry, and art not only in concept, that is, involvement with energy, but in the involvement with forms of circuitry, amplifiers, oscillators, digital computers, wheels (Seauwright), the integration of television circuits with audiovisual devices (Martial Raysse), the use of technical motion employing a dependency on a series of permutations (Von Graevnitz), or a sequence—predetermined and repetitive, as in the light machines of Malina, Livinus, and Healy. Minimal Art is motorized by Breer in his columns that progress across the floor, creating a relationship between the parts by pure chance. The technology of Charles Frazier produces sculpture that swims, dances, and flies. Stephen Von Heune creates an extension of man in his humanized machine—he has combined a pneumatic sound-producing system with a Kinetic work. Jean Tinguely, the Dadaist of Kinetics, works in a wry manner—he is anti-machine. Schöffer, the cybernetician, wants to humanize the machine in order to liberate mankind. Haacke's use of foam in kinetic expression displays an interesting use of kinetics related to new materials, as does Eugene Massin, who combines cinetics, kinetics, and light—he encases acrylic silhouettes within polyester castings that *appear* to walk, run, and dance.

The natural elements of wind and water combined with the new material plastic is incorporated by Sadamasa Motonaga of the Japanese Gutai Group of Osaka. He partially fills soft plastic sleeves of thirty-foot lengths with water. These are then hung in catenaries between trees. Changes in form are dependent on wind and water movement. Oil and water combine in the work of Hans Haacke.

Movement is combined with sound (Tinguely) by employing noisy devices and radios; François and Bernard Baschet also make use of this method. Other phenomena include springs, kaleidescopic mirrors, and magnetism.

The lists of artists working within the realms of Kinetics and Light is long. These artists are working in one area or the other or employing as many combinations as the imagination will allow. The concepts are new—working with light and computers as mediums, with energy as an art form. They are still at the beginning of exploration.

Part III

The New Art

9

Rhetoric or Renaissance?

Artists of the 1960s, a decade in flux, worked in every direction conceivable—from paring down art to a minimal module and then enlarging the module to a monumental monolith, to the visualization of abstract systems. Artists executed works in their own studios or preplanned for factory fabrication. One creator worked in immovable masses, another in networks of fine filament; one constructed or assembled, while another carved, modeled, or welded. No interest was too great or too small. Motion was explored, energy utilized, and earth, water, and natural elements rediscovered as ecology became an artistic concern. Architecture, sculpture, and painting were combined. No material or process was overlooked. Works flew, floated, made noise, moved across the floor; imposed their "presences"; or flashed on and off; works were soft, hard, colored, white, solid, liquid; or were made of car bumpers. Sculpture pushed against tradition, while science and technology supplied the means.

Traditional limitations have been upset. The base or stand has been confronted and eliminated at will —sculpture can now hang from the ceiling or walls, as well as sit directly on the floor. The concept of media and "truth to materials" has been disturbed. Optics in art, for example, helped to destroy this aesthetic by making a surface appear to be something it wasn't. New colors, supplied by industry, in the form of plastics, epoxies, lacquers, and paints also added impetus to this breakdown.

The entire classification of sculpture in the visual arts has become *passé*—modern sculpture has extended its boundaries to unlimited possibility. At one time, a collection of sculpture was exhibited. Today, exhibits may be held of Light Art or Kinetic Art, which may incidentally include sculpture and painting, but most probably would also include works that are neither.

An exhibit that includes a survey of recent sculpture might eliminate works that are frontally oriented. In one exhibit this was indeed a stipulation.[1] This limitation could possibly exclude sculpture such as Louise Nevelson's assemblages—assembled and painted works that resemble a traditional sculptural relief. These works are termed *sculpture,* yet they might be excluded from an exhibit of "sculpture."

Shaped canvases, belonging to what is known as "the third stream," are neither painting nor sculpture. The area between painting and sculpture, and sculpture and architecture, has become so complex that classification, it would seem, must to a great extent be highly personal or arbitrary.

Since artists are not generally concerned with categories and classifications—categories and classifications being conceived after the fact, that is, the work—one finds that the modern artist's main concern is with new forms and concepts. It is no longer critical for a work to be carved, to enclose, divide, or displace space. There is little concern as to whether a surface is painted or not; factors of this sort are only incidental.

Kinetics, Light, and Serial and Modular Systems, among others, emerge as extensive fields in themselves. These areas, incidentally, can use the third dimension.

Not only has the term *sculpture* in the visual arts been challenged, but the term *visual* is at times quite

1. Fry, "Sixties," p. 26.

tenuous, since the voluminous amount of verbalization used in order to understand or appreciate the visual far surpasses the object viewed. Minimal or Serial Works provide the case in point. The average viewer can not walk up to a Minimal or Serial piece and comprehend its meaning.

Technological effects on the mental clime are reflected in an art that is becoming more and more intellectual and conceptual as a pursuit. This intellectualization is seen in the idea of single-*gestalt* imagery. It is also evident in the educational systems, as well as in the artists themselves, who are seeking to keep abreast of the new scientific theories and discoveries.

Science is, in fact, such a dominating influence in our society that it is sometimes felt to be a threat to art. The feeling exists that failure to compete with science will result in the cessation of art.

On the other hand, art as resulting in achievement of Fry's "Faustian" dream—the creation of life and intelligence—is seen as a future possibility. The new art is to replace art based on the sensuous and physical qualities of an object. It would be first indicated by the use of energy, including light and movement, followed by cybernetics. Incidentally tangible the new art would exist only to verify the presence of intangible systems.[2] (These trends already exist; witness Minimal, Serial, Kinetics, Conceptual, and Light.)

Verifying the presence of intangible systems, the works of many of the Minimal artists celebrate what is termed *entropy,* or "energy drain." The works serve as a visible analogy to the Second Law of Thermo-dynamics, which relates that energy is more easily lost than gained.

It is no doubt possible that we have come to the

end of an era, and, beginning with the 1960s, to the start of a new florescence. It is difficult, however, to think of a renaissance or rebirth when artists are involved with "energy drain": it is equally difficult to visualize the creation of life and intelligence with negativism.

In the area of Kinetics, Fletcher Benton feels that a great amount of technical knowledge must be acquired by the first generation of Kineticists so that successive generations can more readily utilize the information.[3] However, at present one finds aimless hitching of motors to some device which, when not in motion, seems commonplace. The use of these motors, many times, produces a naive or clichéd art. Sometimes one is aware of products that resemble an entire laboratory of experiments that were petrified into final shape before the experiments were concluded. Still, there are rare exceptions, among which Calder, Rickey, and Tinguely are listed.

In the main, however, materials and concepts seem to be dominating the artist, who does not yet seem to be fully in control of his medium. Rather than directing, he is being directed.

There also seems to be an incessant demand for change for the sake of change. It has been suggested that some artists have profited from uncertainty in taste, and have established reputations less from their new art than from lost convictions in the old.[4] The response to practically everything produced has been real antagonism, and is, many times, over-received. As George Rickey has noted: "Artists prosper, but it becomes no clearer what art is. To present a Swedish roller bearing as art is at least as plausible as Warhol presenting a commercial container."[5]

2. *Ibid.,* p. 28.

3. Peter Selz, *Directions in Kinetic Sculpture* (Berkeley: University of California, 1966), p. 19.
4. Sidney Tillim, "New York," *Artforum* 6, no. 5 (1968): 54.
5. George Rickey, "The Métier," *Arts Yearbook-8,* p. 166.

10

The Fusion of Art and Science: Closing the Gap

Science and technology, although exerting much influence on art today, is felt by some to be an inadequate influence on traditionally oriented artists. Kepes, of MIT, is one who feels this way, and he is actively seeking the fusion of art and science through his Center for Advanced Visual Studies and through his publications. He has been attempting to keep the artist abreast of contemporary and technological activities. His program at MIT is designed to produce a "special breed" trained in a particular background that affords a special vision. The product of this system is called a "visual designer." In an interview, Kepes stated:

> Our artists do not fight any more against the past, but without knowing it, against the future. Lacking orientation in our contemporary scientific world, many have inevitably drawn into themselves. An experimental effort to encourage interthinking between different disciplines in the visual arts and scientific and technical fields is more than overdue.[1]

Harvard, as well, is offering visual design courses as part of its architectural program.

New programs, actively seeking a fusion between art and science and dedicated to the reduction of the time lag between industrial product and artistic manipulation, have sprung up in the United States and in other countries as well. EAT (Experiments in Art and Technology) and the Esthetic Research Center of Venice, California, are two examples of a growing number. Industry, interested from a commercial point of view, actively supports organizations of this type.

However, according to a questionnaire distributed by Barbara Rose to artists working mostly in and around the New York area, there is opposition to this group effort. Rose has stated that, according to her survey, "there is a positive antipathy toward anything that would suggest communal activity."[2] The artists interviewed felt that their problems were individual. They understood that industry has the necessary facilities, materials, and knowledge needed for solutions to contemporary sculptural problems. They felt, however, that it is more practical to go to the specific industries themselves than to set up a center for experimental research.

In the past, the gap between industrial advance and artistic advantage was much wider than it is today. In part, the Bauhaus (founded in 1919) helped to bring art and science closer. The current resurgence of technological interest acknowledges this parentage, but it is of a very different nature and arises out of substantially different circumstances. The communal Bauhaus had a coordinated program of design reform, which had its basis in the Cubist style and Utopian socialist philosophy. Technology was exalted as the savior of art and man. Moral values were assigned to machine forms, and the new materials were thought to herald a new age. In the Bauhaus, there were programmatic aim and stylistic homogeneity.

In the contemporary "scene," the programmatic aim of one group may be very different from that of another group or of individual artists. This results in stylistic differences; and, as noted, there are opposing views as to the means of effecting the merger between art and technology. Still, the gap be-

1. Jane H. Kay, "Art and Science on the Charles," *Art in America* 55, no. 5 (September–October 1967) :64.

2. Barbara Rose, "Shall We Have a Renaissance?" *Art in America* 55, no. 2 (March–April 1967) : 31.

tween art and science is narrowing. Various methods are facilitating this merger: formal educational programs; the efforts of organized groups; the active support of industry; and the individual artist who consults industry personally. Also, rapid communications and mass media add impetus to the fusion.

As with every new giant step, questions, criticisms, and reevaluations are the healthy reactions to a sit-uation in flux. Sculpture today is certainly in this condition. The concepts are fascinating, the materials stimulating, and the methods of working increase daily. Certainly, with this great activity, some spectacular visual products must evolve. We may, indeed, be in the throes of a great renaissance that was started in the 1960s.

Selected Bibliography

Books

McLuhan, Marshall, and Fiore, Quentin. *The Medium is the Massage, An Inventory of Effects.* New York, London, Toronto: Bantam Books, Inc., 1967.

Newman, Thelma R. *Plastics as an Art Form.* New York, Philadelphia, London: Chilton Book Co., 1969.

Piene, Otto. *More Sky 1.* Cambridge, Mass.: Migrant Apparition Inc., 1970.

Read, Sir Herbert Edward [Knight]. *A Concise History of Modern Sculpture.* New York: Praeger, 1964.

Rich, Jack C. *The Materials and Methods of Sculpture.* New York: Oxford University Press, 1947.

Schon, Donald A. *Technology and Change.* New York: Dell Publishing Company, Inc., Delta Book, 1967.

Catalogue Articles

Alloway, Lawrence. "Serial Forms." *American Sculpture of the Sixties.* Catalogue for the Los Angeles County Museum of Art, April 28–June 25, 1967, and the Philadelphia Museum of Art, September 15–October 29. Edited by Maurice Tuchman. Greenwich, Conn.: New Graphic Society, 1967. Pp. 14–15.

Anderson, Wayne V. "Looking Back from the Sixties." *American Sculpture of the Sixties.* Catalogue for the Los Angeles County Museum of Art, April 28–June 25, 1967, and the Philadelphia Museum of Art, September 15–October 29. Edited by Maurice Tuchman. Greenwich, Conn.: New Graphic Society, 1967. Pp. 15–18.

Ashton, Dore. "Assemblage and Beyond." *American Sculpture of the Sixties.* Catalogue for the Los Angeles County Museum of Art, April 28–June 25, 1967, and the Philadelphia Museum of Art, September 15–October 29. Edited by Maurice Tuchman. Greenwich, Conn.: New Graphic Society, 1967. Pp. 18–21.

Coplans, John. "The New Sculpture and Technology." *American Sculpture of the Sixties.* Catalogue for the Los Angeles County Museum of Art, April 28–June 25, 1967, and the Philadelphia Museum of Art, September 15–October 29. Edited by Maurice Tuchman. Greenwich, Conn.: New Graphic Society, 1967. Pp. 21–23.

Greenberg, Clement. "Recentness of Sculpture." *American Sculpture of the Sixties.* Catalogue for the Los Angeles County Museum of Art, April 28–June 25, 1967, and the Philadelphia Museum of Art, September 15–October 29. Edited by Maurice Tuchman. Greenwich, Conn.: New Graphic Society, 1967. Pp. 24–26.

Lippard, Lucy R. "As Painting is to Sculpture: A Changing Ratio." *American Sculpture of the Sixties.* Catalogue for the Los Angeles County Museum of Art, April 28–June 25, 1967, and the Philadelphia Museum of Art, September 15–October 29. Edited by Maurice Tuchman. Greenwich, Conn.: New Graphic Society, 1967. Pp. 31–34.

Rose, Barbara. "Post-Cubist Sculpture." *American Sculpture of the Sixties.* Catalogue for the Los Angeles County Museum of Art, April 28–June 25, 1967, and the Philadelphia Museum of Art, September 15–October 29. Edited by Maurice Tuchman. Greenwich, Conn.: New Graphic Society, 1967. Pp. 37–40.

Sandler, Irving. "Gesture and Non-Gesture in Recent Sculpture." *American Sculpture of the Sixties.* Catalogue for the Los Angeles County Museum of Art, April 28–June 25, 1967, and the Philadelphia Museum of Art, September 15–October 29. Edited by Maurice Tuchman. Greenwich, Conn.: New Graphic Society, 1967. Pp. 40–43.

Tuchman, Maurice. "Introduction." *American Sculpture of the Sixties.* Catalogue for the Los Angeles County Museum of Art, April 28–June 25, 1967, and the Philadelphia Museum of Art, September 15–October

29. Edited by Maurice Tuchman. Greenwich, Conn.: New Graphic Society, 1967. Pp. 10–12.

Encyclopedia Article

Argan, Guilio Carlo. "Sculpture." *Encyclopedia of Art* (1966) , 12:815–38.

Magazine Articles

"Anthony Caro Interviewed by Andrew Forge." *Studio International* 171, no. 873 (January 1966) :7.

Bann, Stephen. "Environmental Art." *Studio International* 173, no. 886 (February 1967) :78–81.

Baro, Gene. "American Sculpture; A New Scene." *Studio International* 175, no. 896 (February 20, 1968) :9–19.

Battcock, Gregory. "Kenneth Snelson: Dialogue Between Stress and Tension at the Dwan." *Arts Magazine* 42, no. 4 (February 1968) :27–29.

Bochner, Mel. "The Serial Attitude." *Artforum* 6, no. 4 (December 1967) :28–33.

Burnham, Jack Wesley. "Sculpture's Vanishing Base." *Artforum* 6, no. 6 (November 1967) :47–55.

Busch, Julia. "A Painter's Plastic Sculpture." *Art Journal* 29, no. 4 (Summer 1970) :438–39.

Clay, Jean. "A Cultural Heatwave in New York." *Studio International* 175, no. 897 (February 1968) :72–75.

Danieli, Fidel A. "Los Angeles Commentary." *Studio International* 173, no. 890 (June 1967) :320–21.

———. "West Coast Grotesque: Stephen Von Heune." *Artforum* 6, no. 5 (January 1968) :50–52.

Davis, Douglas M. "Art and Technology: The New Combine." *Art in America* 56, no. 1 (January–February 1968) :28–37.

French, Palmer. "Plastics West Coast." *Artforum* 6, no. 5 (January 1968) :48–49.

———. "San Francisco." *Artforum* 6, no. 6 (February 1968) :56–59.

Fried, Michael. "Two Sculptures by Anthony Caro." *Artforum* 6, no. 6 (February 1968) :24–25.

Fry, Edward F. "Sculpture of the Sixties." *Art in America* 55, no. 5 (September–October 1967) :26–43.

Glaser, Bruce. "Questions to Stella and Judd." *Art News* 65, no. 5 (September 1966) :58–60.

Hahn, Otto. "Paris." *Arts Magazine* 42, no. 1 (September–October 1967) :46–47.

Hudson, Andrew. "Scale as Content." *Artforum* 6, no. 4 December 1967) :46–47.

"Images." *Arts Magazine* 42, no. 1 (September–October 1967) :12–13.

Kay, Jane H. "Art and Science on the Charles." *Art in America* 55, no. 5 (September–October 1967) :62–67.

Morris, Robert. "Notes on Sculpture." *Artforum* 4, no. 6 (February 1966) :44.

———. "Notes on Sculpture, Part II." *Artforum* 5, no. 2 (October 1966) :21–23.

"New Talent USA." *Art in America* 54, no. 4 (July–August 1966) :22–69.

Piene, Nan R. "Light Art." *Art in America* 55, no. 3 (May–June 1967) :24–47.

Pincus-Witten, Robert. "New York." *Artforum* 6, no. 4 (December 1967) :52–56.

———. "New York." *Artforum* 6, no. 5 (January 1968) : 59.

Popper, Frank. "The Luminal Trend in Kinetic Art." *Studio International* 173, no. 886 (February 1967) : 72–77.

Reichardt, Jasia. "A Perspective of Kinetic Art." *Studio International* 173, no. 886 (February 1967) :58–59.

Rickey, George. "Kinesis Continued." *Art in America* 53, no. 8 (December–January 1965–66) :45–55.

———. "Origins of Kinetic Art." *Studio International* 173, no. 886 (February 1967) :65–69.

Robins, Corine. "Object, Structure or Sculpture; Where are We?" *Arts Magazine* 40, no. 9 (October 1966) : 33–37.

Rose, Barbara. "ABC Art." *Art in America* 53, no. 5 (October–November 1965) :57–69.

———. "Shall We Have a Renaissance?" *Art in America* 55, no. 2 (March–April 1967) :30–39.

"Sculpture: Master of the Monumentalists." *Time* 90, no. 15 (October 13, 1967) :80–86.

Smithson, Robert. "Entropy and the New Monuments." *Artforum* 4, no. 10 (June 1966) :26–27.

"Statements by Kinetic Artists." *Studio International* 173, no. 886 (February 1967) :60–63.

Tillim, Sidney. "New York." *Artforum* 6, no. 5 (January 1968) :53–57.

Wasserman, Emily. "New York." *Artforum* 6, no. 5 (January 1968) :58.

Yearbook Articles

Buhler, Margaret. "The Shaw Process." *Contemporary Sculpture: Arts Yearbook–8.* New York: Arts Digest Inc., 1965. Pp. 190–94.

Geist, Sidney. "Color it Sculpture." *Contemporary Sculpture: Arts Yearbook–8*. New York: Arts Digest Inc., 1965. Pp. 91–98.

Glaser, Bruce; Kipp, Lyman; Sugarman, George; and Weinrib, David. "Where Do We Go From Here?" *Contemporary Sculpture: Arts Yearbook–8*. New York: Arts Digest Inc., 1965. Pp. 150–55.

Greenberg, Clement. "Anthony Caro." *Contemporary Sculpture: Arts Yearbook–8*. New York: Arts Digest Inc., 1965. Pp. 106–9.

Judd, Donald. "Specific Objects." *Contemporary Sculpture: Arts Yearbook–8*. New York: Arts Digest Inc., 1965. Pp. 74–83.

Rickey, George. "The Métier." *Contemporary Sculpture: Arts Yearbook–8*. New York: Arts Digest Inc., 1965. Pp. 164–66.

Seitz, William C. "Introduction." *Contemporary Sculpture: Arts Yearbook–8*. New York: Arts Digest Inc., 1965. Pp. 7–9.

Index

Illustrations

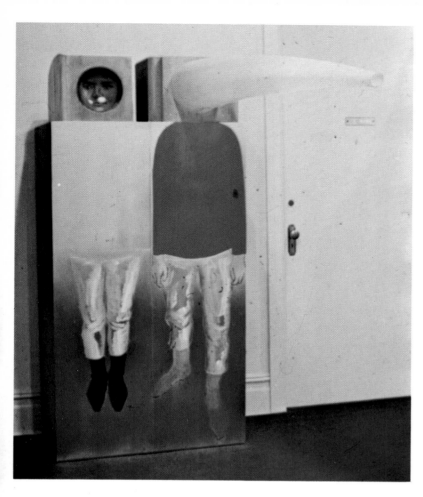

PLATE I Marisol. COUPLE I. 1965–66. Mixed media. 67″ x 86″ x 41½″. *Courtesy Sidney Janis Gallery, New York*

PLATE II Tony Smith. DIE. Late 1960s. 6′ x 6′ x 6′. *Courtesy M. Knoedler and Co., New York*

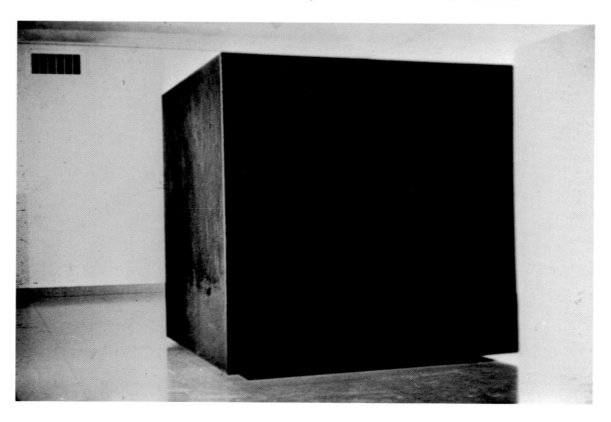

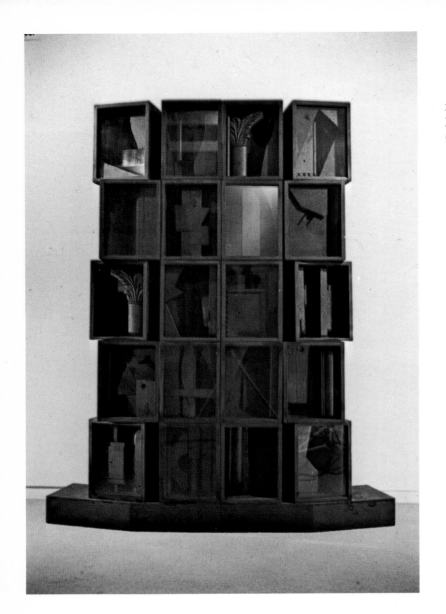

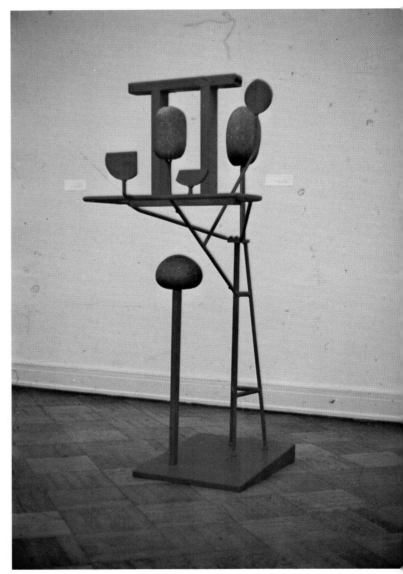

PLATE III Louise Nevelson. SILENT MUSIC III. 1964. Painted wood. 80″ x 50″. Copyright 1965 by Portable Gallery Press, Inc. *Courtesy Pace Gallery, New York*

PLATE IV Wilfred Zogbaum. II. 1962. Painted metal and stone. 69″ x 37″ x 26″. *Courtesy San Francisco Museum of Art. Gift of Friends of the Artist*

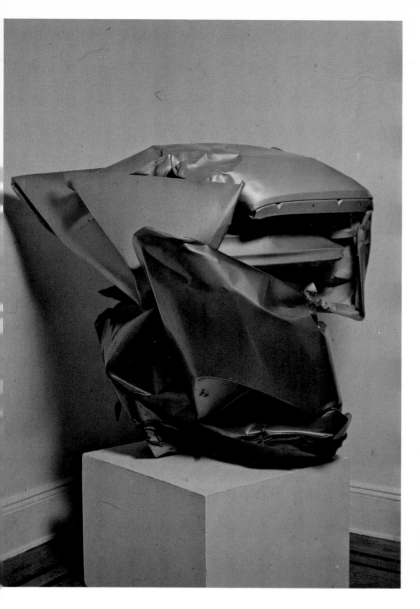

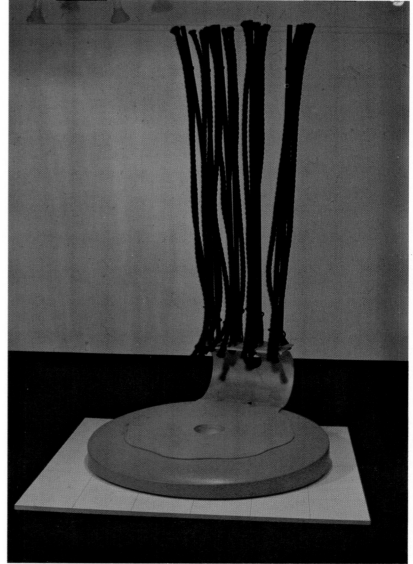

PLATE V John Chamberlain. CA-D'ORO. 1964. Auto metal. 34″ x 37″ x 32″. *Courtesy Leo Castelli Gallery, New York*

PLATE VI Claes Oldenburg. HEROIC SCULPTURE IN THE FORM OF A BENT TYPEWRITER ERASER—STRUCTURAL MODEL. 1970. Steel, aluminum, cast stone, rope. 48″ x 84″ high. Collection of the artist. *Courtesy Sidney Janis Gallery, New York*

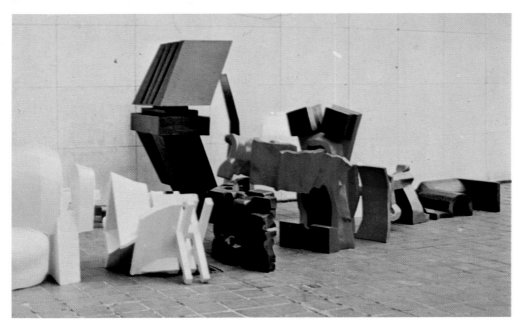

PLATE VII George Sugarman. TWO IN ONE. 1966. Polychromed laminated wood. 23½″ x 11″ x 7″. *Photography by John A. Ferrari. Courtesy of the artist*

In my sculpture, the color is as important as form and space. The important thing is that it has a tremendous emotional impact, and the experience of the spectator, in seeing color allied to a three-dimensional form, is something that is quite novel at first, in fact, quite shocking. An important aspect is that the color is . . . used to articulate the sculpture in space. George Sugarman, from Bruce Glaser, Lyman Kipp, George Sugarman, and David Weinrib, "Where Do We Go from Here?" *Contemporary Sculpture: Arts Yearbook–8* (New York: The Arts Digest, Inc., 1965) , p. 54.

PLATE VIII Sondra Beal. BRULE REACH. 1965. Painted wood. 29″ x 40″ x 22″. *Courtesy of the artist*

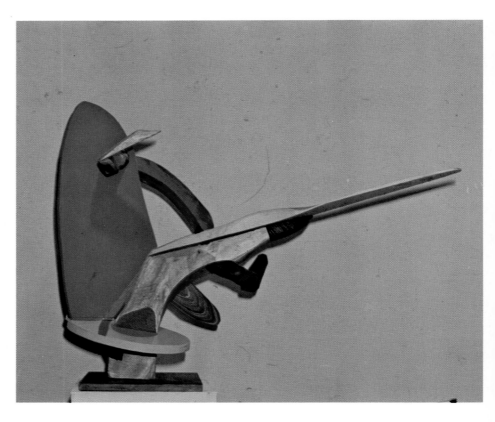

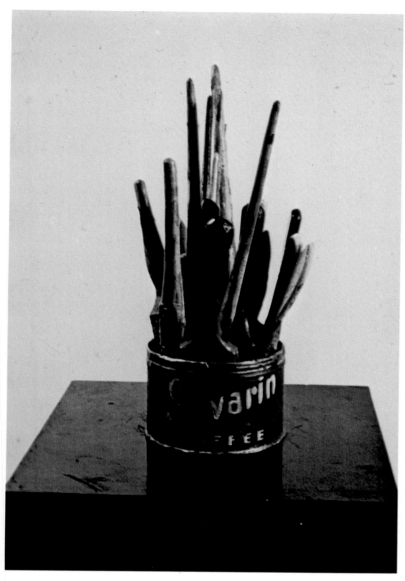

PLATE IX Jasper Johns. SAVARIN CAN. 1960. Combine. 13½″ x 8″ diameter. Collection of the artist. *Courtesy Leo Castelli Gallery, New York*

PLATE X Anne Arnold. CHARLIE. 1969. Acrylic over wood. 49″ x 23″ x 27″. *Courtesy Fischbach Gallery, New York*

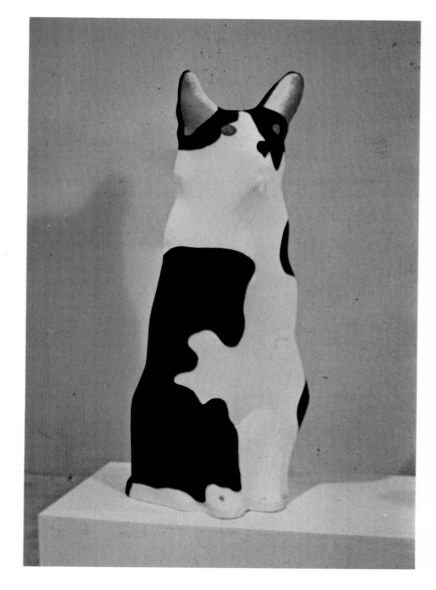

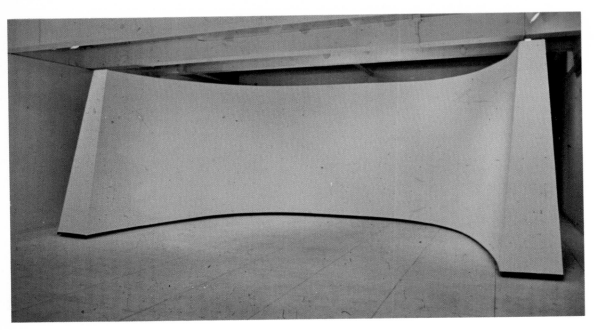

PLATE XI Ronald Bladen. UNTITLED. 1969. Painted plywood. 9' x 22' x 15'. *Courtesy Fischbach Gallery, New York*

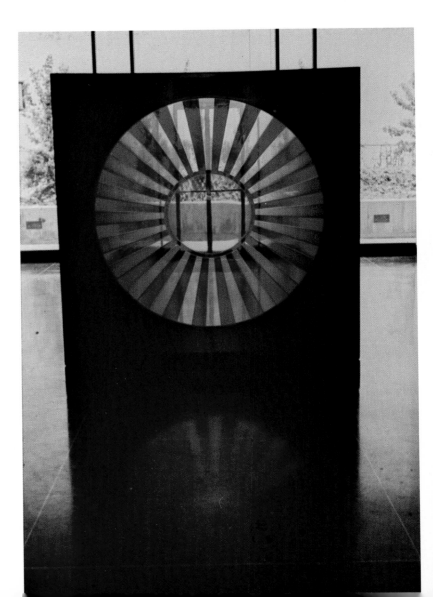

PLATE XII James Grant. FLABELLUM. Cast polyester resin. 6' x 6' block. 1800 lbs. Commissioned for Golden West Towers, Oakland, California. *Photography by j. h. b. peden. Courtesy of the artist*

A most technically demanding piece, FLABELLUM was cast in a fiberglass reinforced plywood mold lined with mylar. The 6' x 6' block has two cylindrically concave faces. It is 3" in depth in the center and 14" in depth at the edges.

> The center orange cylinder and the individual blue radiating segments were cast separately. They were sanded and fitted into a circular central section of the mold in which the red was then cast. That was taken out of the mold, turned and sanded and then returned to the center of the complete mold in which the transparent black was cast. The piece was then ground and polished. James Grant (in a June 1972 letter to the author).

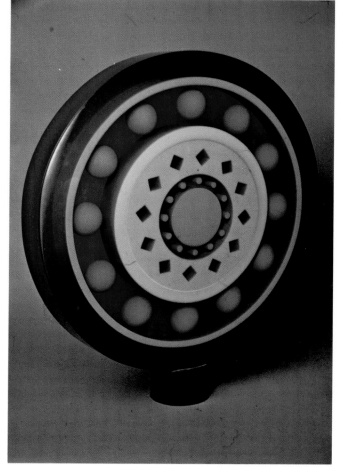

PLATE XIII James Grant. THE GOLDEN WEST RAIN-BOW. Polyester and acrylic sheet with 6 neon tubes inside. 8½″ across. Commission for the Golden West Savings and Loan in Mountain View, California. *Courtesy of the artist*

PLATE XIV James Grant. CIRCUS WHEEL. 1969. Cast polyester resin. 19″ in diameter. *Photography by j. h. peden. Courtesy of the artist*

CIRCUS WHEEL is a combination of transparent and opaque polyester. . . . It was cast from the center out with the circular and square rods and the balls precast and included into each appropriate cylinder. James Grant (in June 1972 letter to the author).

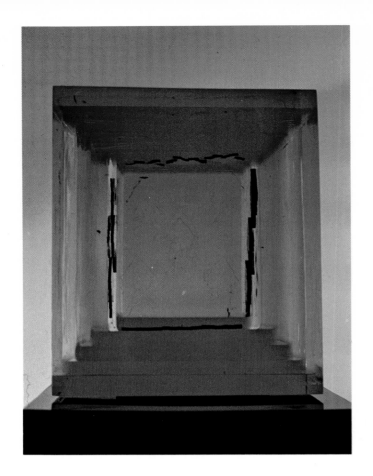

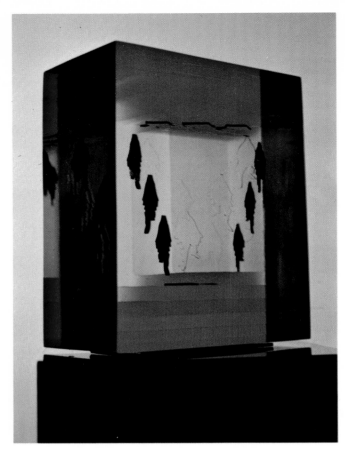

PLATES XV, XVI, XVII, XVIII, XIX, XX Eugene Massin. CHINESE PUZZLE. 1969. Cast polyester resin with acrylic inclusions. 40" x 12" x 12" overall. *Photography by Shirley Busch. Courtesy of the artist*

Operating on principles of reflections, mirror images, and multiple surface views, eighteen cut-out acrylic silhouettes of "running men" (three to each side of the six-sided cube) are contained within layers of intense red, subtle purple, avocado, and clear polyester resin. The figures, set in motion by an imperceptible turntable hidden in the base, appear and disappear at a glance, electrify when hit by light, and change from heavy outline to a delicate lacelike etching to invisibility, while distinct layers of color merge and blend to form a misty green played against a brilliant red. Eugene Massin (in a 1969 interview by the author).

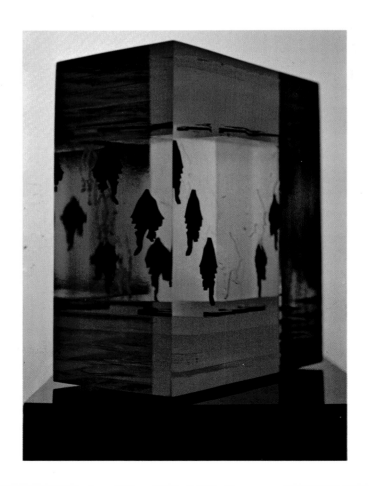

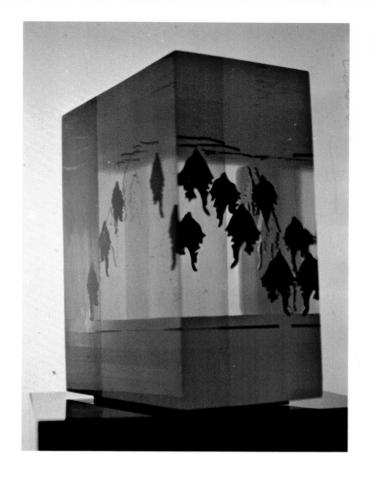
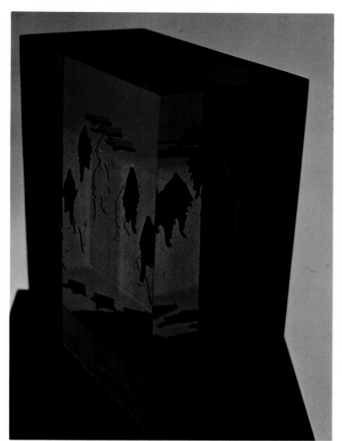
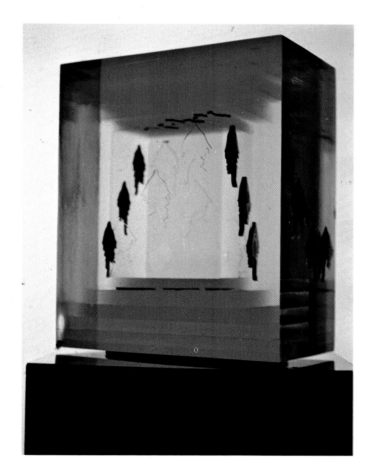

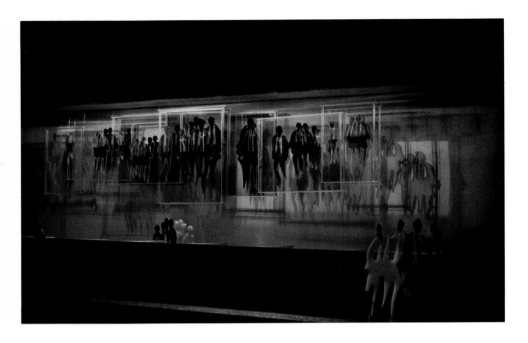

PLATE **XXI** Eugene Massin. Study of **MURAL FOR CITY NATIONAL BANK OF MIAMI BEACH, FLOR-IDA.** 1969–72. Acrylic sheet and electric light. 12′ x 52′ overall. *Photography by Shirley Busch. Courtesy of the artist*

Working first from drawings, Eugene Massin constructed a scale model one inch to a foot. Since the actual sections filled only half the wall and light projected through the acrylic was to flood most of the other wall area, lighting engineers were contacted. They fed the problem to a computer, which gave the angles for maximum lighting efficiency. About this time Sun Plastics of Hallandale, Fla., was contacted to see if the acrylic sections were readily adaptable to factory fabrication. (It was im-possible to handle a work of this size in the studio.) This accomplished, large cartoons were drawn up and the work progressed from there.

PLATE **XXII** Eugene Massin. **MURAL FOR CAFRITZ BUILDING, WASHINGTON, D.C.** 1965. Acrylic painted on acrylic sheet. 10′ x 36′. *Photography by Rob-ert C. Lautman. Courtesy of the artist*

This work incorporates the reflections of the viewers as well as the street traffic outside the building lobby. In order to incorporate the mirrored images, the angles at which the sections of the mural were set against the wall were geometrically computed. Materials for the work were supplied by the DuPont Company and the large cut-out sections were factory produced under the artist's supervision.

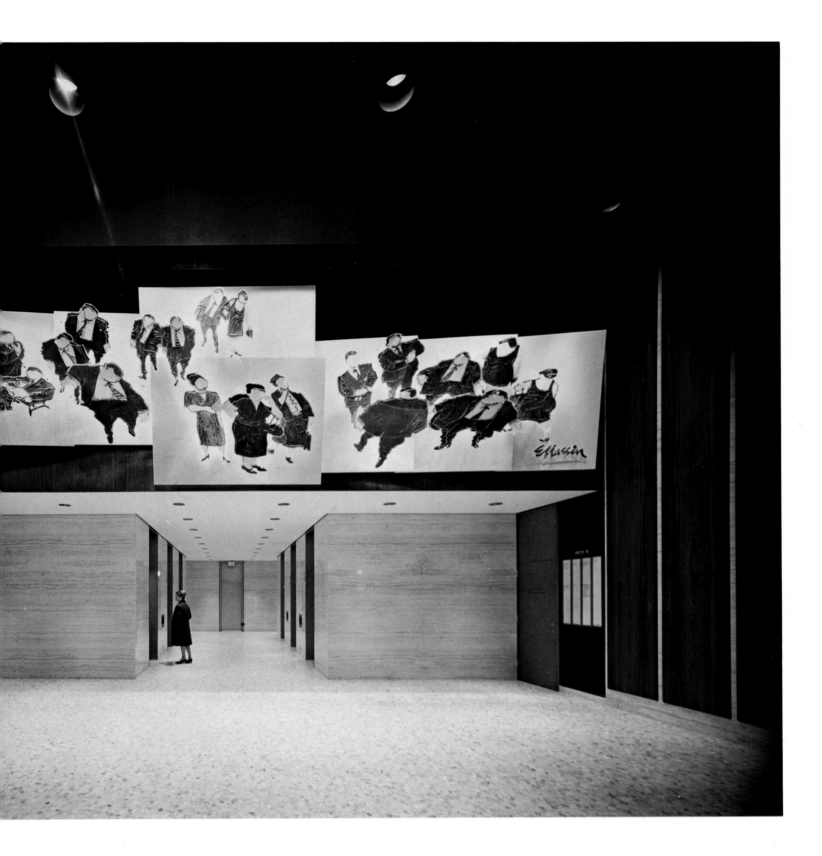

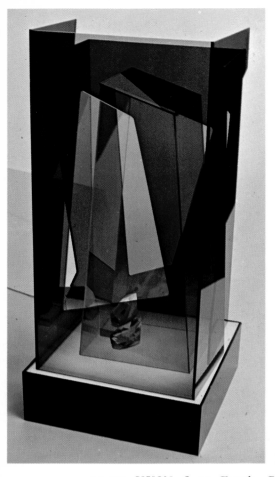

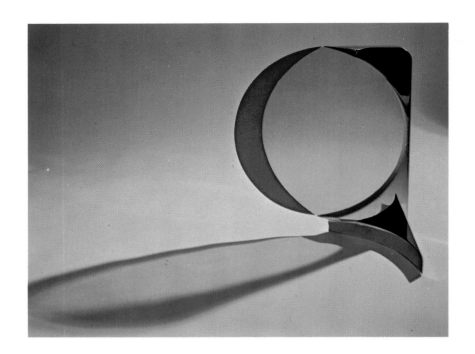

XXIII

PLATE XXIII Jane Frank. PRISM #II. Late 1960s. Acrylic sheet. 44″ in height. Base 23″ square. 15-watt candelabra lighting. *Photography by Metee. Courtesy of the artist*

It is plain to see by now that the limitless possibilities of plexiglass, or other plastics, whether used in conjunction with metals or by itself alone, also with built-in lighting, have a great variety of exploration and adventure ahead. For those who wish to pursue them, it seems that the conglomerate vistas have only just begun. Jane Frank (in a 1972 letter to the author).

PLATE XXIV Jane Frank. NEW MOON. Late 1960s. Mirror-finished aluminum plexiglass. 17″ x 15″ x 10″. Collection of Mr. and Mrs. David Halle. *Courtesy of the artist*

PLATE XXV Jane Frank. APRIL SCREEN. Late 1960s. Acrylic (Lucite) and aluminum. 61″ x 66″ x 18″. *Photography by Metee. Courtesy of the artist*

I have been engaged actively with the media of acrylics and metals since 1967. . . . Starting with no knowledge of the bare mechanics nor the multiple manipulation of the plastic sheet, I had much to learn in this area about such tools as bench power saw, drill press, rasp, wet and dry sandpaper, buffing wheel, jig saw, and most important the acrylic sheet itself. Jane Frank (in 1972 letter to the author).

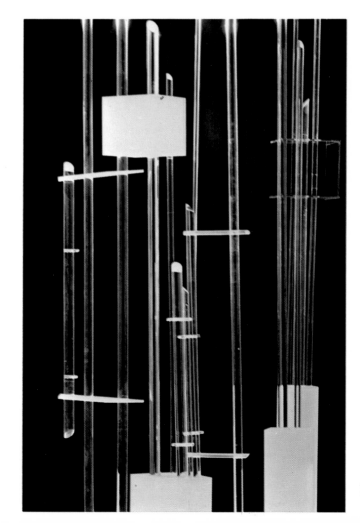

XXV

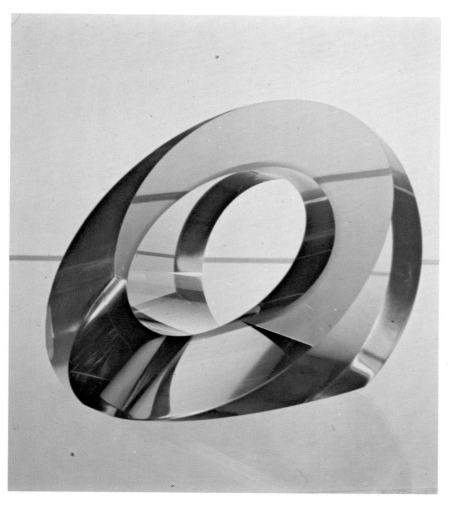

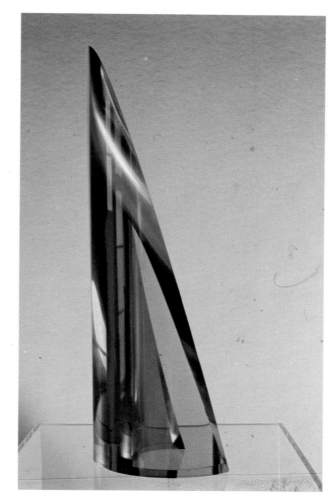

PLATE XXVI Fred Eversley. OBLIQUE PRISM II. Cast polyester resin. Oakland Museum Collection. *Courtesy of the artist*

PLATE XXVII Fred Eversley. UNTITLED 1970. Cast polyester resin. *Courtesy of the artist*

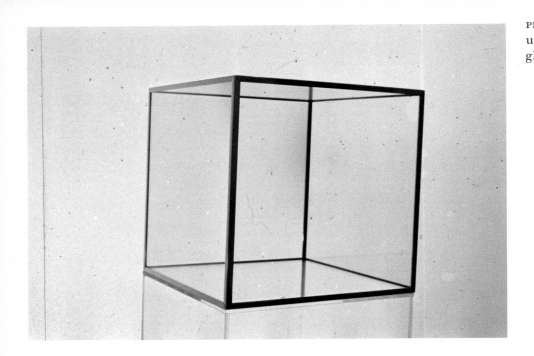

PLATE XXVIII Larry Bell. UNTITLED. 1966–67. Vacuum plated glass/metal binding. 20″ x 20″ x 20″. Plexiglass pedestal. *Courtesy Pace Gallery, New York*

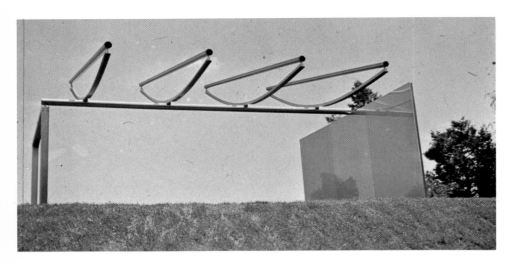

PLATE XXIX David Von Schlegell. #8. Stainless steel 16′ x 15′ x 9′. *Courtesy of the artist*

My wish is to take hold of the invisible feelings one has toward form, space and motion and to make them visible. In this way sculpture cannot be ponderous but must be fragile, as well as large. David Von Schlegell, "New Talent USA," *Art in America* 54, no. 4 (July–August 1966) : 38.

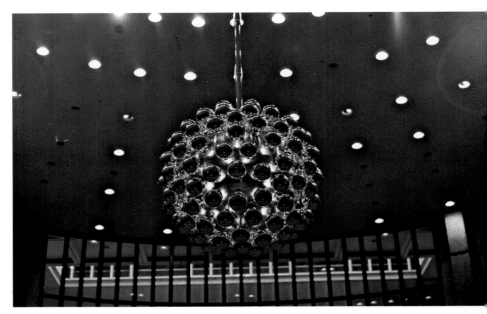

PLATE XXX Otto Piene. SUN. 1969–71. Kinetic light sculpture in the House of Representatives, Hawaii State Capitol, Honolulu, Hawaii. *Photography by Otto Piene. Courtesy of the artist*

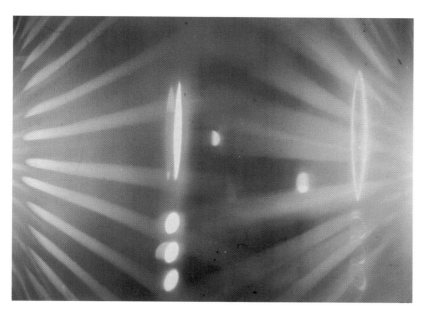

PLATE **XXXI** Frank J. Malina. **INTERPLANETARY SPACE.** #1032/1967. 74 cm. x 105 cm. Reflectodyne System. *Courtesy of the artist*

PLATE **XXXII** Frank J. Malina. **COSMIC LIFE.** #1039/1968. 80 cm. x 60 cm. 3-component Lumidyne System. Kinetic painting. *Courtesy of the artist*

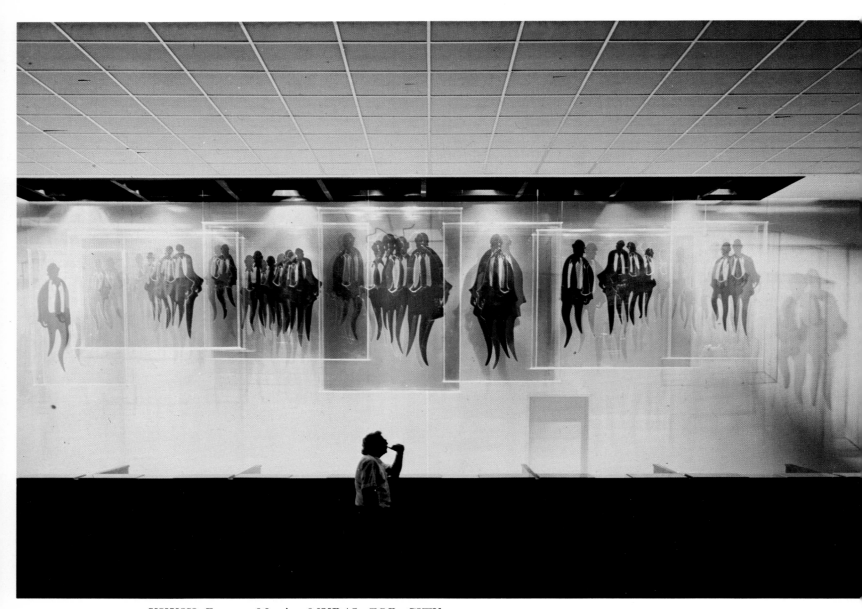

PLATE **XXXIII** Eugene Massin. **MURAL FOR CITY NATIONAL BANK OF MIAMI BEACH, FLORIDA** (on site) . 1969–72. Acrylic sheet and electric light. 12' x 52' overall (including light projections) . *Photography by Les Rachline. Courtesy of the artist*

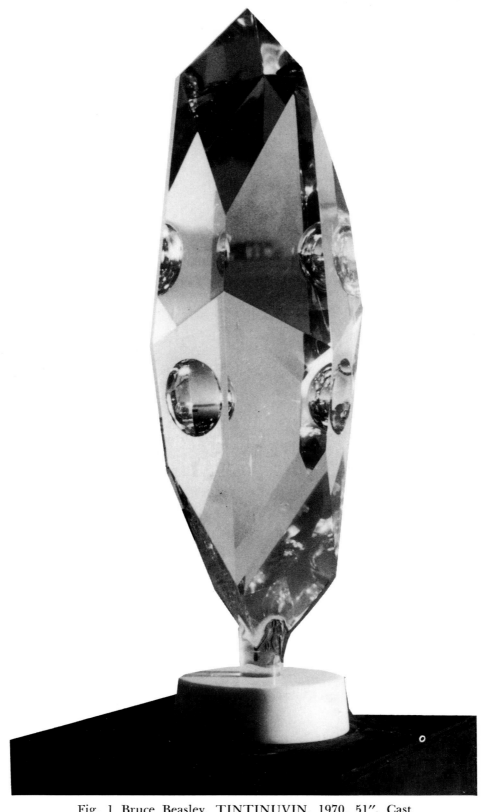

Fig. 1 Bruce Beasley. TINTINUVIN. 1970. 51″. Cast
Lucite. *Courtesy of the artist*

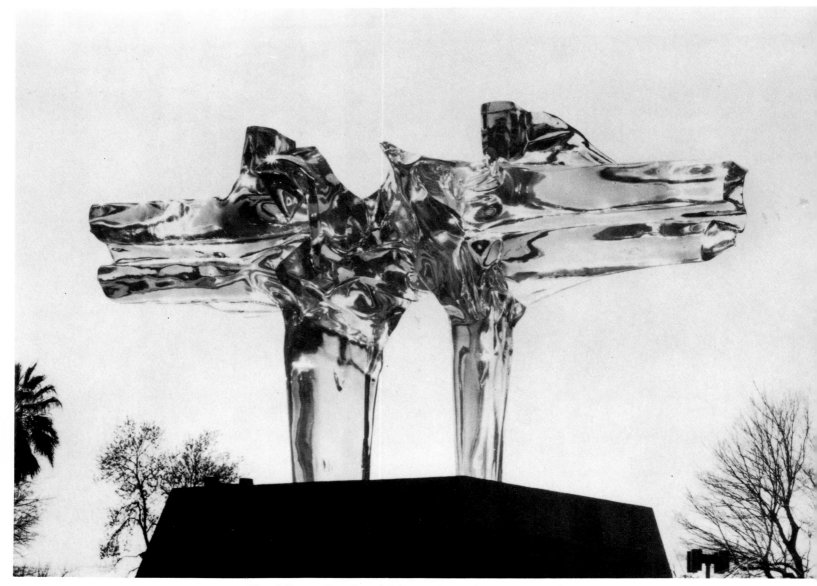

Fig. 2 Bruce Beasley. APOLYMON. 1969. 9′ x 15′. Cast acrylic (Lucite). *Courtesy of the artist*

APOLYMON is a work weighing 13,000 pounds that took more than two years in the making and was cast in a 30,000 pound autoclave, which is a "giant pressure cooker." Modifying the chemical formula to create a work of this size and building his own cranes to move the mammoth autoclave, Beasley stated, "I think this is what gives West Coast sculpture its great technological adventuresomeness. In New York, they're frightened to death of technology; they farm all the work out. When you've known how to weld since you were 13, it doesn't seem like much trouble to build a crane." "This World," *San Francisco Sunday Examiner and Chronicle*, p. 39.

Fig. 3 Carl Andre. One Man Show at the irving blum Gallery. 1968. 18′ long and 36″ wide. Each of four pieces has 6 units. Each unit is 36″ x 36″ x ⅜″ thick. *Courtesy Dwan Gallery, New York*

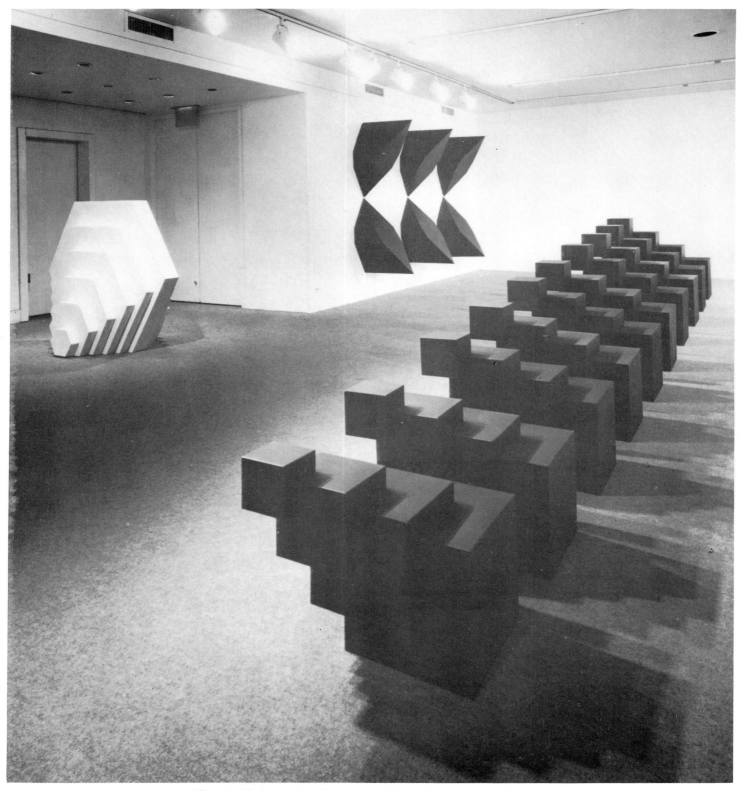

Fig. 4 Robert Smithson. INSTALLATION SHOT, DWAN GALLERY. 1966. Left to right: TERMINAL DOUBLES, PLUNGE (Collection of Mr. and Mrs. John G. Powers). *Photography by John D. Schiff. Courtesy Dwan Gallery, New York*

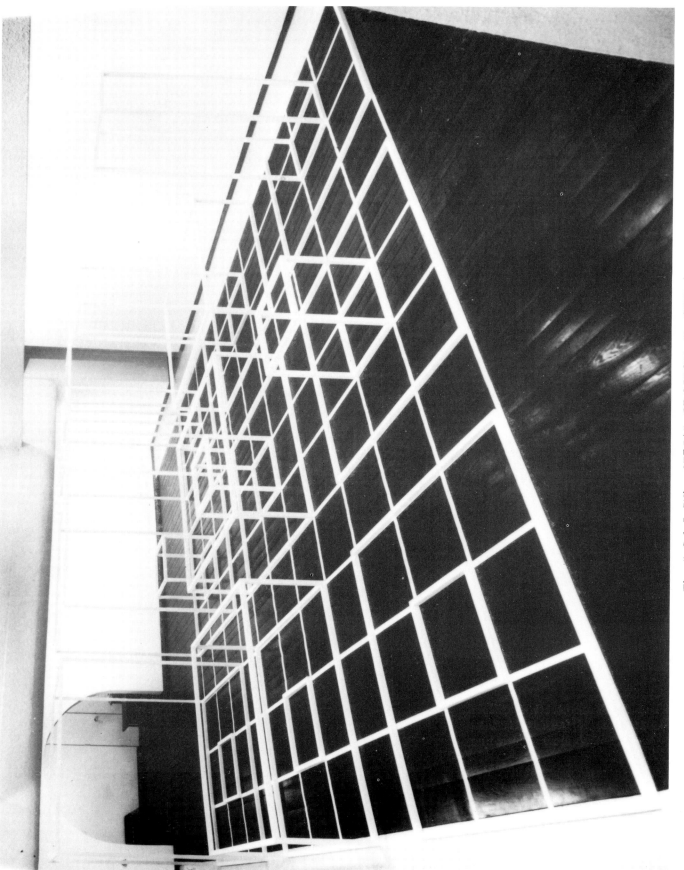

Fig. 5 Sol LeWitt. SERIAL PROJECT #1, SET A. 1966. Installation, Dwan Gallery, Los Angeles, April 4–29, 1967. *Courtesy Dwan Gallery, New York*

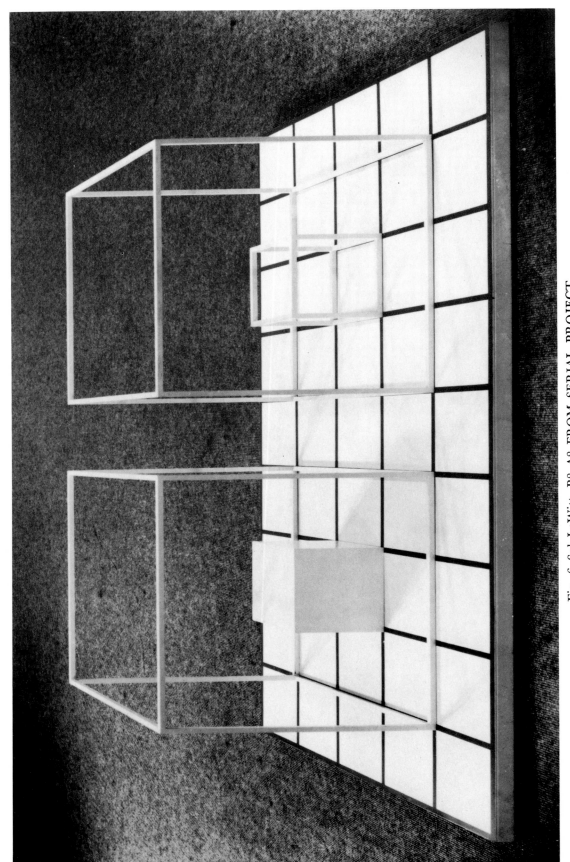

Fig. 6 Sol LeWitt. B8 A8 FROM SERIAL PROJECT #1. 1966–68. Baked enamel/aluminum. *Courtesy Dwan Gallery, New York*

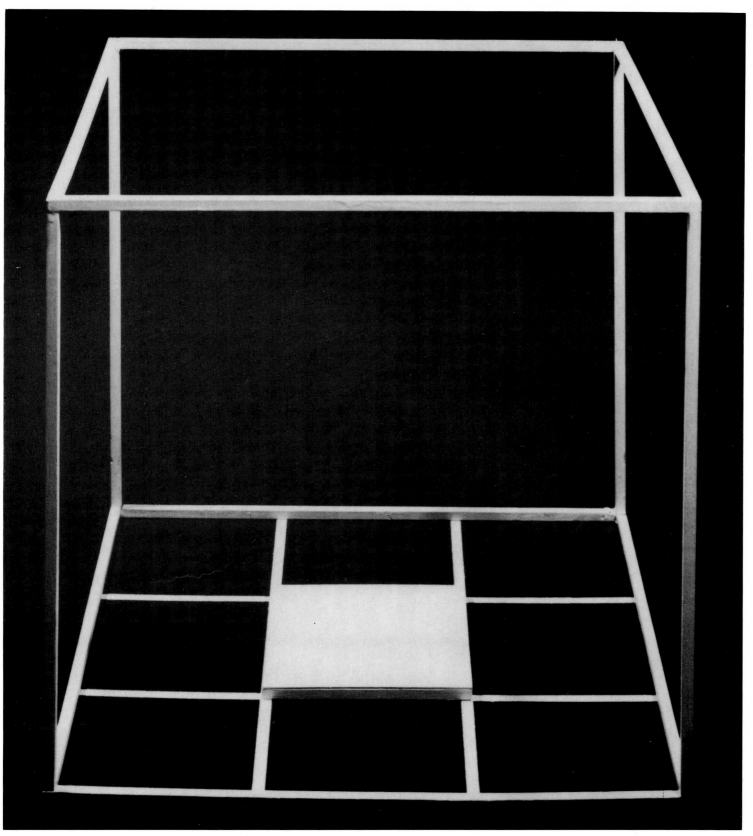

Fig. 7 Sol LeWitt. B7 FROM SERIAL PROJECT #1. 1966. Painted metal. 13½″ x 13½″ x 13½″. *Courtesy Dwan Gallery, New York*

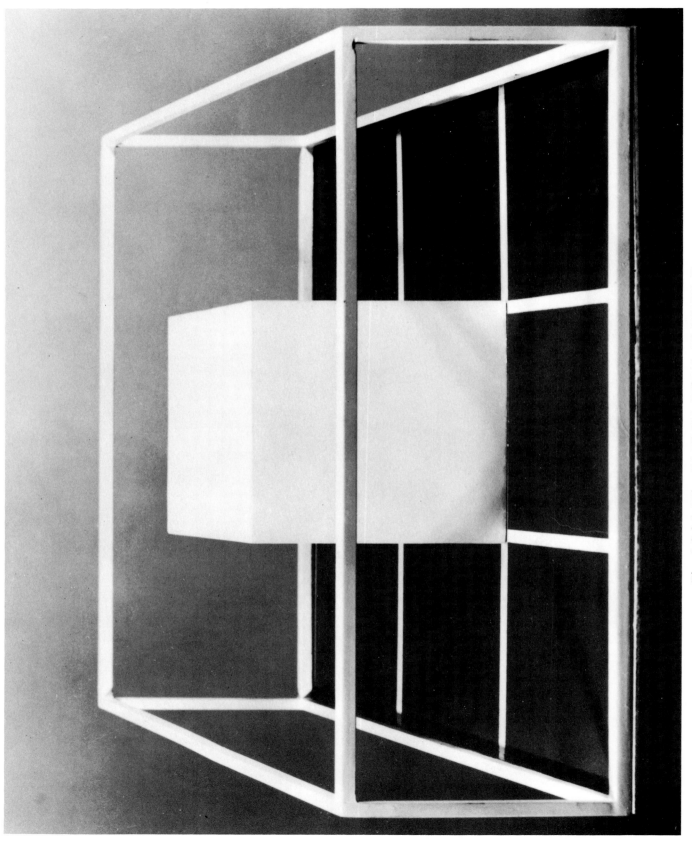

Fig. 8 Sol LeWitt. B5 FROM SERIAL PROJECT #1. 1966. Painted metal. 4⅞″ x 13½″ x 13½″. *Courtesy Dwan Gallery, New York*

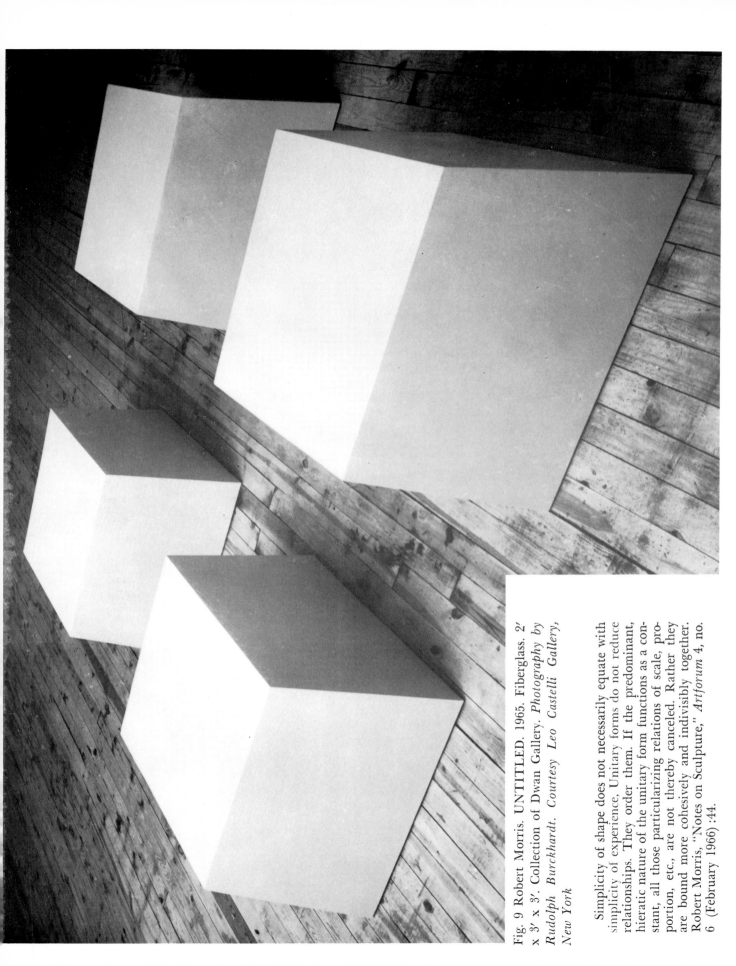

Fig. 9 Robert Morris. UNTITLED. 1965. Fiberglass. 2′ x 3′ x 3′. Collection of Dwan Gallery. *Photography by Rudolph Burckhardt. Courtesy Leo Castelli Gallery, New York*

Simplicity of shape does not necessarily equate with simplicity of experience. Unitary forms do not reduce relationships. They order them. If the predominant, hieratic nature of the unitary form functions as a constant, all those particularizing relations of scale, proportion, etc., are not thereby canceled. Rather they are bound more cohesively and indivisibly together. Robert Morris, "Notes on Sculpture," *Artforum* 4, no. 6 (February 1966) :44.

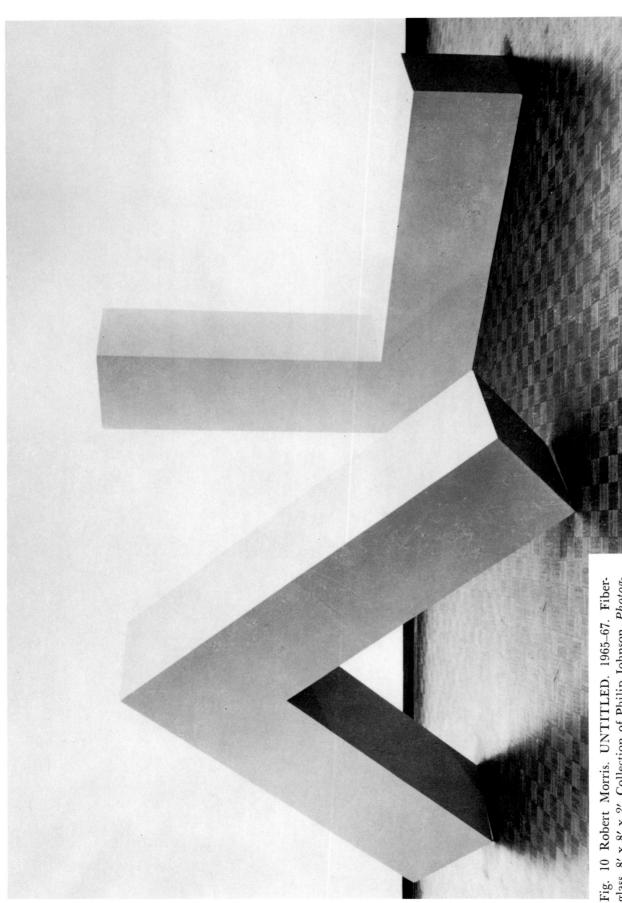

Fig. 10 Robert Morris. UNTITLED. 1965–67. Fiberglass. 8′ x 8′ x 2′. Collection of Philip Johnson. *Photography by Rudolph Burckhardt. Courtesy Leo Castelli Gallery*

Only one aspect of the work is immediate: the apprehension of the gestalt. The experience of the work necessarily exists in time. *The intention is diametrically opposed to Cubism with its concern for simultaneous views in one plane.* Robert Morris, "Notes on Sculpture, Part II," *Artforum* 5, no. 2 (October 1966): 23.

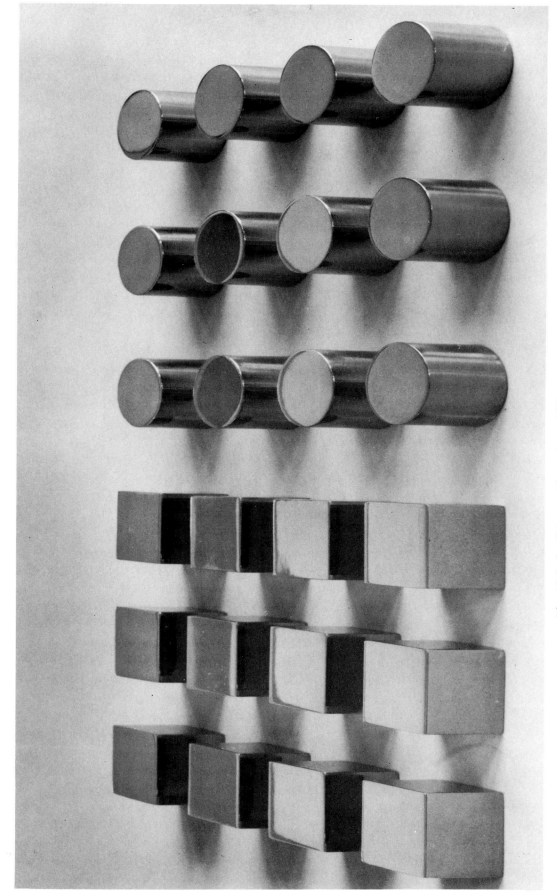

Fig. 11 Judy Chicago (Gerowitz). CUBES AND CYLIN-DERS–REARRANGEABLE. 1967. 24 pieces each 1½" x 1½", gold-plated steel. Collection of Mr. J. Patrick Lannan. *Photography by John F. Waggaman. Courtesy of the artist*

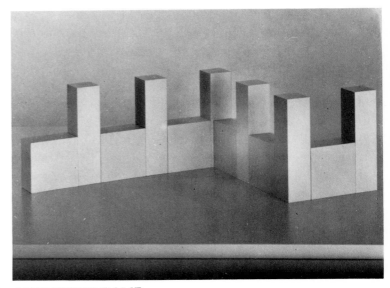

Fig. 12 Judy Chicago (Gerowitz). ALUMINUM GAME. 1967. Sandblasted, precision-cut aluminum pieces. 12 pieces–4″ x 2″ x 2″ (6), 2″ x 2″ x 2″ (6), on board 18″ x 18″. *Photography by John F. Waggaman. Courtesy of the artist*

Fig. 13 Donald Judd. UNTITLED. 1968. Stainless steel. 8 boxes, each 9″ x 40″ x 31″ (9″ intervals, 135″ total height). *Photography by Rudolph Burckhardt. Courtesy Leo Castelli Gallery, New York*

I don't consider [my work] nihilistic or negative or cool or anything else. Also I don't think my objection to the Western tradition is a positive quality of my work. It's just something I don't want to do, that's all. I want to do something else. Donald Judd, from Bruce Glaser, "Questions to Stella and Judd," *Art News* 65, no. 5 (September 1966):60.

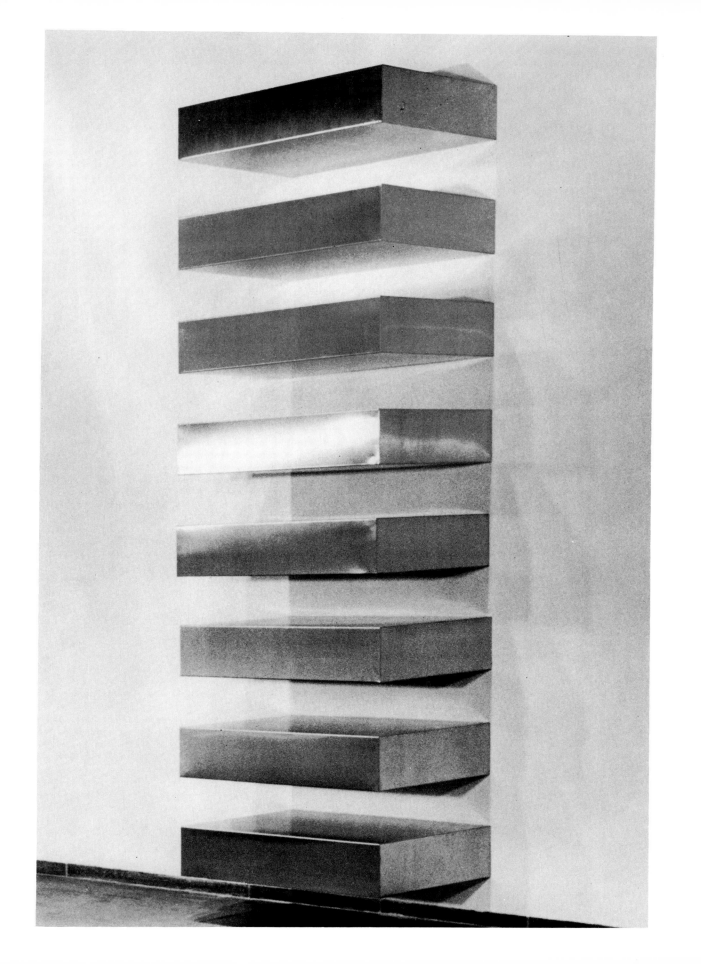

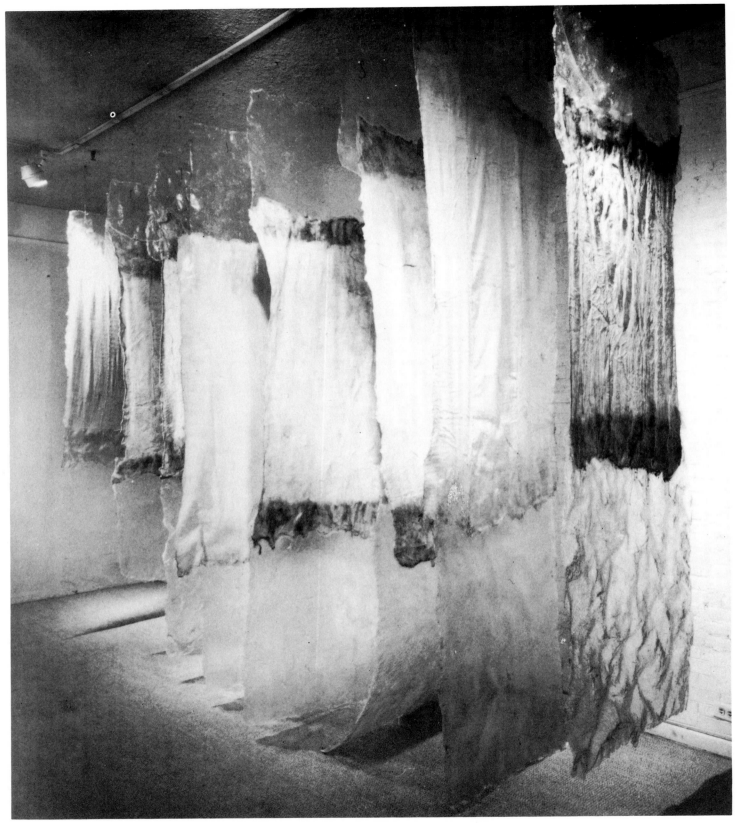

Fig. 14 Eva Hesse. CONTINGENT. 1969. Fiberglass, rubberized cheesecloth. 8 units each 14' x 3'. *Courtesy M. Knoedler and Co., New York*

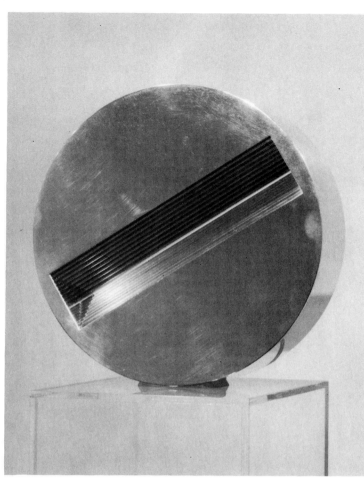

Fig. 15 Tony DeLap. SHARPY. 1969. Silver-plated aluminum (outside), polished aluminum (inside). 11" x 2½". *Photography by EEVA. Courtesy Robert Elkon Gallery, New York*

Fig. 16 Peter Forakis. LASER LIGHTENING. 1966. Painted cardboard. 40' long (can be any length). *Courtesy Paula Cooper Gallery, New York*

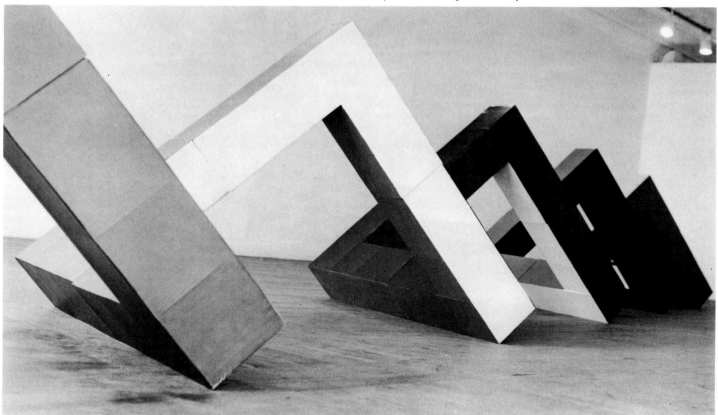

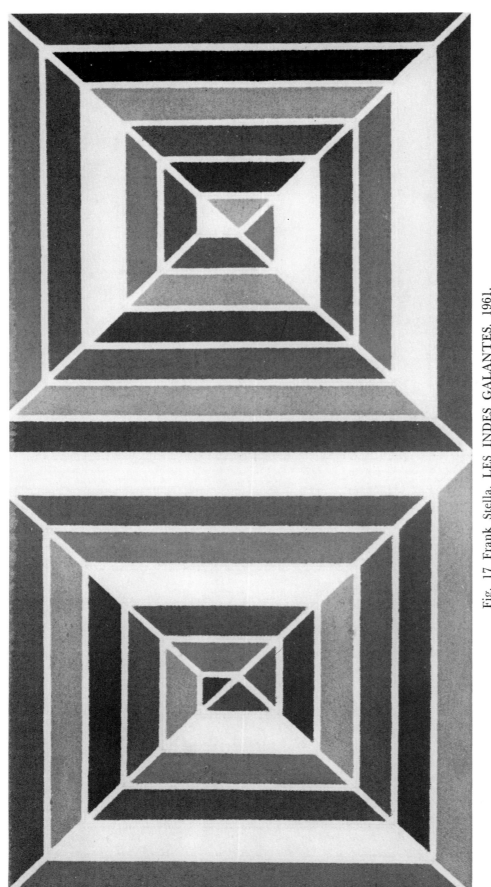

Fig. 17 Frank Stella. LES INDES GALANTES. 1961. Oil on canvas. 9″ x 18″. Collection of Larry Rubin. *Photography by Rudolph Burckhardt. Courtesy Leo Castelli Gallery, New York*

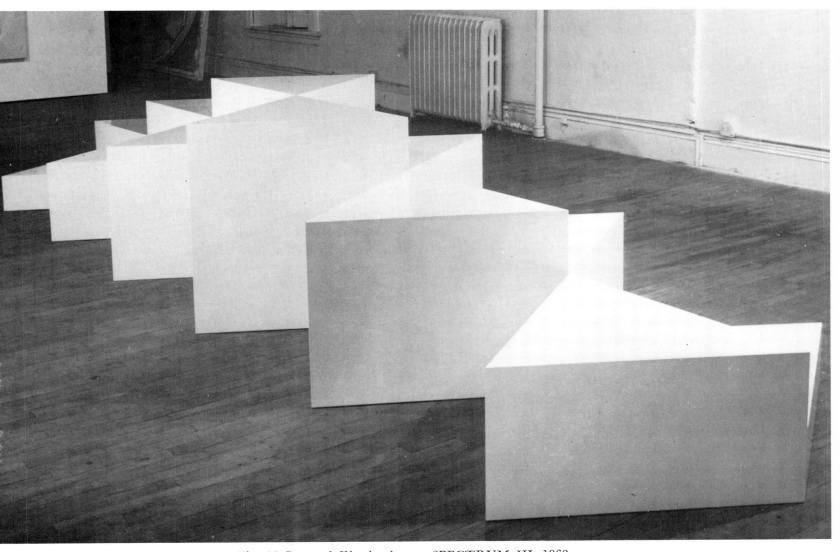

Fig. 18 Bernard Kirschenbaum. SPECTRUM III. 1968.
Painted wood. 34″ x 60″ x 24′8″. *Photography by John
D. Schiff. Courtesy Paula Cooper Gallery, New York*

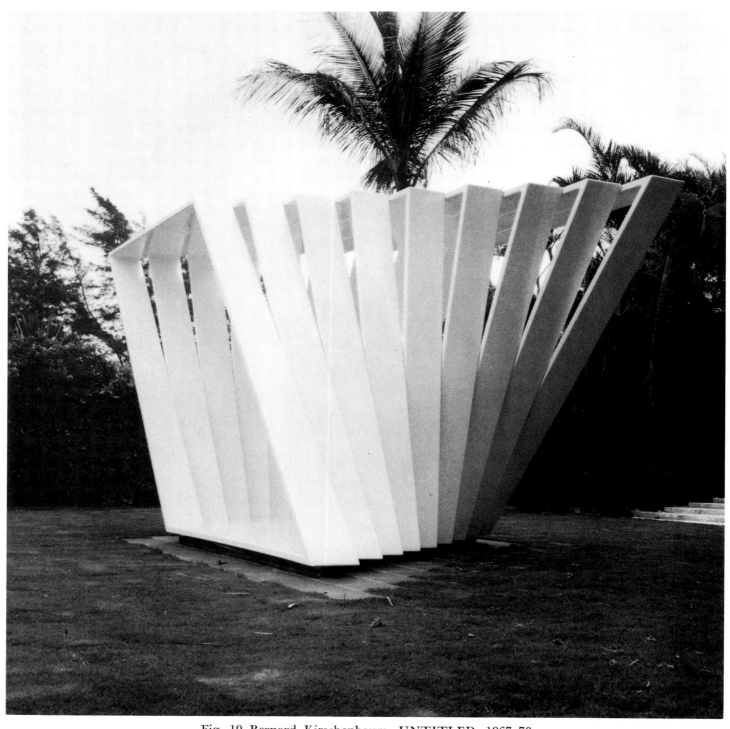

Fig. 19 Bernard Kirschenbaum. UNTITLED. 1967–70.
Welded aluminum, painted. 9′ x 9′ x 18′. *Collection
The Lannan Foundation. Courtesy Paula Cooper Gallery, New York*

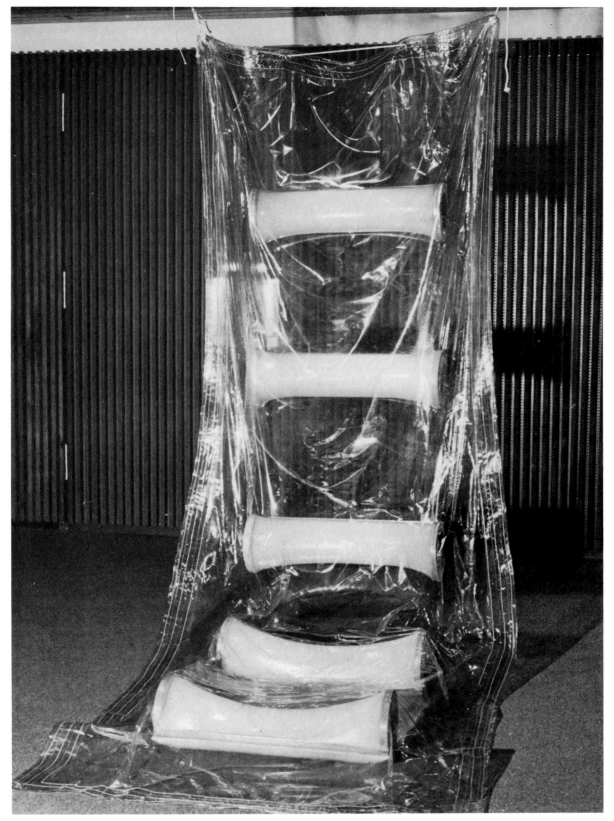

Fig. 20 Mike Bakaty. UNTITLED #00000. Plywood, muslin, polyester resin, vinyl, hardware. 1960s. 4′ x 10′ with 20″ components. *Courtesy of the artist*

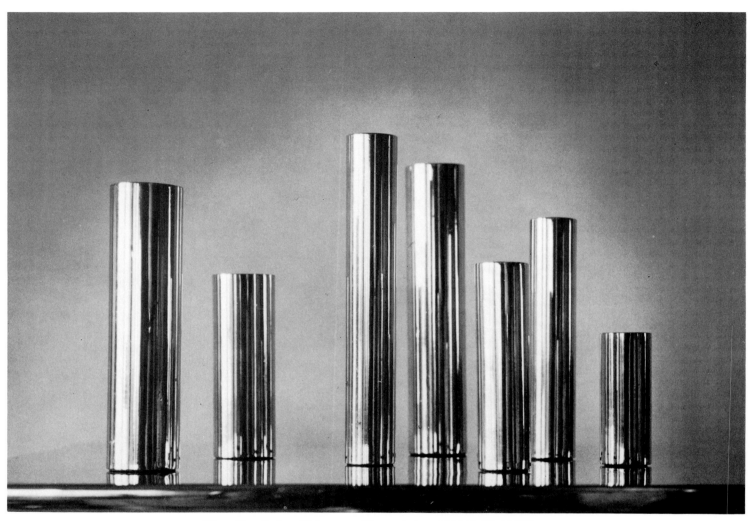

Fig. 21 Judy Chicago (Gerowitz). **GOLD-PLATED GAME.** 1967. 12″ x 12″ board. *Photography by John F. Waggaman. Courtesy of the artist*

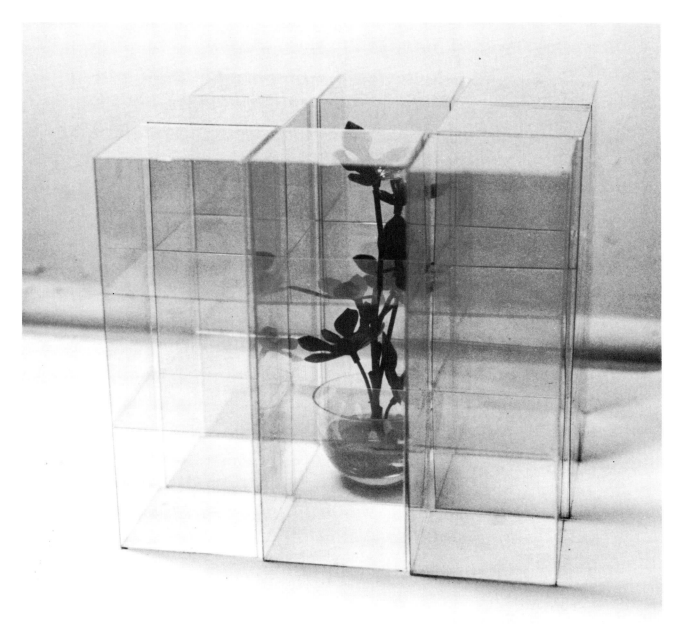

Fig. 22 Charles R. Frazier. THE LOTUS. 1969. *Photography by Charles R. Frazier. Courtesy of the artist*

Model for 6′ cube constructed of 24/2′ glass cubes of sandwiched liquid crystals, each pane controlled thermally by a control system acting as a bridge for the plant. Plant response is translated through the machine as heat that affects the polarity of the liquid crystals. The crystals appear red at cool temperature and through the spectrum to violet at warm temperature. Charles R. Frazier.

Figs. 23A, 23B Charles R. Frazier. SNOW PAINTINGS, PAUL SCHIELE'S WOODS. Buck's County, Pennsylvania. January 1969. *Photography by Charles R. Frazier. Courtesy of the artist*

23B

Fig. 24 Robert Smithson. 20 SHOTS OF 5 SITES OF FRANKLIN, N.J. NON-SITE. 1968. 18″ x 18″. *Photography by Walter Russell. Courtesy Dwan Gallery, New York*

Fig. 26 Robert Smithson. A NON-SITE (Franklin, N.J.). Aerial map. 1968. *Courtesy Dwan Gallery, New York*

Fig. 25 Robert Smithson. 400 SEATTLE HORIZONS. 1969. Snapshot-size photographs destroyed. *Courtesy Dwan Gallery, New York*

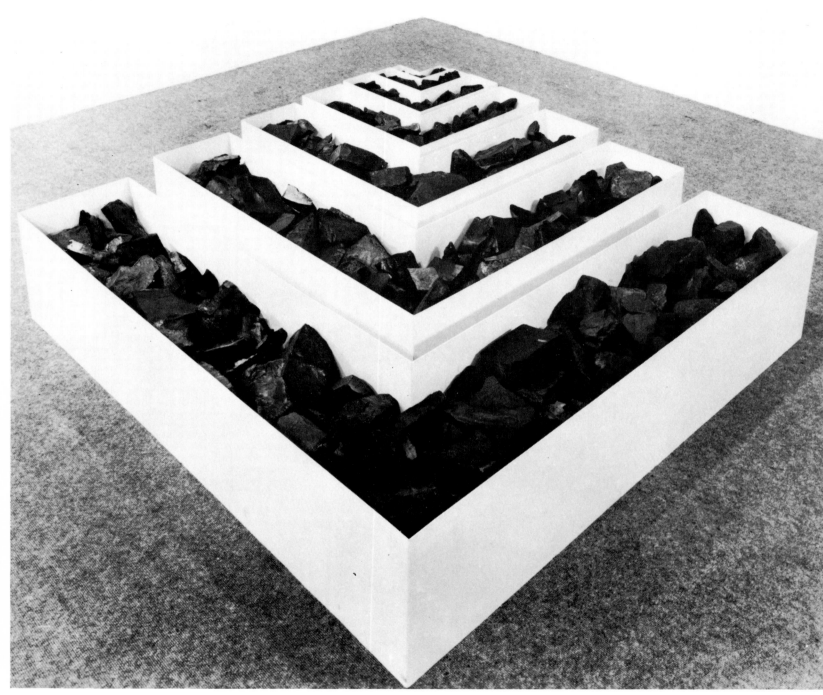

Fig. 27 Robert Smithson. NON-SITE—SITE UNCER-
TAIN. 1968. 7 L-shaped bins. Beige/cannel coal. 15″
x 90″ x 90″. *Courtesy Dwan Gallery, New York*

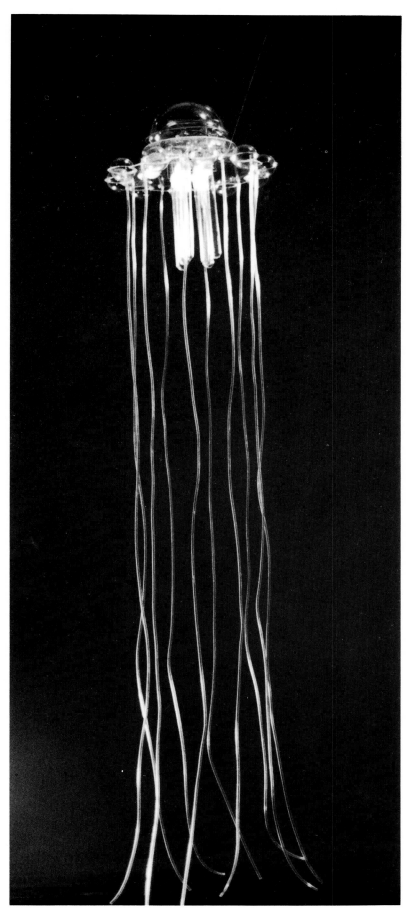

Fig. 28 Charles R. Frazier. DRIFT STRUCTURE. 1969–70. *Photography by Charles R. Frazier. Courtesy of the artist*

This mechanical jellyfish was fashioned after the original because of its structure, each unit having a distinct function but creating a whole. A sea water battery of living organisms creates electricity to power the light system in the body and tentacles. Solar cells collecting sunlight activates a small transmitter. The total structure of plastics and electronic hardware is an intersection for the conversion of energies.

The concept of a floating energy exchange center could be expanded to a one-mile-in-diameter structure which could be a biosphere to house people, flora, fauna, insects, all living creatures, a floating EDEN. Part of the bottom structure would detach like an elevator to the bottom of the ocean, serving as an anchor laboratory and storage for underwater farming. Retractable tentacles would provide stability, contain the sea water batteries and create a wall of bubbles, a column of air from the ocean floor to the perimeter of the structure to contain fish. The fish would stay within the air fence providing a continuous supply. Sunlight can be used to convert sea water into fresh water. Seeds in hydroponic solution inside plastic balloons that stick together would grow to become fields of plants, each in its own greenhouse. The fields would float on the surface of the water. Everything consumed would be purified and put back into the system. Charles R. Frazier, from a caption enclosed with photograph.

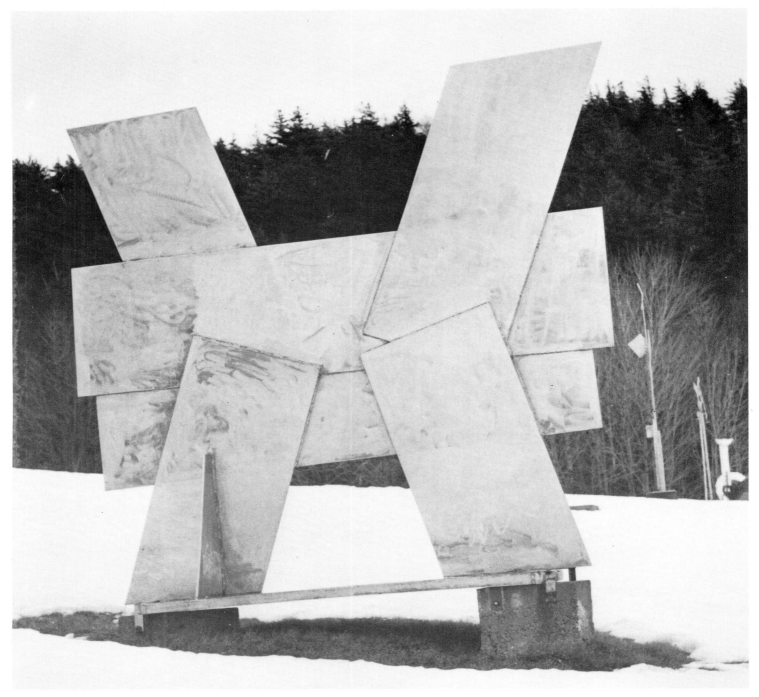

Fig. 29 David Smith (1906–65). BECCA. 1965. Stainless steel. 116″ x 31½″ x 120¼″. *Courtesy of the Marlborough Gallery, New York*

To buy a new material—I need a truckload before I can work on one [a new work]. To look at it every day—to let it soften—to let it break up in segments, planes, lines, etc.—wrap itself in hazy shapes. Nothing is so impersonal, hard and cold as straight rolling-mill stock. David Smith, "Notes on My Work," *Arts* 34, no. 5 (February 1960) :44.

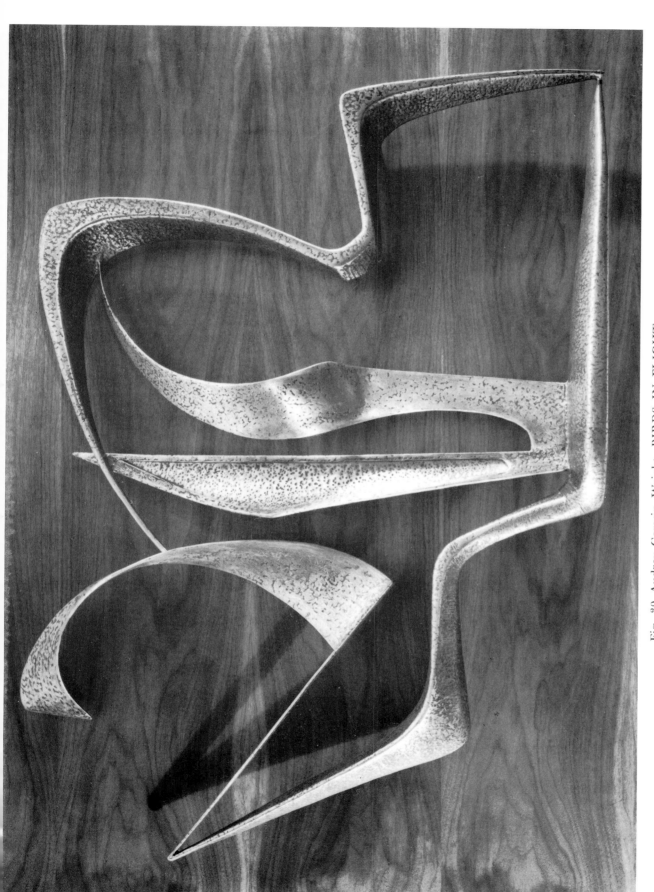

Fig. 30 Audrey Corwin Wright. BIRDS IN FLIGHT. 1965. 3′ x 4′. Silfos brazed on copper wire over plaster core and copper sheet/walnut. Commission for the blind. The forms indicate birds in flight. *Photograph courtesy of the artist*

art is, after all, a legitimate fantasy. . . . If it works, it's a valid situation. We know what worked in the past, let's find out what will work in the future. From a summer 1971 interview by the author.

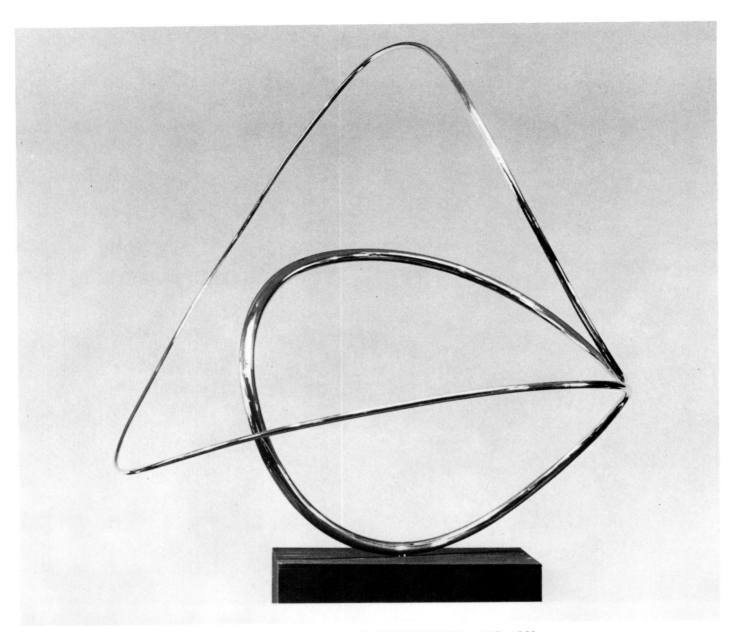

Fig. 31 José De Rivera. CONSTRUCTION #117. 1969.
Stainless steel. 34″ x 37″ x 32″. *Photograph Courtesy of
Grace Borgenicht Gallery, New York*

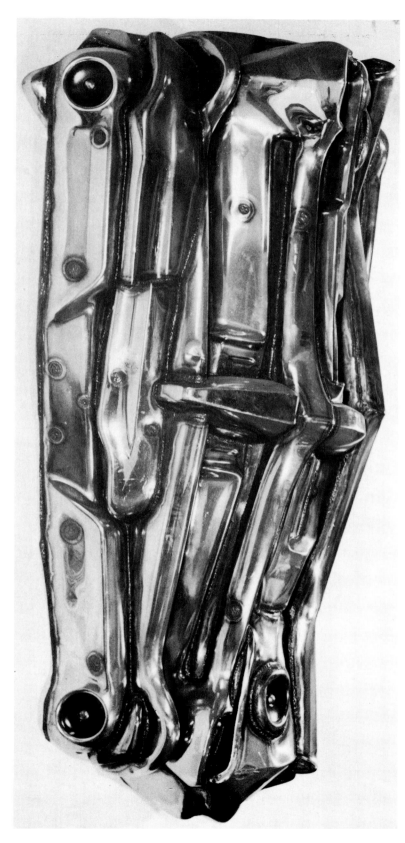

Fig. 32 Jason Seley. HANOVER II. 1968. Chromium-plated steel. 8' x 4' x 2½'. *Photography by Jay Cantor. Courtesy Kornblee Gallery, New York*

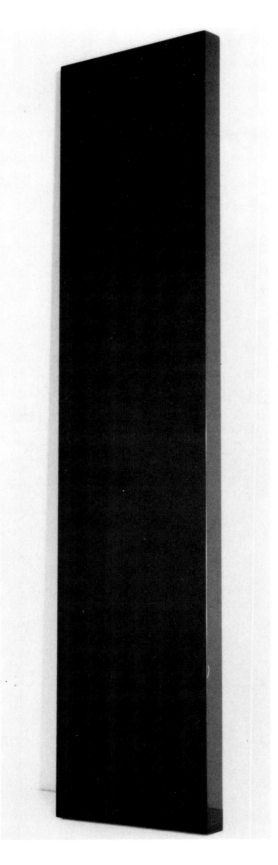

Fig. 33 John McCracken. UNTITLED 1970. Wood, fiberglass, and polyester resin. 8' x 22" x 3⅛". *Photography by Nick Sheidy. Courtesy of Sonnabend Gallery, New York*

I have found that a certain range of mainly primary and some secondary colors and a certain combination of color intensity and transparency and surface finish provide me with the expressive means I want, at least for the present. John McCracken, "New Talent USA," *Art in America* 54, no. 4 (July-August 1966) :66.

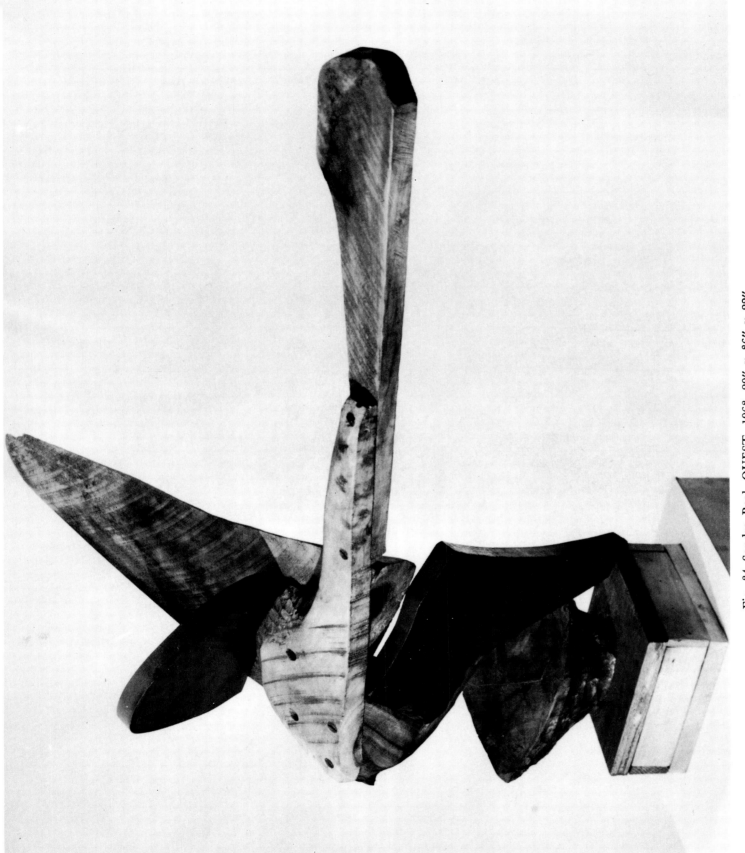

Fig. 34 Sondra Beal. QUEST. 1963. 29″ x 36″ x 22″. Wood. *Photography by Nathan Rabin. Courtesy of the artist*

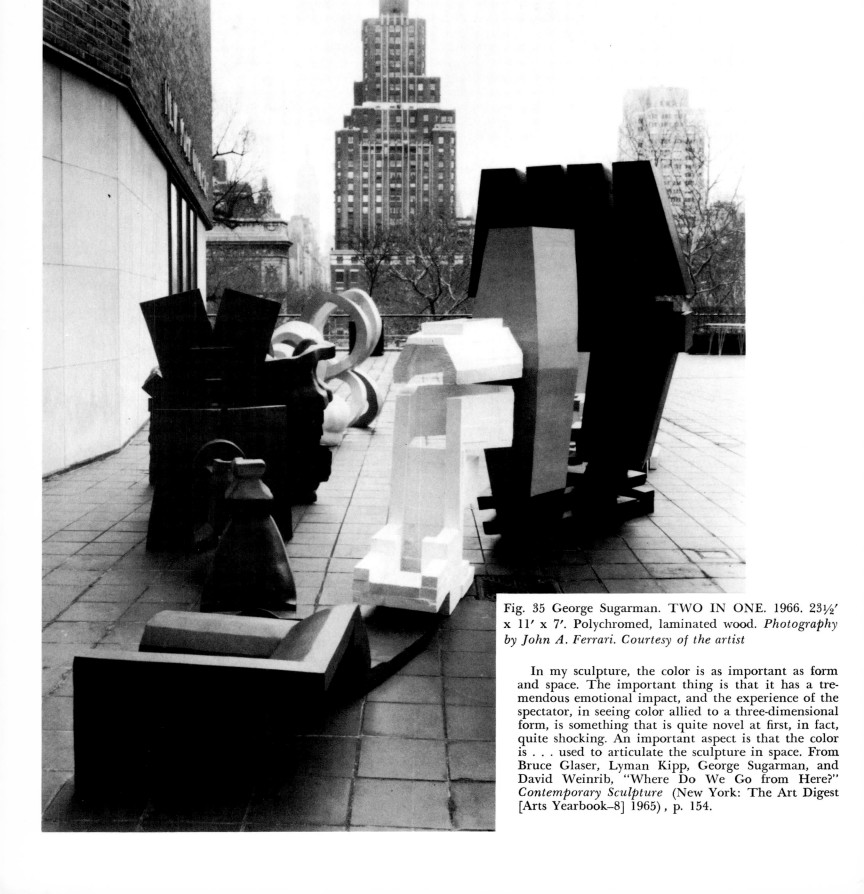

Fig. 35 George Sugarman. TWO IN ONE. 1966. 23½′ x 11′ x 7′. Polychromed, laminated wood. *Photography by John A. Ferrari. Courtesy of the artist*

In my sculpture, the color is as important as form and space. The important thing is that it has a tremendous emotional impact, and the experience of the spectator, in seeing color allied to a three-dimensional form, is something that is quite novel at first, in fact, quite shocking. An important aspect is that the color is . . . used to articulate the sculpture in space. From Bruce Glaser, Lyman Kipp, George Sugarman, and David Weinrib, "Where Do We Go from Here?" *Contemporary Sculpture* (New York: The Art Digest [Arts Yearbook–8] 1965) , p. 154.

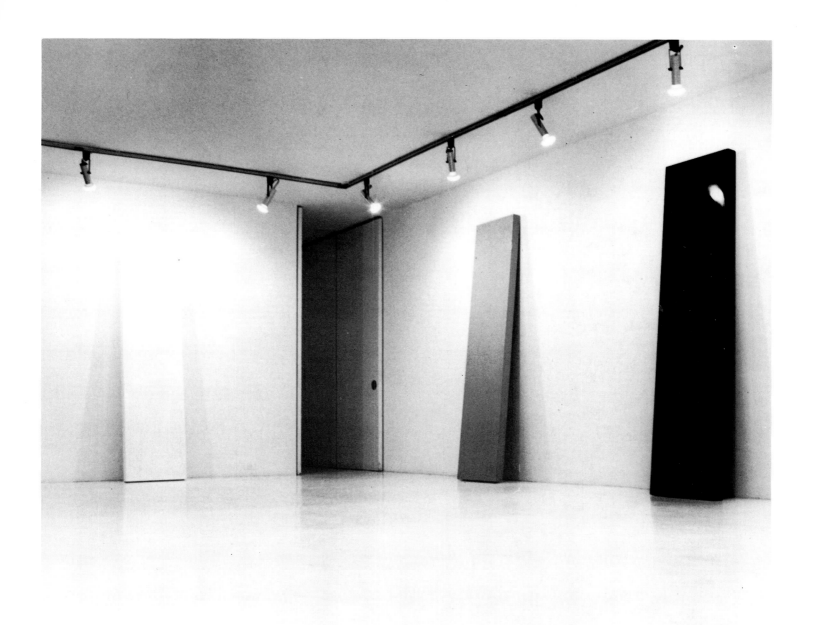

Fig. 36 John McCracken. INSTALLATION. May 1970. *Photography by Nick Sheidy. Courtesy Sonnabend Gallery, New York*

I think of color as being the structural material I use to build the forms I am interested in. John McCracken, from "New Talent USA," *Art in America* 54, no. 4 (July–August 1966) :66.

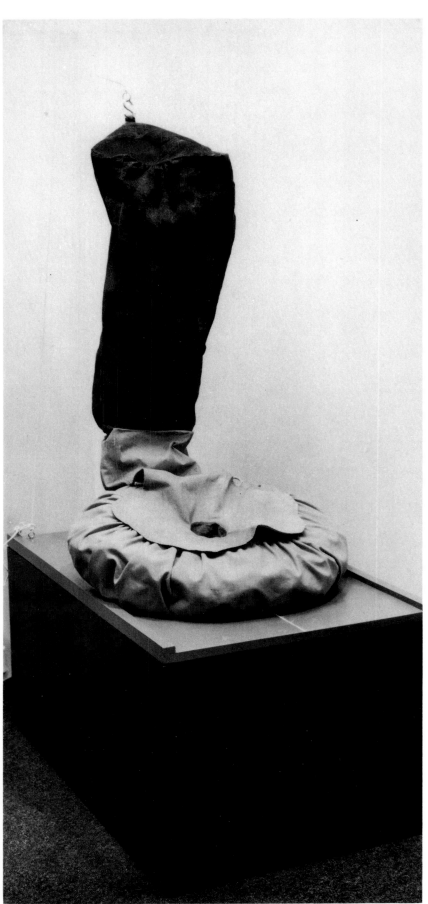

Fig. 37 Claes Oldenburg. PROPOSAL FOR A GIANT BALLOON IN THE FORM OF A TYPEWRITER ERASER—STRUCTURAL MODEL. 1970. Painted canvas, spray enamel, liquitex, and shredded foam rubber. 58″ high. *Photography by Geoffrey Clements. Courtesy Sidney Janis Gallery, New York*

I have combined my unworldly fantasy in a shock wedding to banal aspects of everyday existence . . . so completely . . . the thing is likely to burst either way . . . either into banality or the other way into poetry. Claes Oldenburg, from "Claes Oldenburg: Extracts from the Studio Notes (1962–64)," *Artforum* 4, no. 5 (January 1966) :32.

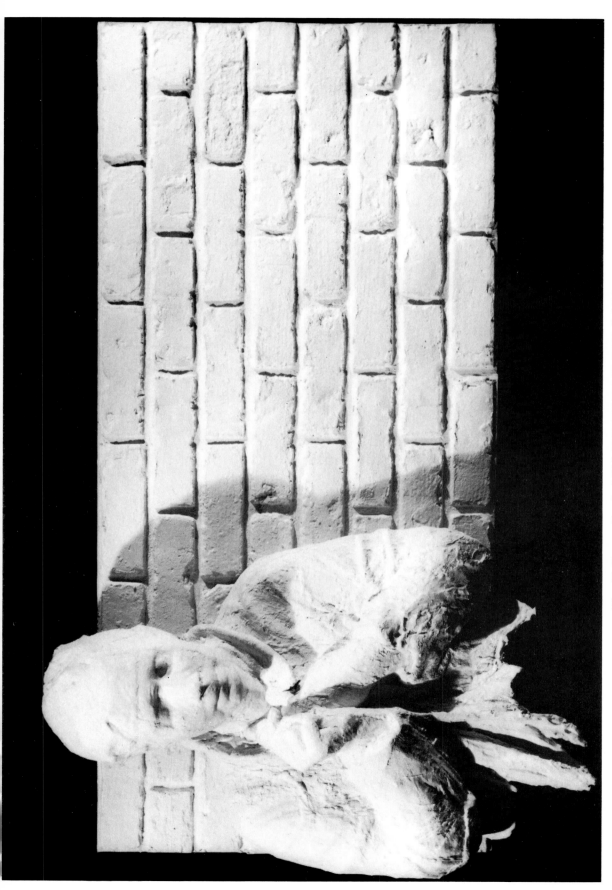

Fig. 38 George Segal. GIRL BUTTONING HER RAIN-COAT. 1970. Plaster, wood, and plastic. 24″ x 48″ x 15″. *Photography by Eric Pollitzer. Courtesy Sidney Janis Gallery, New York*

the peculiar shape and qualities of the actual empty air surrounding the volumes becomes an important part of the expressiveness of the whole piece. The distance between . . . a figure and another object becomes crucial. My pieces often don't end at their physical boundaries. George Segal, from Henry Geldzahler, "An Interview with George Segal," *Artforum* 3, no. 2 (November 1965) :29.

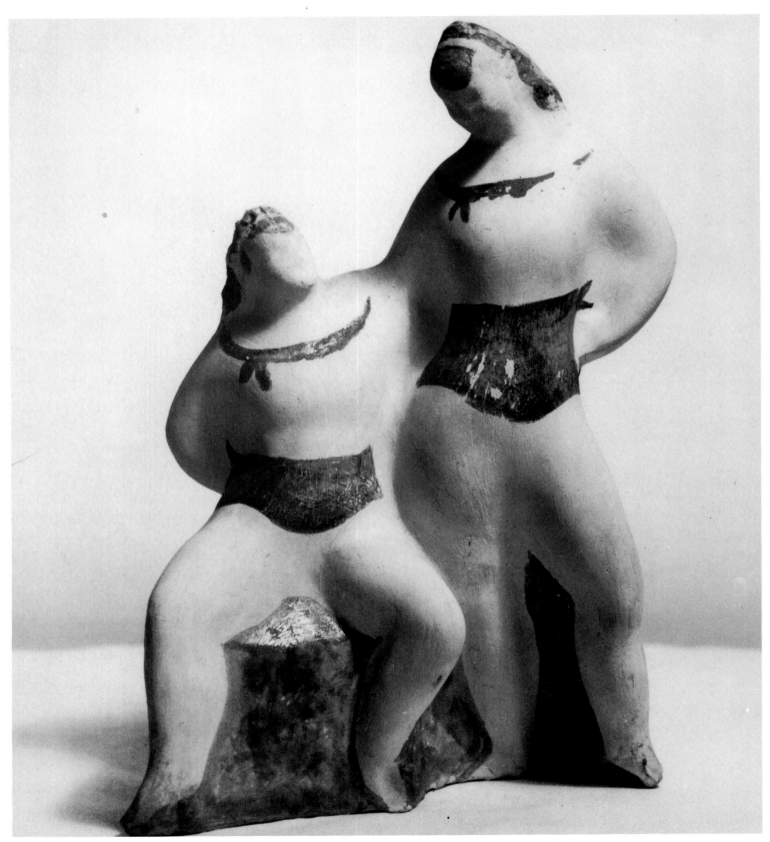

Fig. 39 Elie Nadelman. TWO WOMEN. 1934. Painted
terra cotta. 14″ high. *Photography by John D. Schiff.
Courtesy Zabriski Gallery, New York*

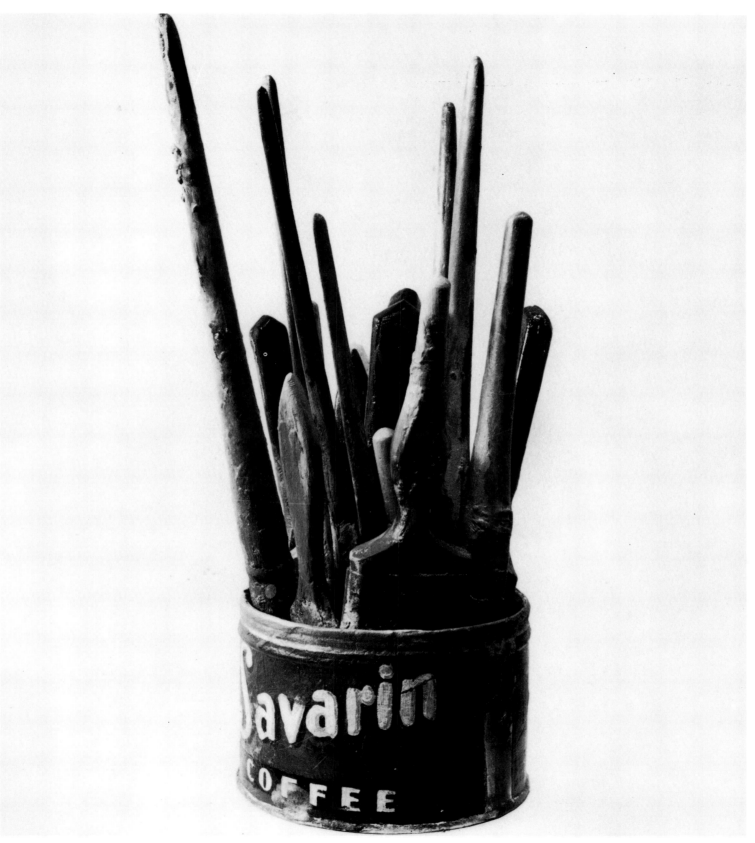

Fig. 40 Jasper Johns. SAVARIN CAN. 1960. Combine,
13½″ x 8″ dia. *Photography by Rudolph Burckhardt.*
Courtesy of the artist

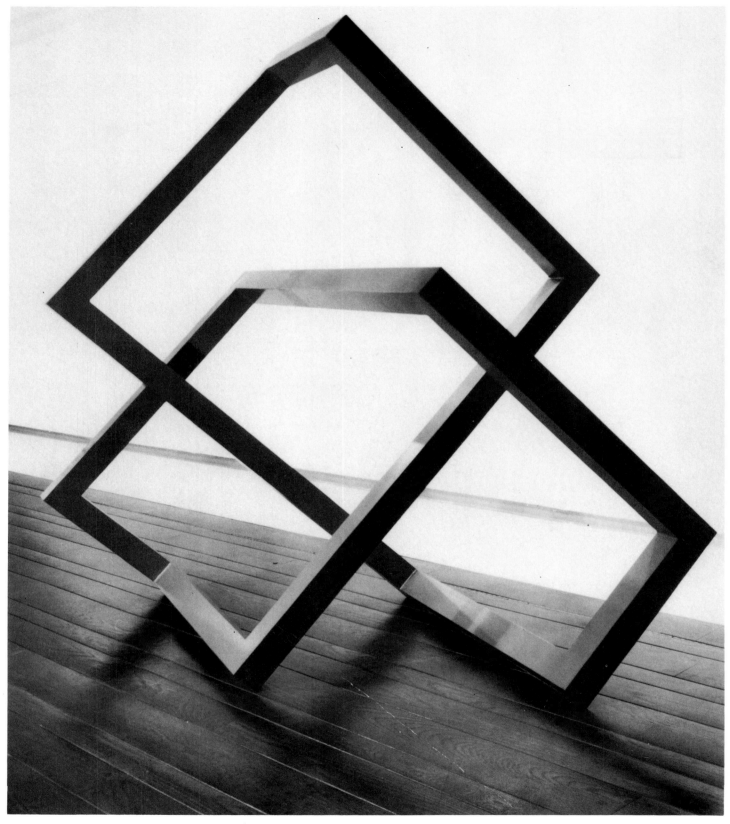

Fig. 41 Forrest Myers. LASER'S DAZE. 1966. Aluminum,
acrylic, lacquer. 84″ x 72″ x 72″. *Courtesy Paula J.
Cooper Gallery, New York*

Fig. 42 H. C. Westermann. WESTERMANN'S TABLE (Center). 1966. 44¾″ high. Plywood and books. Private collection, Paris. *Photography by Nathan Rabin. Courtesy Allan Frumkin Gallery, Inc., New York*

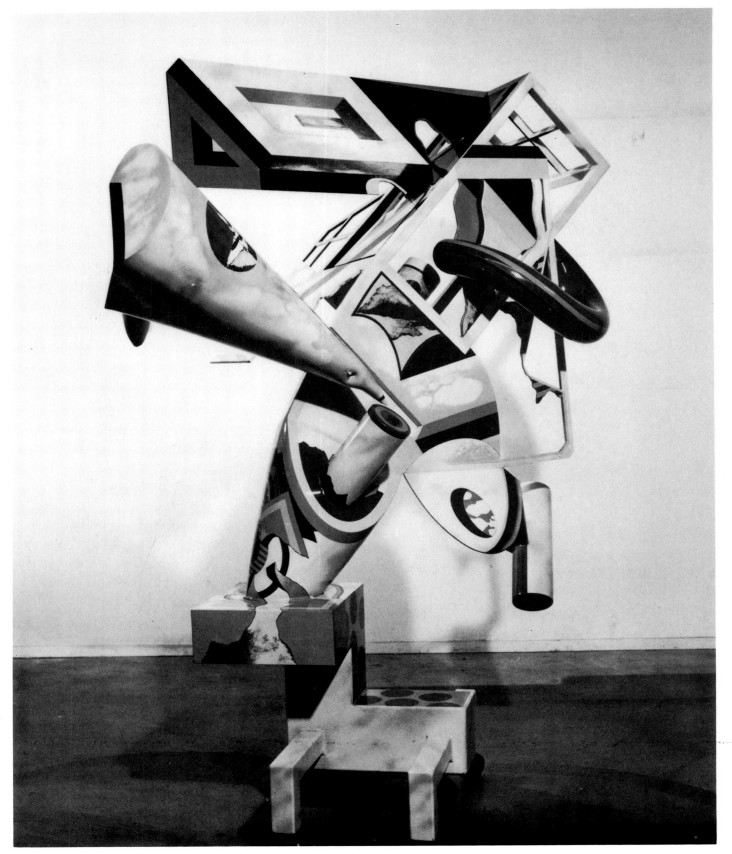

Fig. 43 Robert Hudson. SPACE WINDOW. 1966. Painted steel. 69″ x 60″ x 57″. Collection of Mrs. Philip Lilienthal. *Photography by Frank J. Thomas. Courtesy Allan Frumkin Gallery, New York*

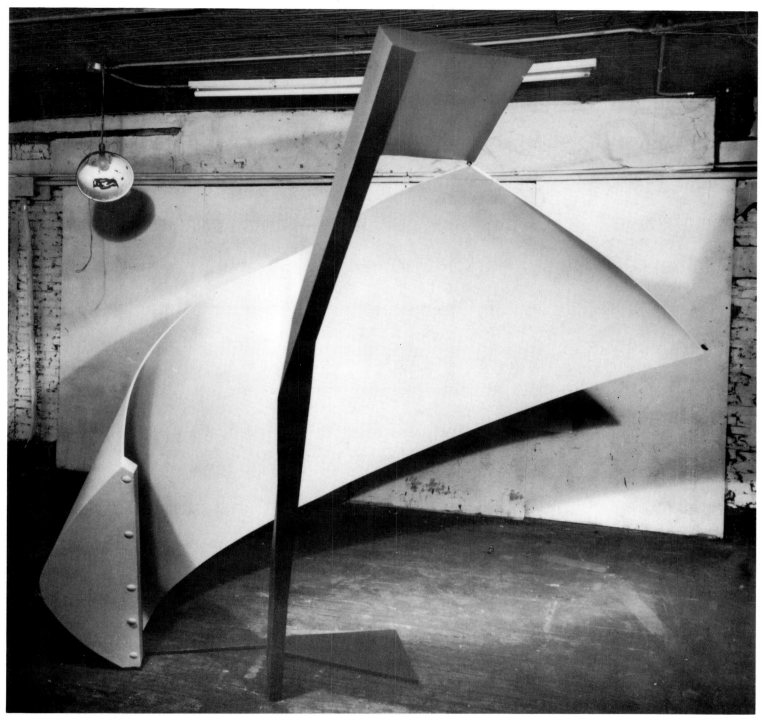

Fig. 44 Tom Doyle. "LA VERGNE." 1965. Masonite, wood, steel, polychrome sculpture. 8′ x 12′ x 10′. *Photography by John D. Schiff. Courtesy of the artist*

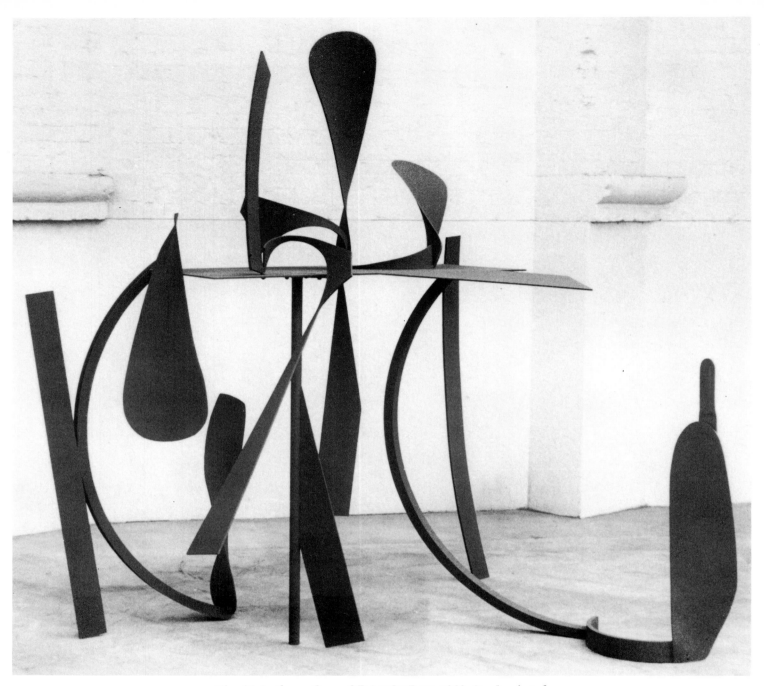

Fig. 45 Anthony Caro. ORANGERIE. 1969. Steel painted. 88½″ x 64″ x 91″. *Courtesy of the artist*

I think . . . part of the disadvantage of sculpture, and also part of the advantage of it is the fact that it's heavy and real; I don't want to make sculpture which has an unreality. I want to make sculpture which is very corporeal, but denies its corporeality. . . . I would really rather make my sculpture out of "stuff" —out of something really anonymous. . . . I have been trying, I think, all the time to eliminate references, to make truly abstract sculpture. Anthony Caro, from "Anthony Caro Interviewed by Andrew Forge," *Studio International* 171, no. 873 (January 1966) :7.

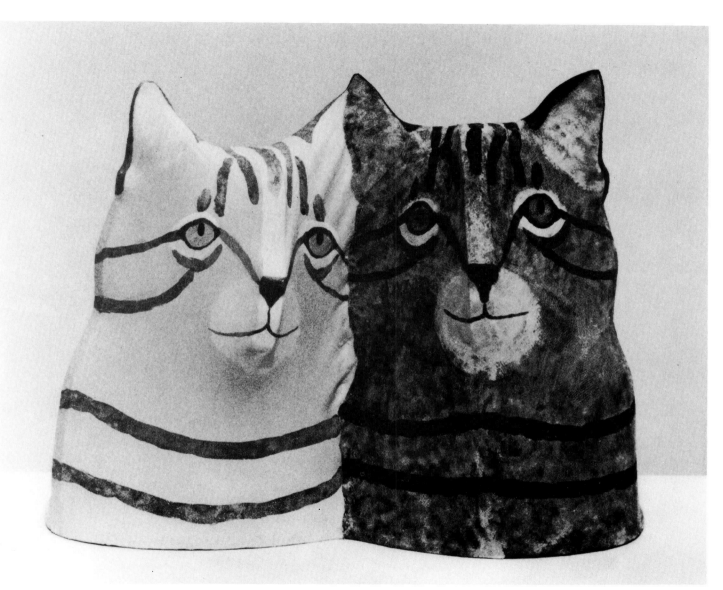

Fig. 46 Anne Arnold. HE AND SHE (#27). 1969.
Acrylic over wood. 25″ x 29½″ x 15½″. *Courtesy Fisch-
bach Gallery, New York*

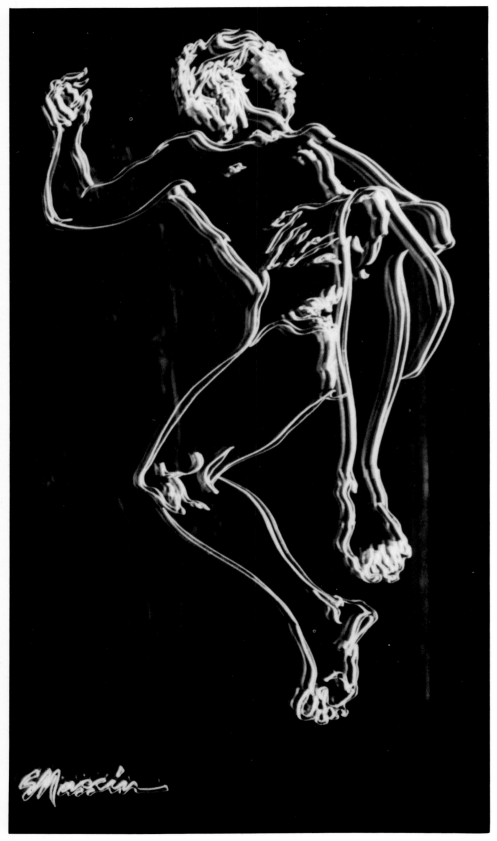

Fig. 47 Eugene Massin. RECLINING WOMAN. 1970. Acrylic cut-out mounted on acrylic sheet. 32″ x 24″. *Photography by Shirley Busch. Courtesy of the artist*

Eugene Massin, who has always been interested in shadows and reflections, utilizes the reflective quality of acrylic sheet with electric light, which is piped through the clear drawing. Arranged in layers, the illuminated drawing is set on a clear acrylic central sheet, which is reflected in the onyx-colored background panel. Meanwhile, the clear front panel pulls another reflected image into the composition, that of the viewer.

Fig. 48 Eugene Massin. RECLINING WOMAN II 1970. Acrylic line drawing mounted on acrylic sheet 36″ x 40″. *Photography by Shirley Busch. Courtesy o the artist*

Utilizing the ambiguity of transparency, clear acryli sheet combines with black cut-out acrylic line to creat an apparition-like "drawing in space."

I begin working from a sketch which I draw ont the masked acrylic sheet. Each line is then cut ou on a scroll saw, sanded, polished and solvent bonde to the background sheet. A third layer is sometime added which "plays" a sculptured transparent shap into the composition. Although liquid in appearance the shapes are cut from acrylic sheeting and sculpted sanded, buffed, and polished. Eugene Massin.

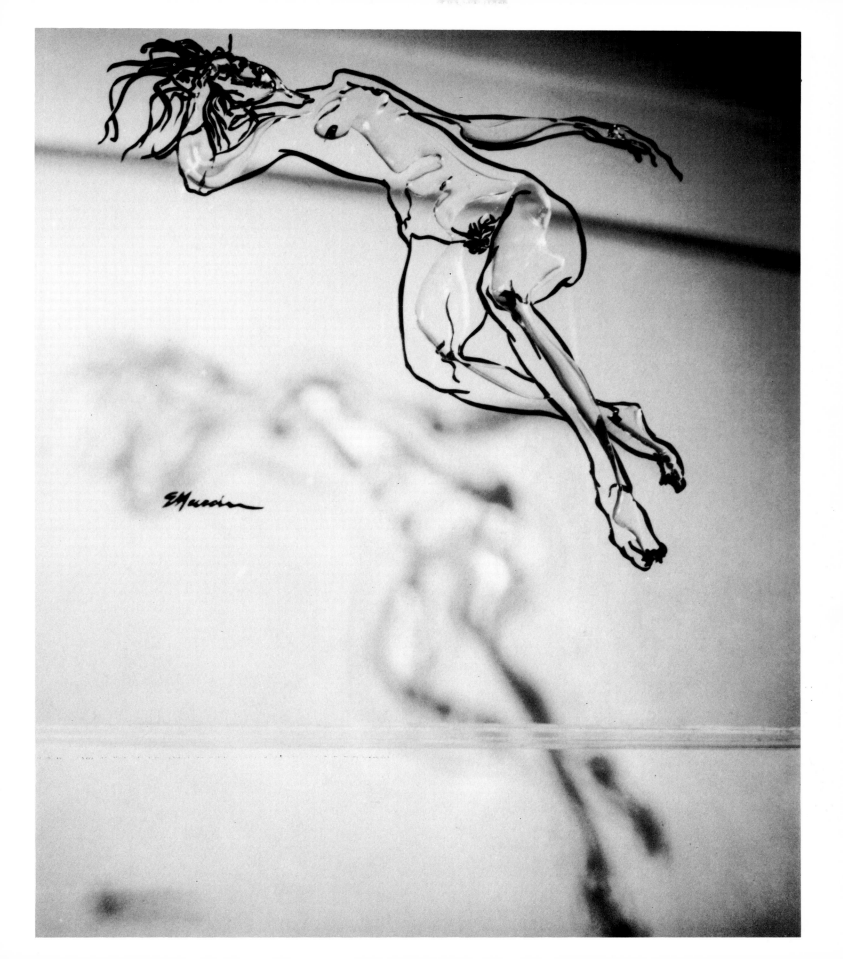

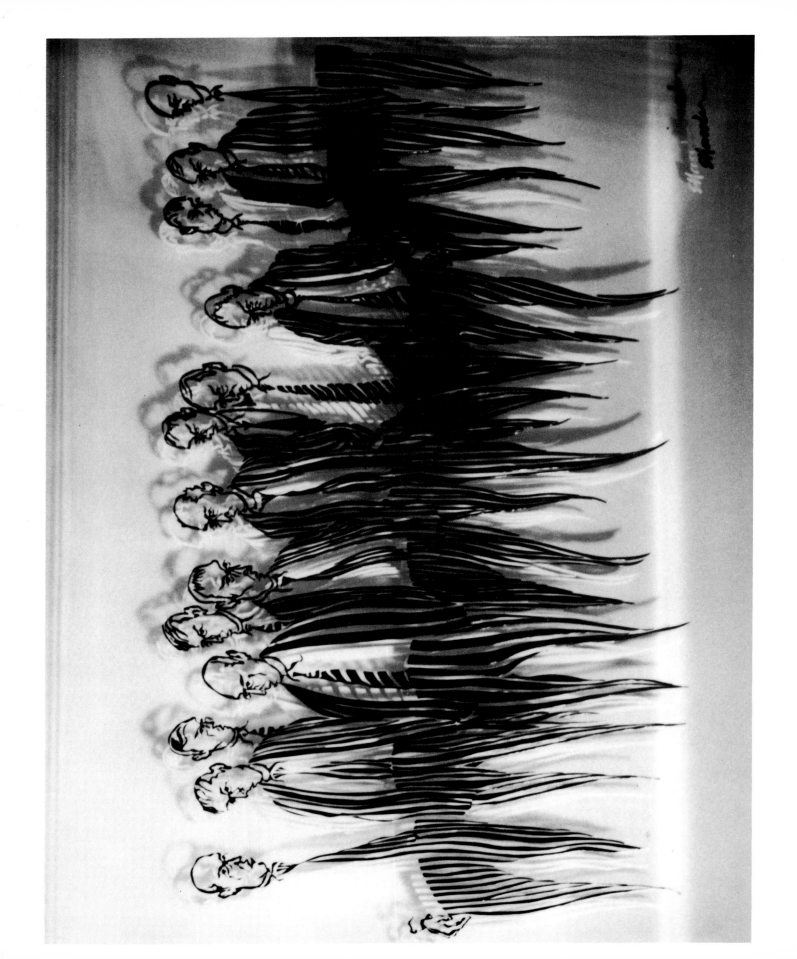

Fig. 49 Eugene Massin. EVERYBODY'S DIFFERENT. Commission for Adlee Corporation, Miami. 6′ x 8′. Acrylic. *Photographed by Shirley Busch. Courtesy of the artist*

Crowds are fascinating—many minds equal one mind equaling no mind. Everybody's different, everybody's indifferent, everybody's somebody, everybody's nobody. Eugene Massin.

The work is in three parts: the front panel houses a row of black figures (these are sandwiched between two clear acrylic sheets, which are mounted into a clear acrylic frame), the second panel houses the set of white figures, and the back panel is translucent white (this catches the shadows of the front two panels and multiplies two rows of figures into a crowd).

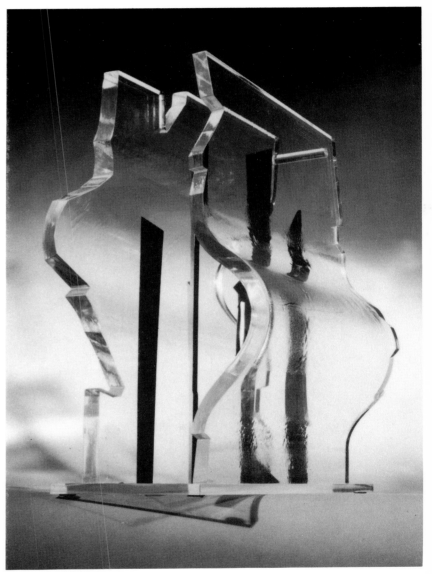

Fig. 50 Jane Frank. DECEMBER I. Late 1960s. Lucite, oven-heated and bent/plexiglass. 8″ x 21″ x 22″. *Courtesy of the artist*

The artist working today has much open to him in both method and media, which even ten years ago would not have been available. There will always be those who are content with the traditional performances. These methods have been proved, and are "safe." But happily there are also those who are curious and restless, who feel that if something can be imagined, it can be accomplished. Jane Frank (in 1972 letter to the author).

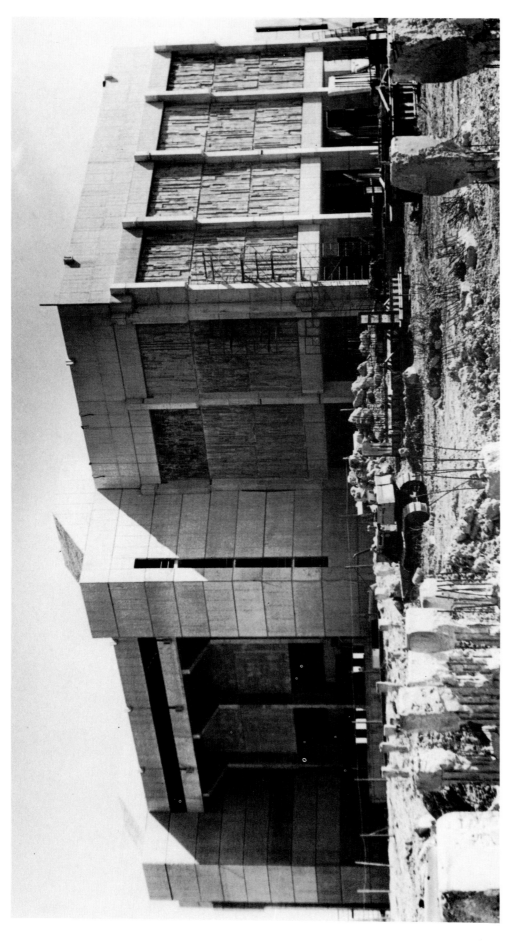

Fig. 51 Al Vrana. THREE STORY CONCRETE
FAÇADE FOR FLORIDA INTERNATIONAL UNI-
VERSITY. 1971–72. *Photography by Shirley Busch.
Courtesy of the artist*

Al Vrana uses styrofoam in which to cast his sculptural,
load-bearing ferro-cement façades. Coupling technology
with his own invention and humor, he has found the
best parting agent in his molds to be pancake syrup.
This he pours on the styrofoam before the steel mesh
and cement are added.

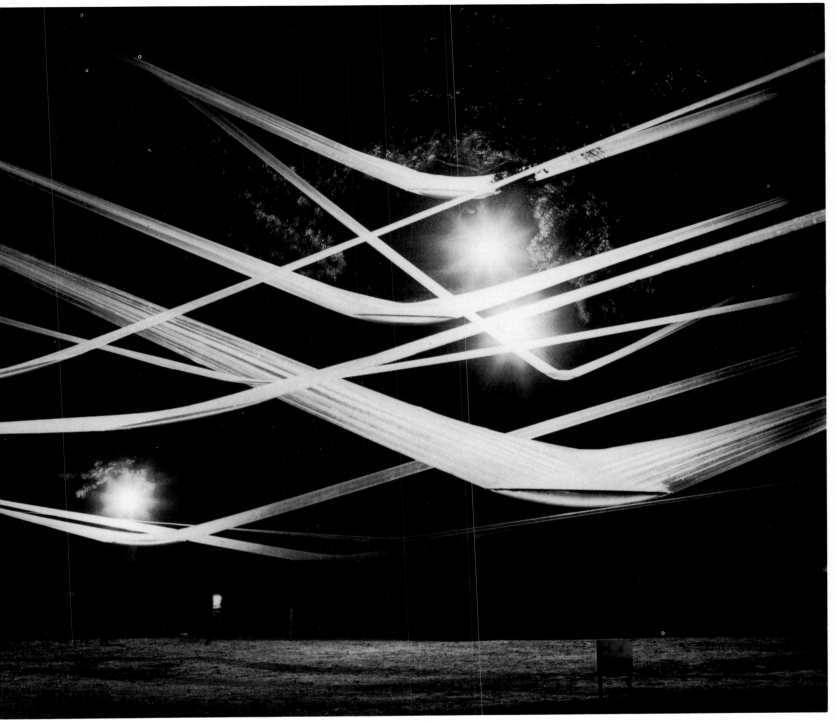

Fig. 52 Sadamasa Montonaga. WORK. 1965. Water, plastic. *Courtesy of the artist*

Working with plastic sleeves filled with water and hung in catenaries from trees, Sadamasa Motonaga's kinetic work moves and changes according to wind currents.

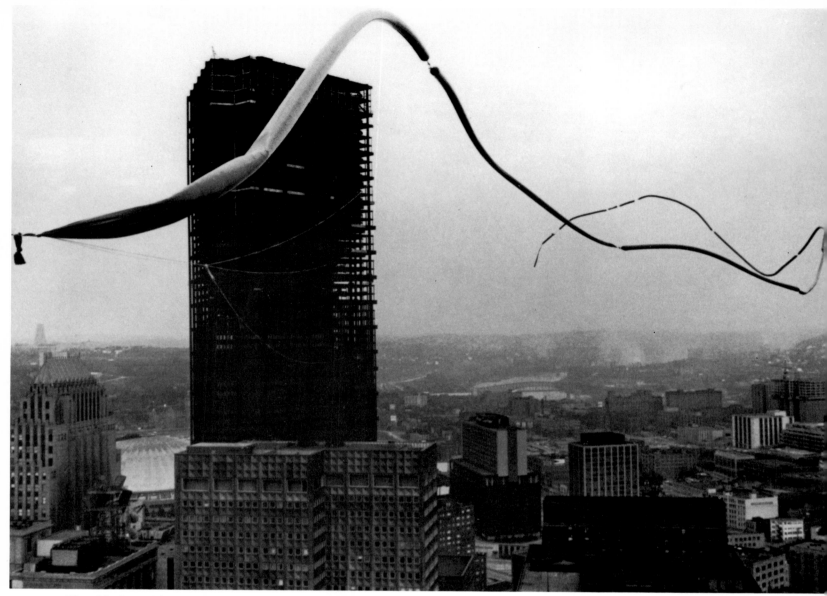

Fig. 53 Otto Piene. RED HELIUM SKYLINE. From CITYTHING SKY BALLET. 1970. Pittsburgh, Pa. *Photography by Walter Seng. Courtesy of the artist*

The helium-filled balloon, approximately 1,500 feet in length, was part of a three-day sky ballet produced by kineticist Otto Piene.

Elements and technology are the means that permit the revival of a large scale of artistic activities. Wind may be considered the new siccative while fire is a new gel. Technology permits the artist to talk to many, design for many, and execute plans for many. Otto Piene, *More Sky 1* (Cambridge, Mass.: Migrant Apparition, Inc. 1970), p. 3.

Otto Piene wants to make art as monumental as nature, sculpture that exists on equal terms with buildings, bridges, and night sky.

Fig. 54 Charles R. Frazier. 50′ BLACK VINYL ROCK-ET/SKYSCRAPER. At Coast Guard Beach, Amagansett, Long Island. Summer 1966. (In the foreground is a weather balloon.) From GAS, a five-day "happening," in collaboration with Allan Caprow, and CBS-TV. Sculpture combined with "happenings," TV, and film in this outdoor event. *Photography by Peter Moore. Courtesy of the artist*

I built the fifty-foot skyscraper rocket of black polyethylene. It was heat-sealed and taped for added strength; in principle it was a long tube sealed at one end, the open end was spread out in a circle on the sand and buried. Nozzles from three vacuum cleaners were inserted and the black undulating form rose to 50 feet of inflated phallic magnificence. Charles R. Frazier. "From a Work Journal of Flying Sculpture," *Artforum* (May 1967), p. 89.

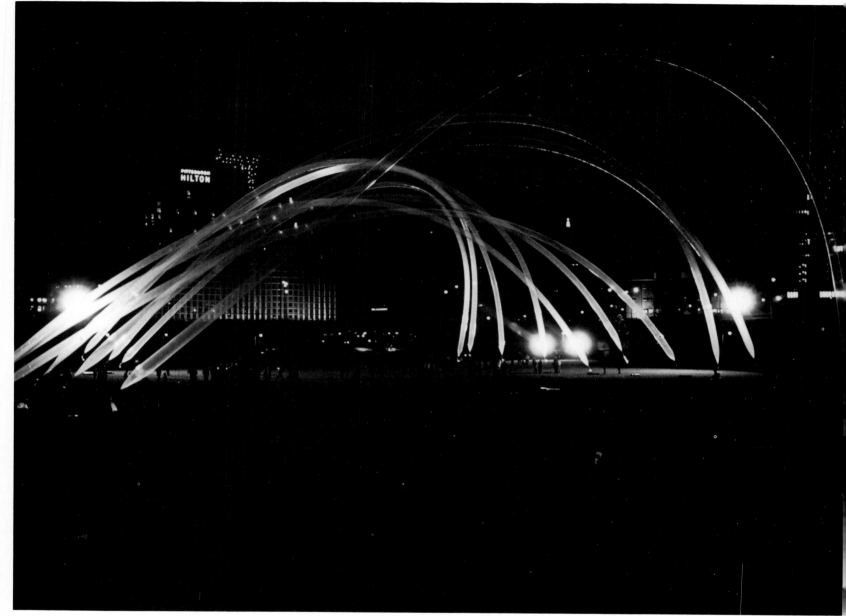

Fig. 55 Otto Piene. MANNED HELIUM SCULPTURE (STAGE I). From CITYTHING SKY BALLET. 1970. Pittsburgh, Pa. *Photography by Walter Seng. Courtesy of the artist*

Villages, cities, regions, states, countries, continents have turned ugly ever since the beginning of the industrial revolution. . . . The artist-planner is needed. He can make a playground out of a heap of bent cans, he can make a park out of a desert, he can make a paradise out of a waste-land if he accepts the challenge. Otto Piene, *More Sky 1* (Cambridge, Mass.: Migrant Apparition, Inc., 1970), p. 3.

Materials used for this sculpture were two 250-foot lengths of clear polyethylene tube, 40 helium tanks, three searchlights, and eight floodlights.

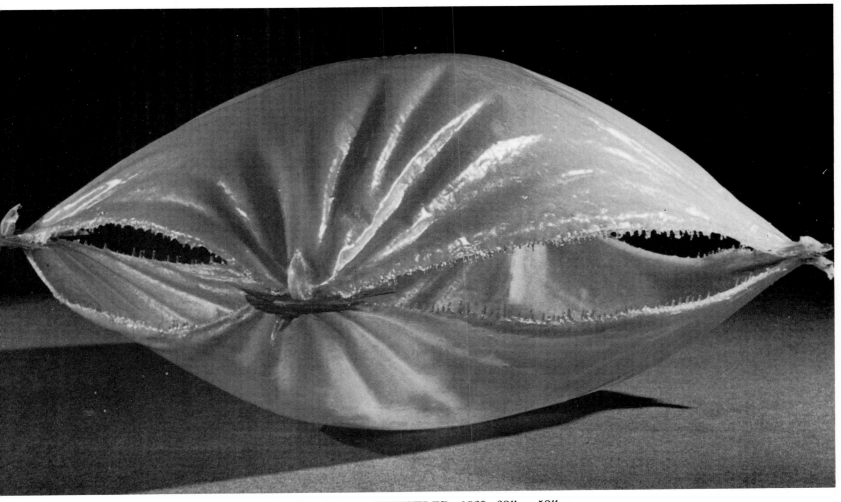

Fig. 56 Mike Bakaty. UNTITLED. 1969. 32″ x 52″ x 27″. Polyester impregnated muslin reinforced with fiberglass. The piece is made in two sections that are not necessarily fixed in this position. *Courtesy of the artist*

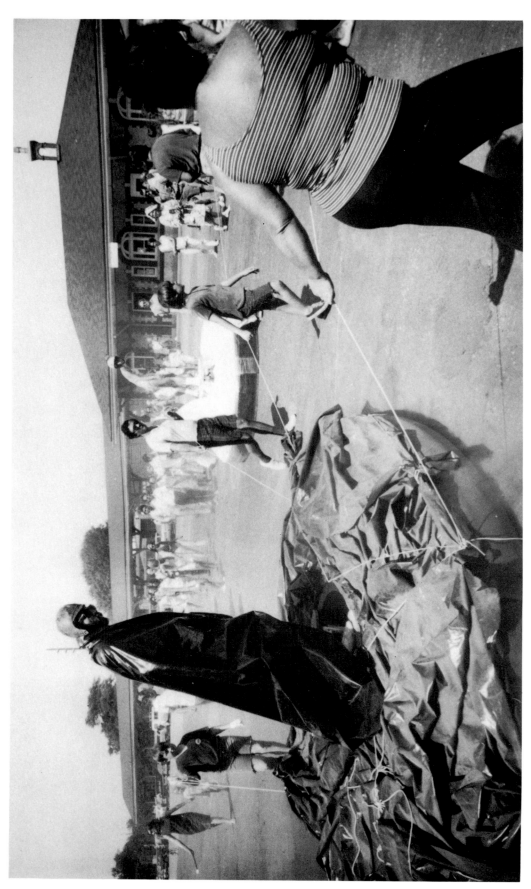

Fig. 57 Charles R. Frazier. From GAS, a 5-day series of events involving sculpture, the "happening," film, and television (GAS was featured on WCBS-TV's EYE ON NEW YORK), in collaboration with Allan Kaprow. Two 10' ground-effect machines were built for the GAS "happening." The ropes were to compensate for the soft steering to eliminate any danger to the crowds. Train station, South Hampton, Long Island. Summer 1966. In rear is WHITE HOVER CRAFT, hovering 18" off the ground on a "cushion of AIR." It is directed like a surfboard by the movement of the hips and legs. *Courtesy of the artist and The Paper Museum*

Fig. 58 Peter Pinchbeck. Untitled structure. 1967. Plywood. In artist's studio. *Photography by Malcolm Varon. Courtesy Paley and Lowe, Inc., New York*

Fig. 59 Peter Pinchbeck. Untitled structure. 1960s. Masonite/acrylic. Proposed in steel. *Courtesy Paley and Lowe, Inc., New York*

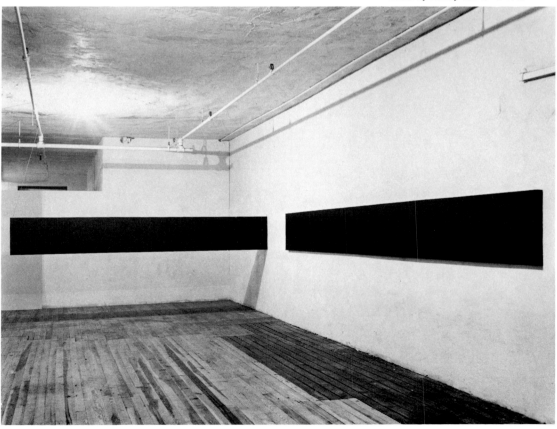

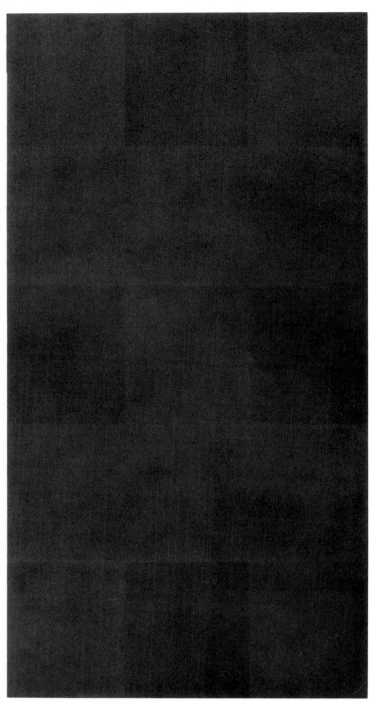

Fig. 60 Ad Reinhardt (1913–67). Abstract painting. 1952. Oil on canvas. 80″ x 40″. *Courtesy Marlborough Gallery, New York*

Suggested steps toward nonsculpture include Ad Reinhardt's paintings that weren't merely decoration.

Fig. 61 Jasper Johns. TARGET WITH PLASTER CASTS. 1955. Encaustic on canvas with plaster casts. 51″ x 44″ x 3½″. Leo Castelli Collection. *Photography by Rudolph Burckhardt. Courtesy of Leo Castelli Gallery, New York*

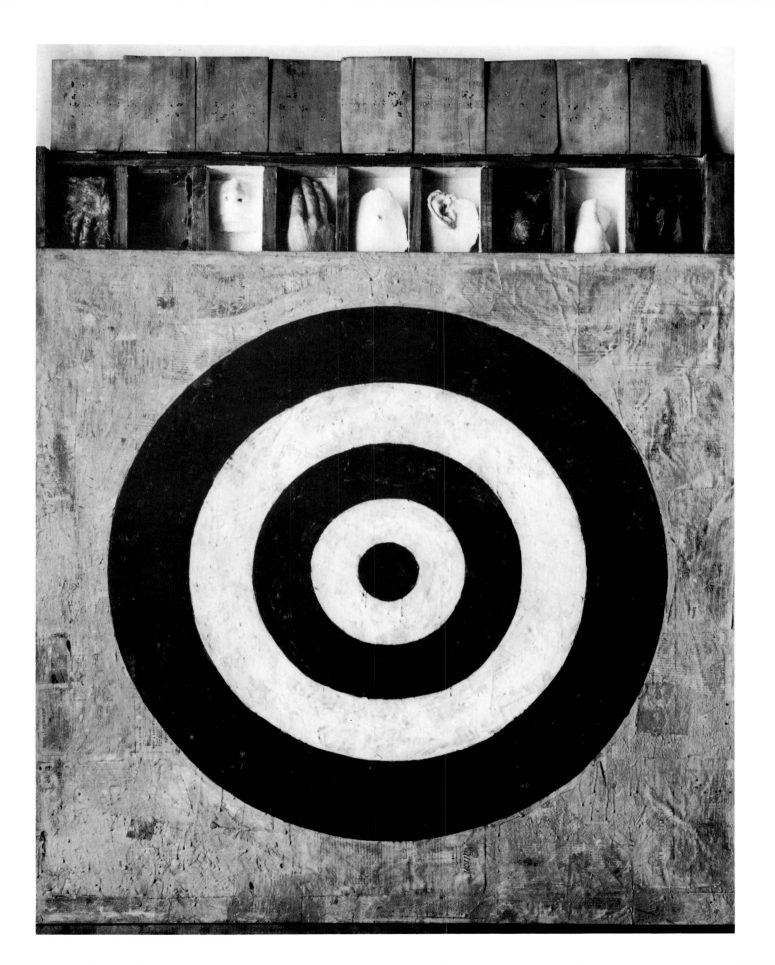

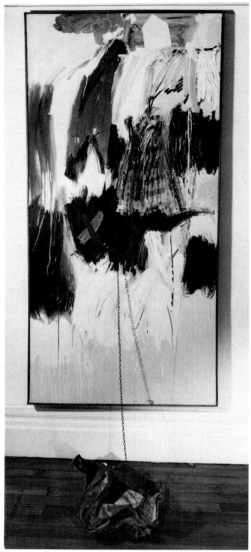

Fig. 62 Robert Rauschenberg. NETTLE. 1960. Combine painting. 84″ x 39″. *Photography by Eric Pollitzer. Courtesy Leo Castelli Gallery, New York*

In the late fifties, Rauschenberg and Johns began to add objects to their paintings that took up three-dimensional space. This, too, is a suggested step to creating nonsculpture and "the object."

Fig. 63 Kenneth Snelson. NEEDLE TOWER. 1968. Anodized aluminum and stainless steel cable. 60′ x 18′ at base. Bryant Park one-man show.

thrust occurs only as a complement of the tension forces on the wires as they introduce compression forces of the tubular elements. Kenneth Snelson (from 1971 letter to author).

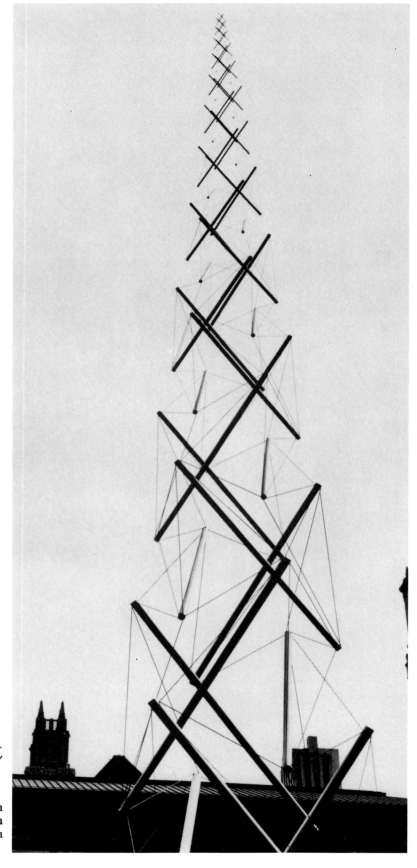

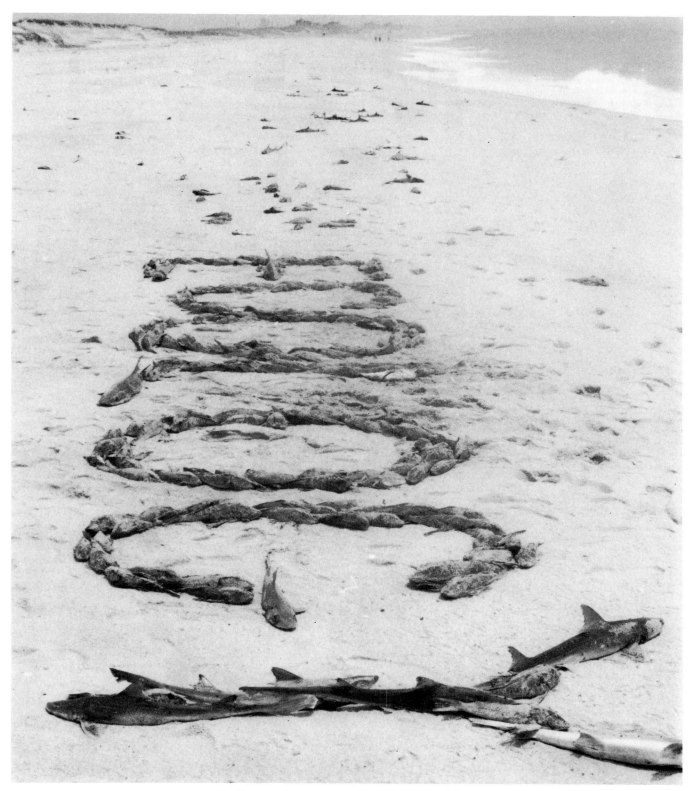

Fig. 64 Charles R. Frazier. ECOLOGY. Amagansett,
Long Island. Spring 1969. The fisherman discarded the
unwanted fish. Frazier used them to spell the word
ecology. The birds came to eat them. The ocean washed
them away. Full circle. *Photography by Charles R.
Frazier. Courtesy of the artist*

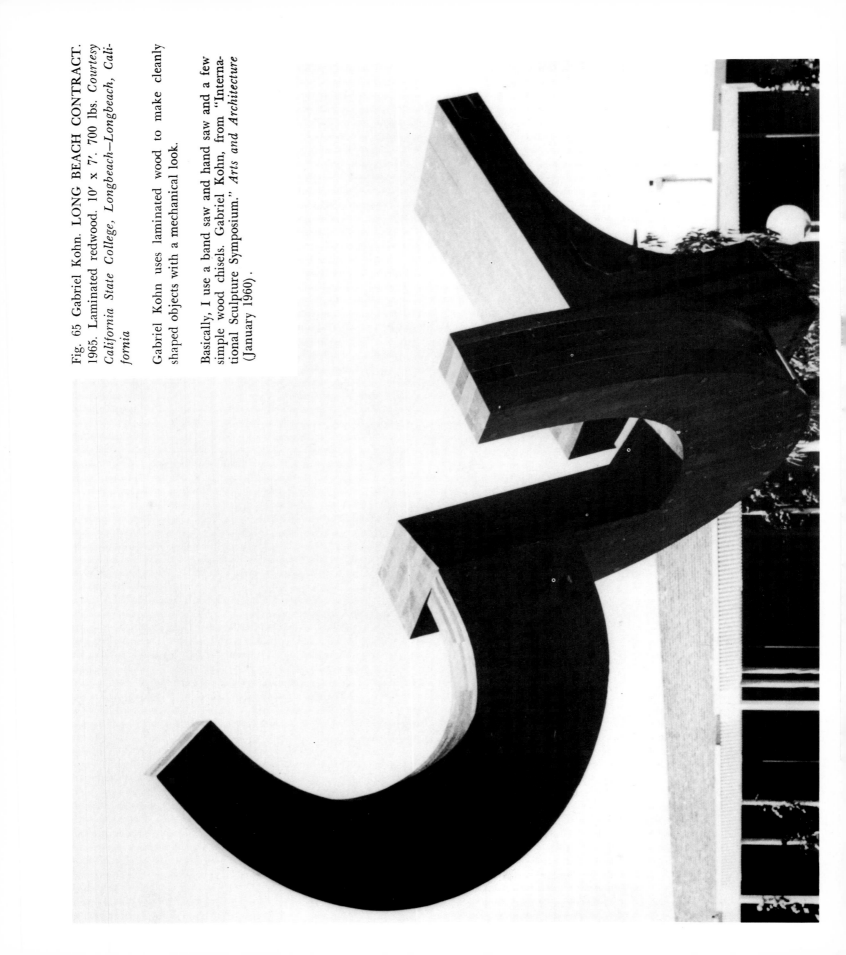

Fig. 65 Gabriel Kohn. LONG BEACH CONTRACT. 1965. Laminated redwood. 10' x 7'. 700 lbs. *Courtesy California State College, Longbeach—Longbeach, California*

Gabriel Kohn uses laminated wood to make cleanly shaped objects with a mechanical look.

Basically, I use a band saw and hand saw and a few simple wood chisels. Gabriel Kohn, from "International Sculpture Symposium." *Arts and Architecture* (January 1960).

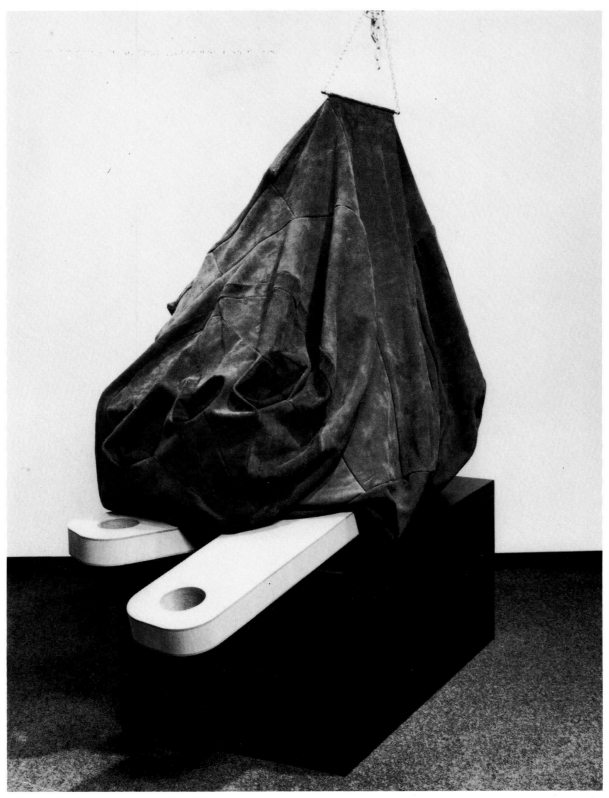

Fig. 66 Claes Oldenburg. GIANT SOFT 3-WAY PLUG
(CUBE TAP) SCALE C. 1970. Leather, wood, canvas,
kapok. 42″ high. *Photography by Geoffrey Clements.*
Courtesy Sidney Janis Gallery, New York

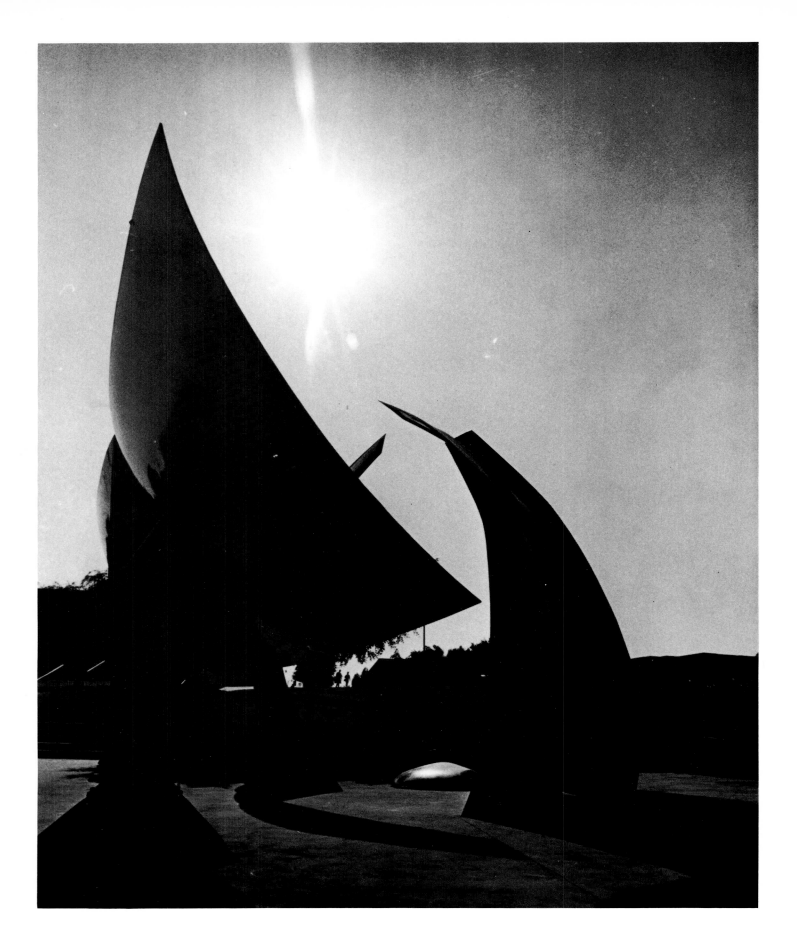

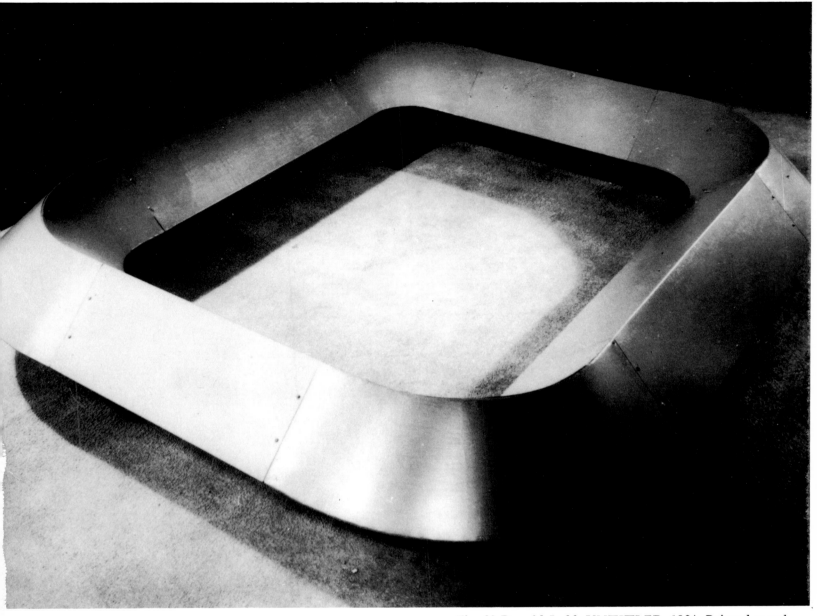

Fig. 68 Donald Judd. UNTITLED. 1964. Painted metal. 78" x 80" x 18". *Courtesy Leo Castelli Gallery, New York*

Fig. 67 Peter Kowalski. NOW. 1965. Stainless steel with radar unit that follows the sun. 29' high. Three sheets of stainless steel each weighing 1850 lbs. *Courtesy California State College, Longbeach—Longbeach, California*

"I sculpture with machines. . . . I set up the forces—pressure, stresses, time—then let them behave with their own laws," states Kowalski, who uses aircraft metal-forming techniques. He attaches dynamite to the metal in computed amounts and explodes the charges underwater. "International Symposium of the Arts," *Arts and Architecture* (January 1966).

It isn't necessary for a work to have a lot of things to look at, to compare, to analyze one by one, to contemplate. The thing as a whole, its quality as a whole, is what is interesting. The main things are alone and are more intense, clear and powerful. They are not diluted by an inherent format, variations of the form, mild contrasts and connecting parts and areas. Donald Judd, "Specific Objects," *Contemporary Sculpture: Arts Yearbook–8* (New York: The Arts Digest, Inc., 1965), p. 78.

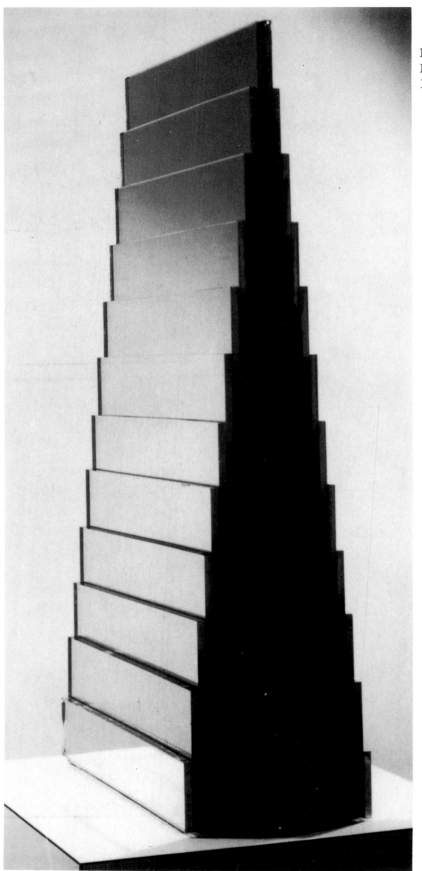

Fig. 69 Robert Smithson. ZIGGURAT MIRROR. 1966. Mirrors. 24″ x 10″ x 5½″. *Courtesy Dwan Gallery, New York*

Instead of causing us to remember the past like the old monuments, the new monuments seem to cause us to forget the future. Robert Smithson, "Entropy and the New Monuments," *Artforum* 4, no. 10 (June 1966) :26.

Fig. 70 Al Vrana. OBELISK. 1969–70. Ferro-cement. 60′ high; 50 tons. Commission for Arlin House, Miami Beach, Florida. *Photography by Ray Fisher. Courtesy of the artist*

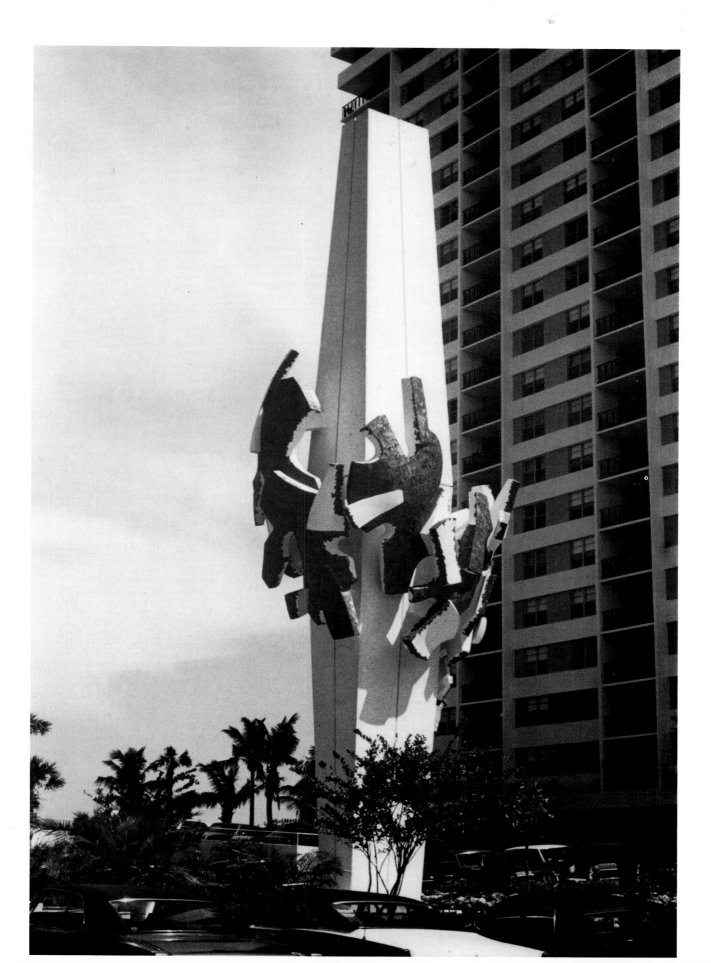

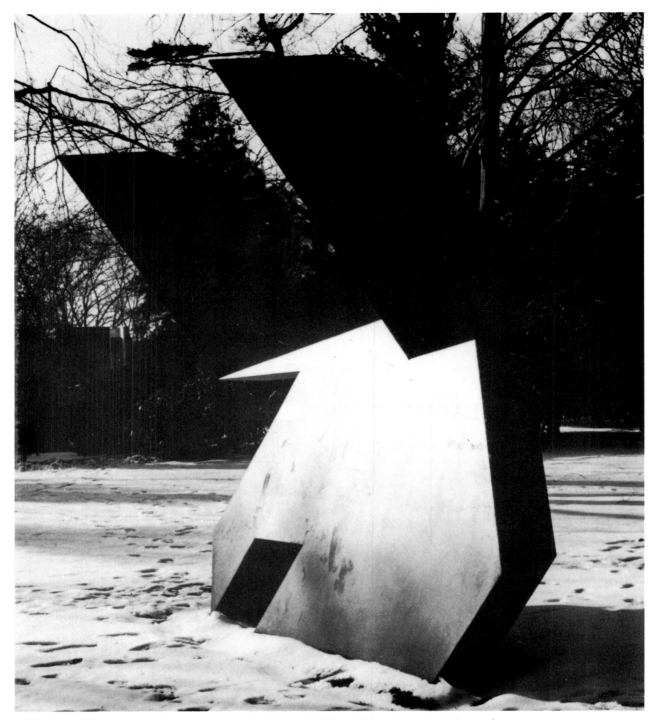

Fig. 71 Tony Smith. MOSES. 1968. Steel (edition of three). 11'6" x 15' x 7'4". *Photography by Tom Bailey. Courtesy M. Knoedler and Co., Inc., New York*

I view art as something vast. I think highway systems fall down because they are not art. . . . In terms of scale, we have less art per square mile, per capita, than any society ever had. Tony Smith, from Samuel Wagstaff, Jr., "Talking with Tony Smith," *Artforum* 5 (December 1966) :17.

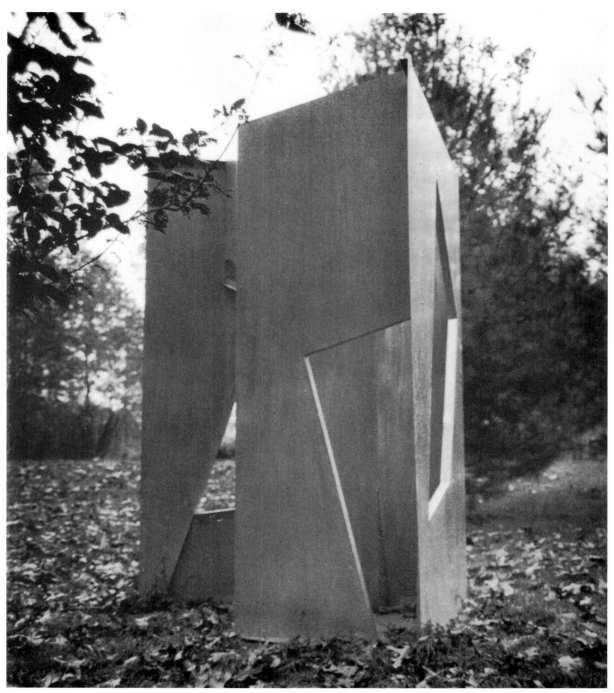

Fig. 72 Jane Frank. SHADOWS OF SUBSTANCE.
Welded aluminum. 8' x 4' x 5'4". *Courtesy of the artist*

I begin [working] from a drawing or cardboard mock-up. I give my welding and aluminum pieces to a machinist with whom I work quite closely. The painting on the outdoor work I do in my studio. Jane Frank (in 1972 letter to the author).

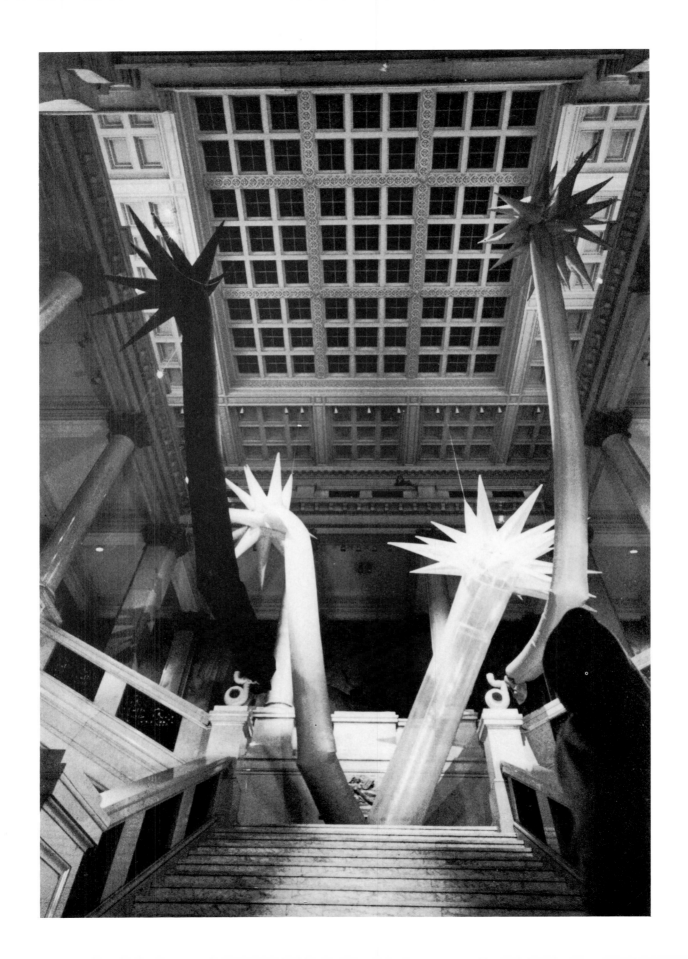

Fig. 73 Otto Piene. RED RAPID GROWTH. 1970.
Polyethylene and silk. 35′ high. Commission by Carnegie
International Exhibition, Pittsburgh, Pa. *Photography
by Walter Seng. Courtesy of the artist*

The red and purple kinetic construction consists of four
flowerlike forms. The members inflate and subside in a
programmed rhythm symbolizing the natural cycle of
growth and decay.

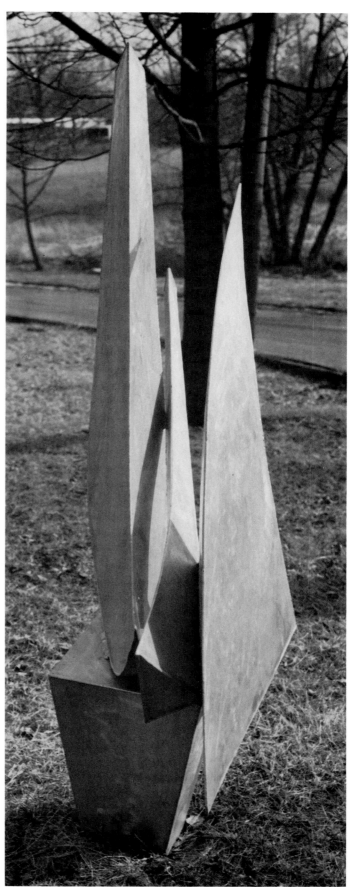

Fig. 74 Jane Frank. ALLAR. Welded aluminum. 5′ x
4′10″ x 2′. *Photography by Metee. Courtesy of the artist*

we all consider art and science to be "brothers," in a
way. Both are concerned with experiment, new hori-
zons, fresh ways of seeing and communicating these
new thoughts. Very often the scientist and the artist
are speaking the same language that is only readily
understood by his peers. Sometimes not even those.
Some artists today set about to utilize consciously and
esthetically what science has already offered. For ex-
ample, sound effects, kinetics, laser beams and many
more. There are also artists who arrive at what would
appear to be a scientific correlation with art, when
in actual fact it was arrived at intuitively; separately
and with no real facts or figures. They would meet
by chance at the "same bend in the road." As I am
not intrinsically mechanically minded, I most surely
belong in the latter category. Jane Frank (in 1971
letter to the author).

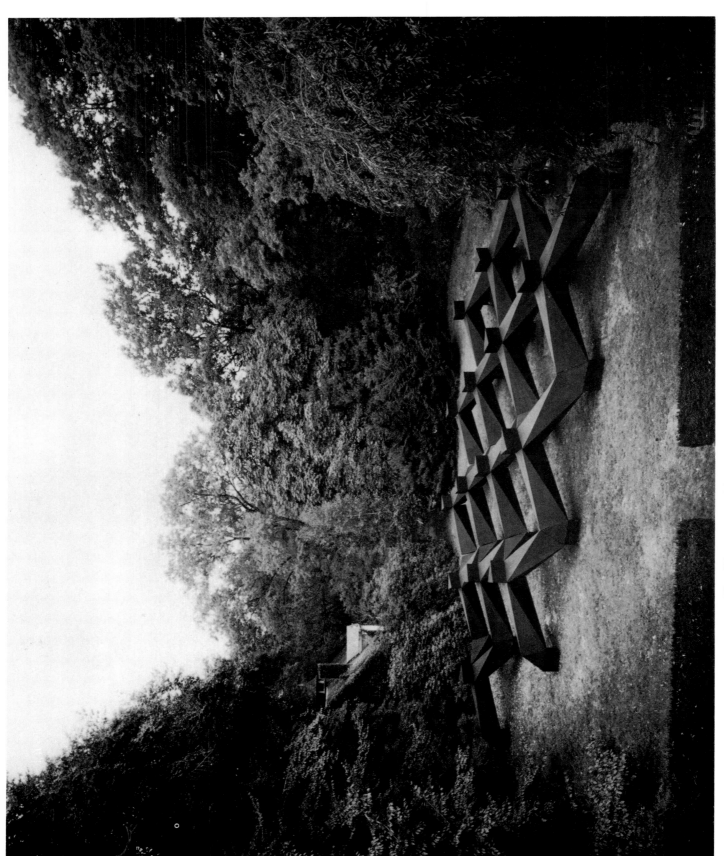

Fig. 75 Tony Smith. SMOG. 1969. 6'10" x 78' x 64'.
Mock-up; to be made in steel (edition of three). *Courtesy M. Knoedler and Co., Inc., New York*

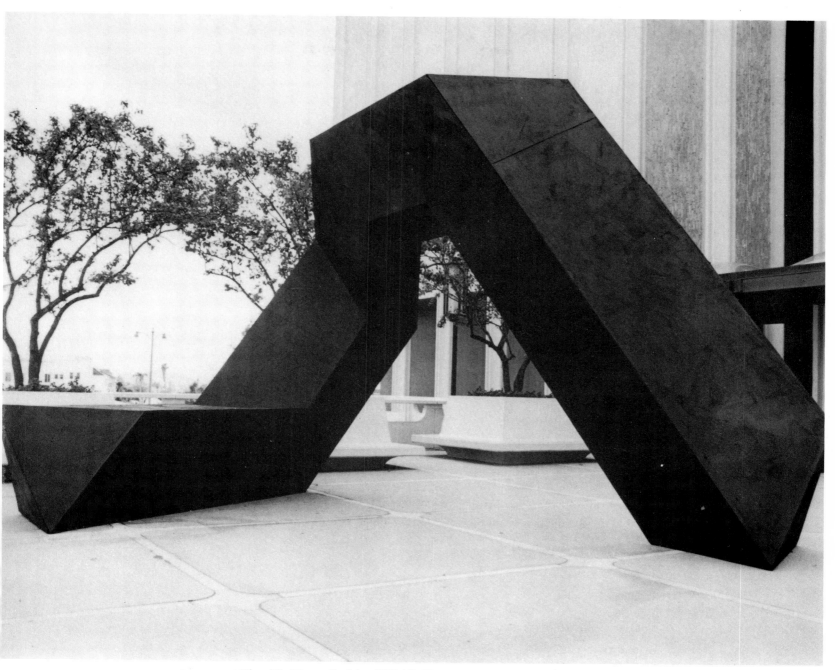

Fig. 76 Tony Smith. CIGARETTE. 1962. 15' x 26' x
18'. Mock-up; to be made in steel (edition of three).
Courtesy M. Knoedler and Co., Inc., New York

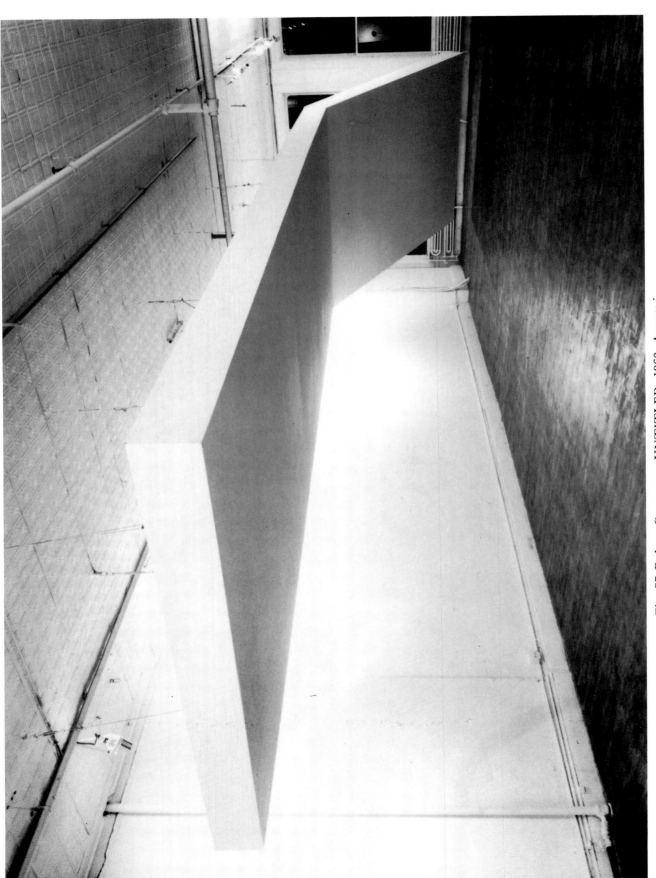

Fig. 77 Robert Grosvenor. UNTITLED. 1968. Approximately 10′ x 40′. Rebuilt 1970. *Photography by Dan Lenore. Courtesy Paula Cooper Gallery, New York*

I don't want my work to be thought of as "large sculpture," they are ideas which operate in the space between the floor and ceiling. Robert Grosvenor, from the Jewish Museum, New York, *Primary Structures: Younger American and British Sculptors*, 1966.

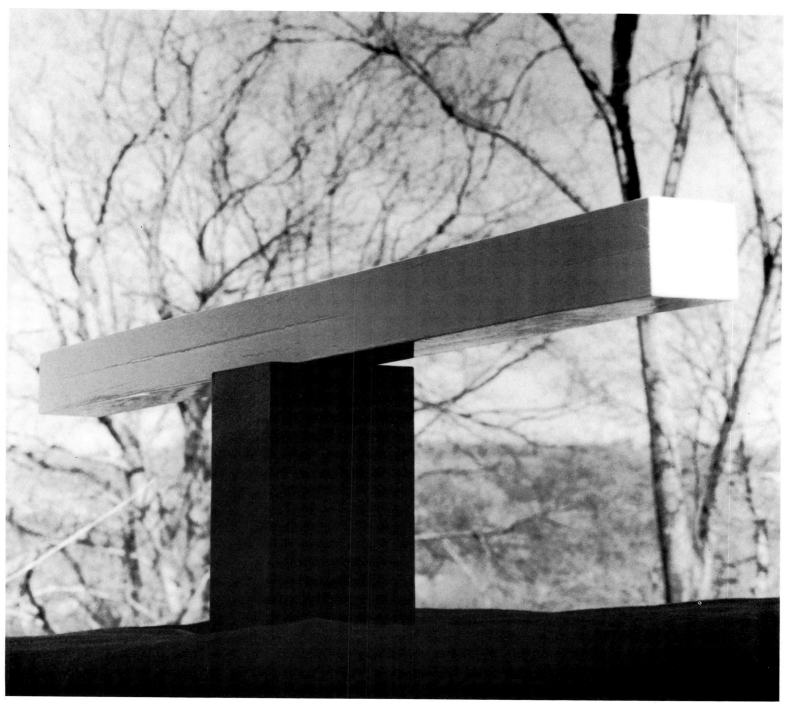

Fig. 78 Lyman Kipp. EBENEZER. 1970. Painted steel.
9' x 4' x 2'. *Courtesy A. M. Sachs Gallery, New York*

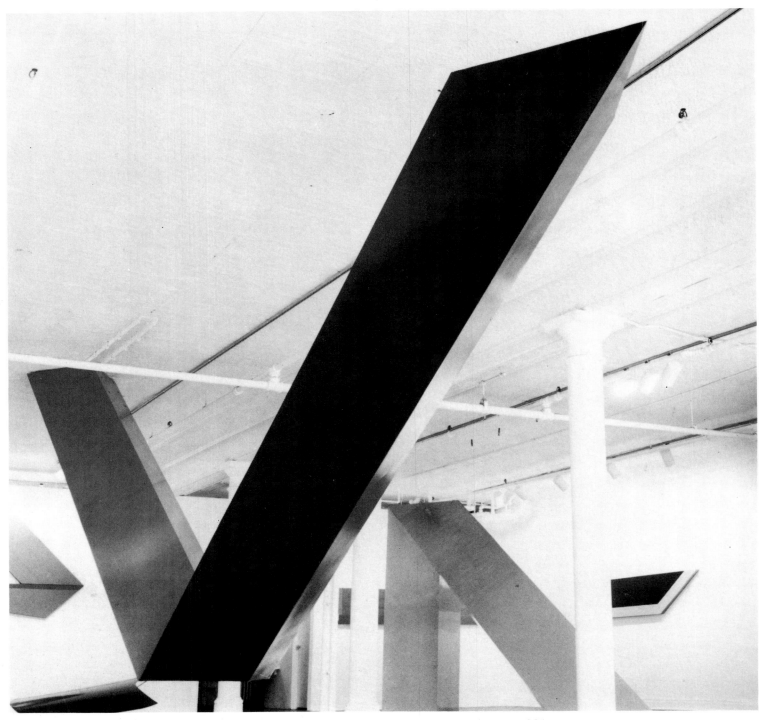

Fig. 79 Robert Grosvenor. TRANSOXIANA. 1965.
Wood, polyester, steel. 10′6″ x 31′ x 3′. *Photography by
Rudolph Burckhardt. Courtesy Paula Cooper Gallery,
New York*

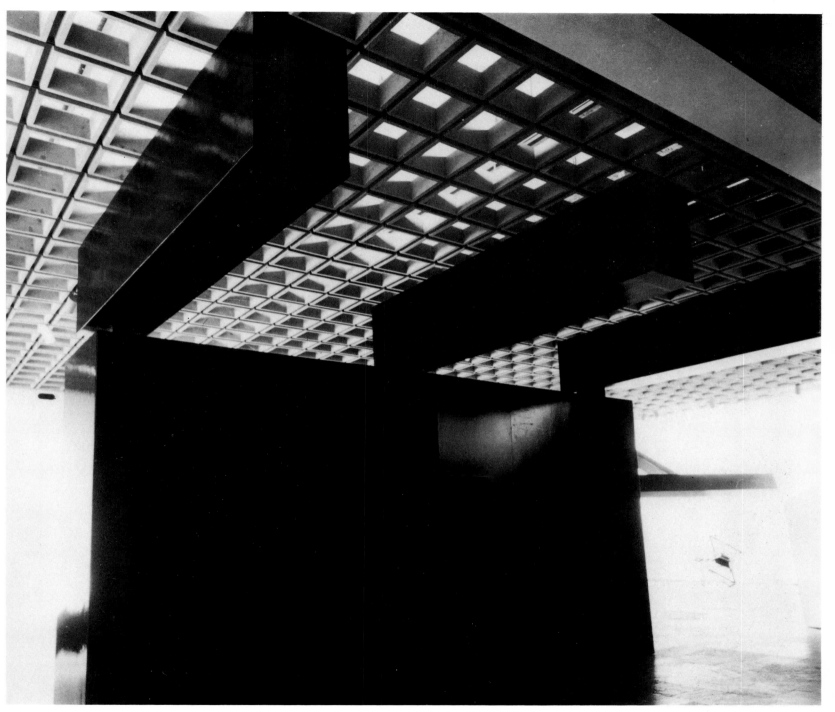

Fig. 80 Ronald Bladen. BARRICADE. 1968. Construction lumber. 15'6" x 24' x 14'. *Courtesy Fischbach Gallery, New York*

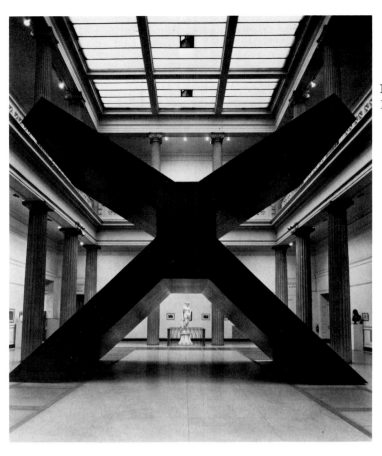

Fig. 81 Ronald Bladen. X. 1967. Wood. 22'8" x 24'6" x 12'6". *Courtesy Fischbach Gallery, New York*

Fig. 82 Kenneth Snelson. KEY CITY. November–December, 1968. Anodized aluminum and stainless steel. 12' x 12' x 12' each modular unit (4). Bryant Park Exhibition. *Courtesy of the artist.*

". . . my work is most *unrelated* to the force of gravity. The forces, real physical ones are stress on the materials themselves induced by the structure *itself*." Kenneth Snelson (in 1971 letter to the author).

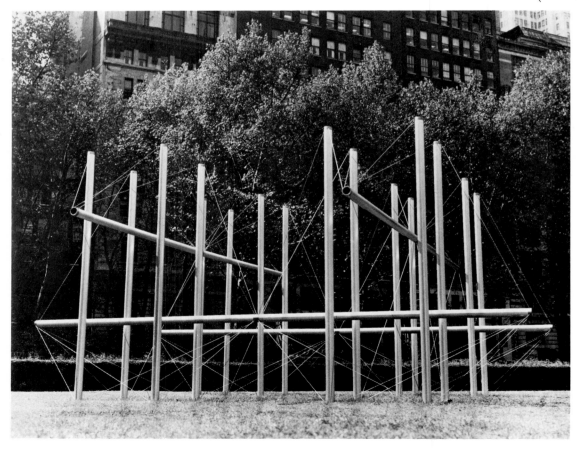

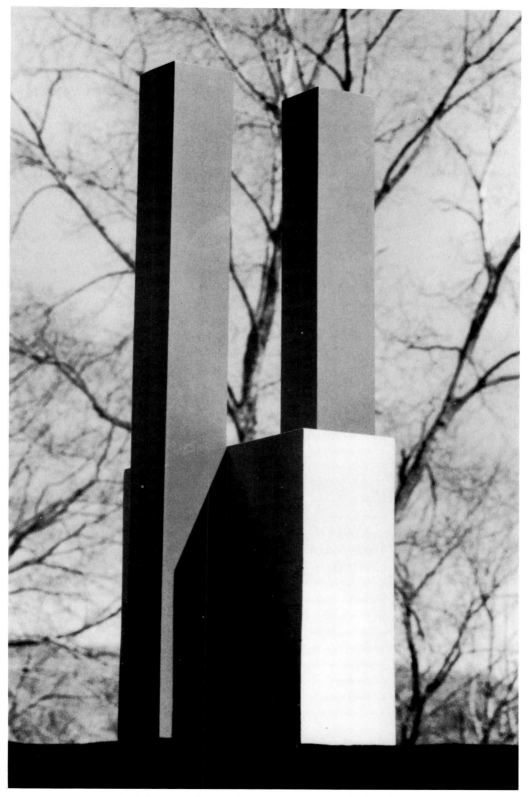

Fig. 83 Lyman Kipp. TOBASCO. 1970. Painted steel.
9′ x 3′ x 4½′. *Courtesy A. M. Sachs Gallery, New York*

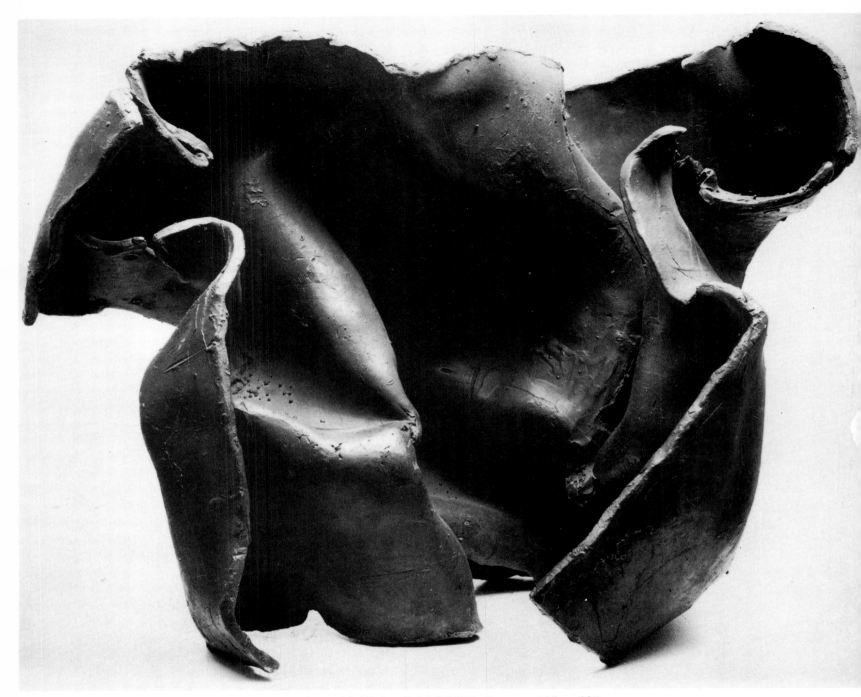

Fig. 84 David Slivka. LAOCOÖN. Bronze. 18″ x 23″.
*Photography by Rudolph Burckhardt. Courtesy Helen
Gee Gallery, New York*

Frequently, when a sculptor chooses a medium, it
can be for such practical reasons as economics, or just
the need of a change to freshen the spirit, or because
something can be better said in a specific medium.
Usually all of the reasons get mixed. My reasons for
choosing wax were many, but most of all I liked the
idea of getting to bronze casting in the most direct
manner. David Slivka, "Lost Wax Regained," *Art
News* (March 1962), p. 40.

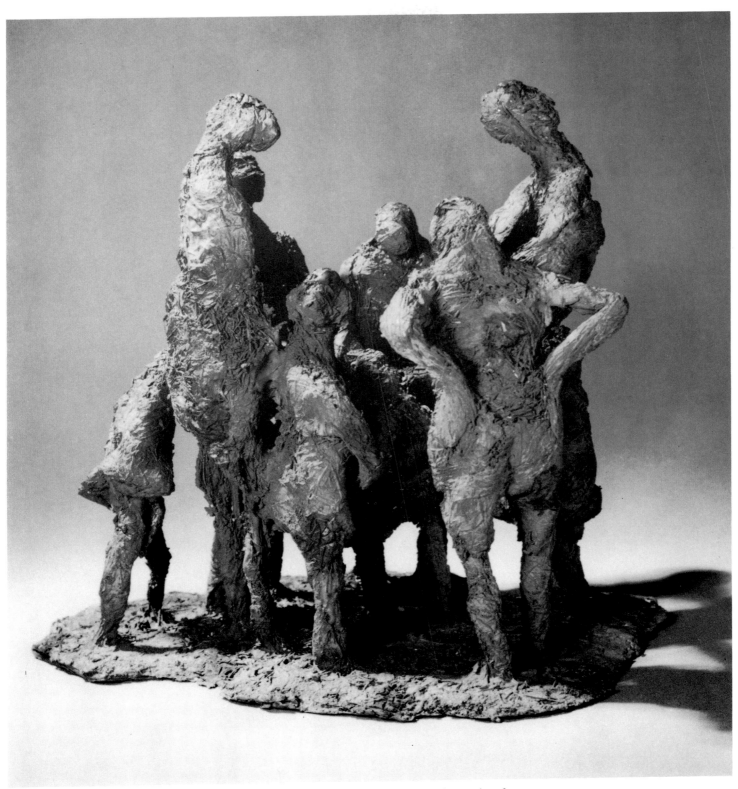

Fig. 85 Al Vrana. FAMILY. Bronze casting using hemp, excelsior, and wax burnout. 14″. *Courtesy of the artist*

Fig. 86 Takis. MAGNETIC FALLOUT (DETAIL).
1969. Toronto. Magnets, iron filings, wooden base and
board. Total 96″ x 96″. *Photography by Peter Ogilvie.
Courtesy of the artist*

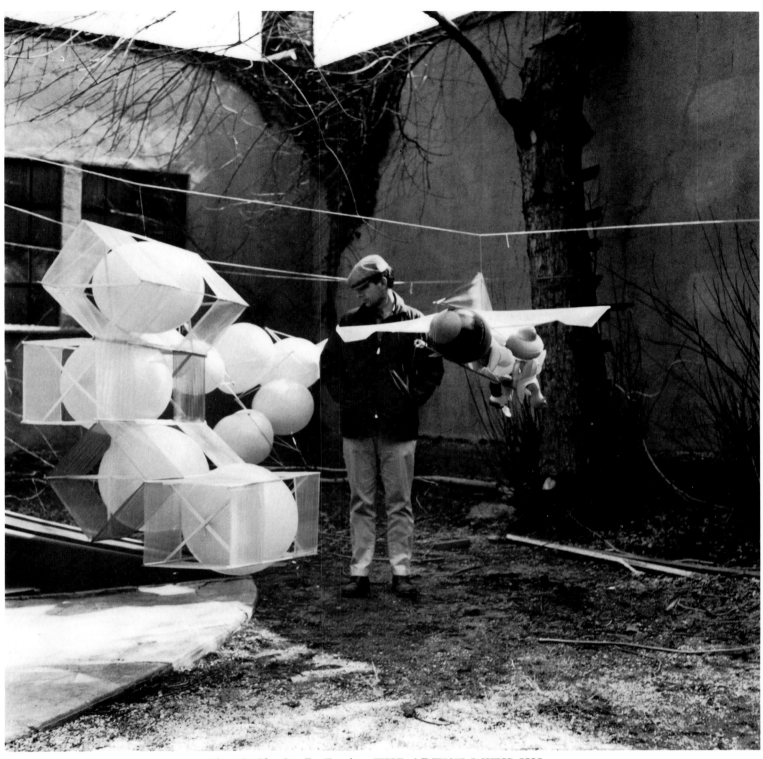

Fig. 87 Charles R. Frazier. THE ARTIST WITH HIS
FIRST EXPERIMENTS: MODELS OF FLYING
SCULPTURE. Seacliff, Long Island. Winter 1965–66.
Photography by Nina Frazier. Courtesy of the artist

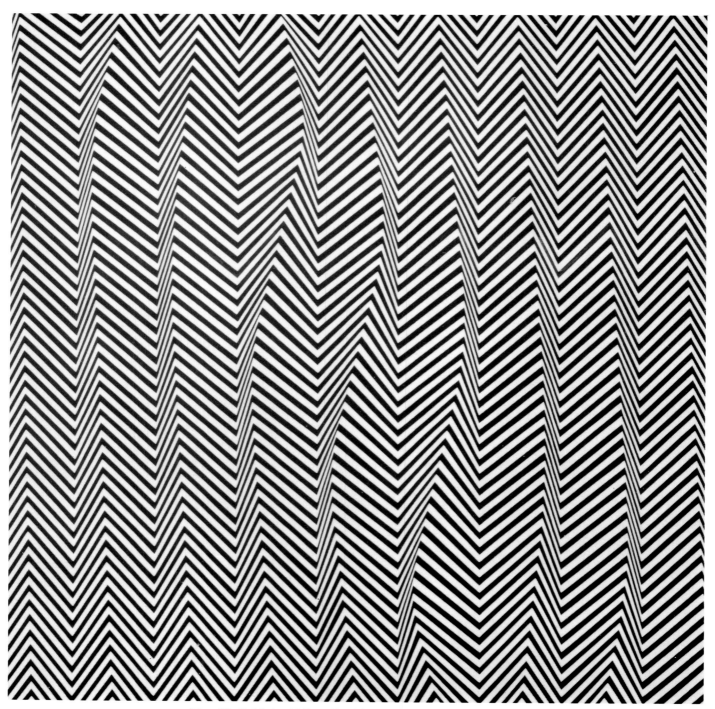

Fig. 88 Bridgitt Riley. DESCENDING. 1965–66. Emul-
sion on board. 36″ x 36″. *Courtesy Rowan Gallery, Lon-
don*

Examples of Op or Optical Art, Figs. 88–91, bear kinship
with Kinetic Works; however, Op Works simulate move-
ment in the eye of the viewer and *appear* to move while
not actually doing so.

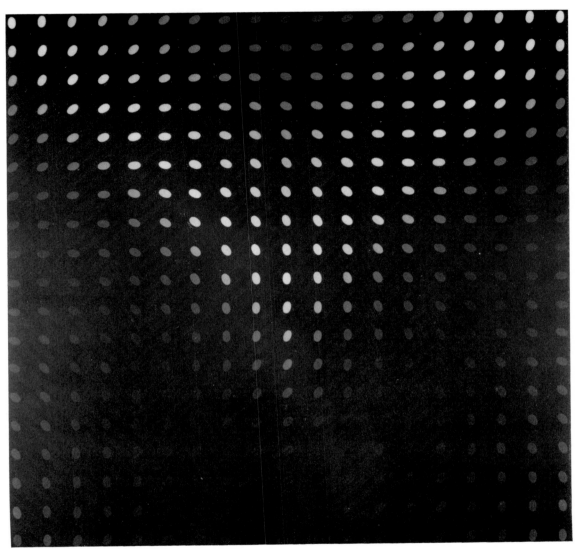

Fig. 89 Bridgitt Riley. DENY II. PVA on canvas. 85½″ x 85½″. *Photography by John Webb FRPS. Courtesy Rowan Gallery, London*

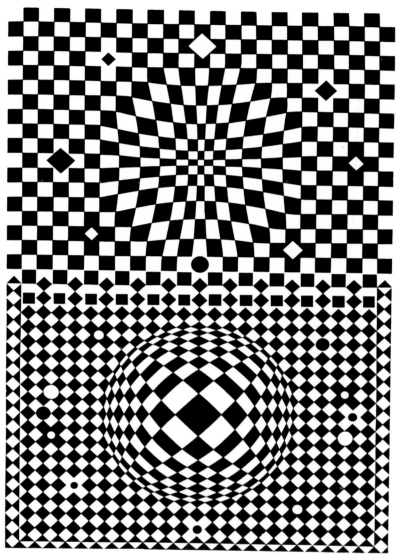

Fig. 90 Victor Vasarely. GERMINORUM 1956–59. Oil painting. 76¾" x 51". *Courtesy of the artist*

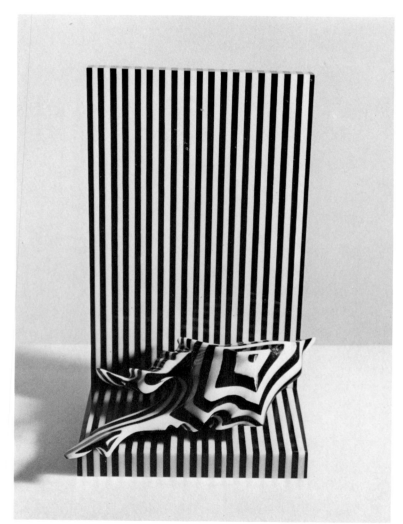

Fig. 91 Eugene Massin. BLACK AND WHITE. 1969. Carved and laminated acrylic sheet. 15" x 6" x 6". Collection of Mr. and Mrs. Tom McCarthy. *Photography by Ray Fischer. Courtesy of the artist*

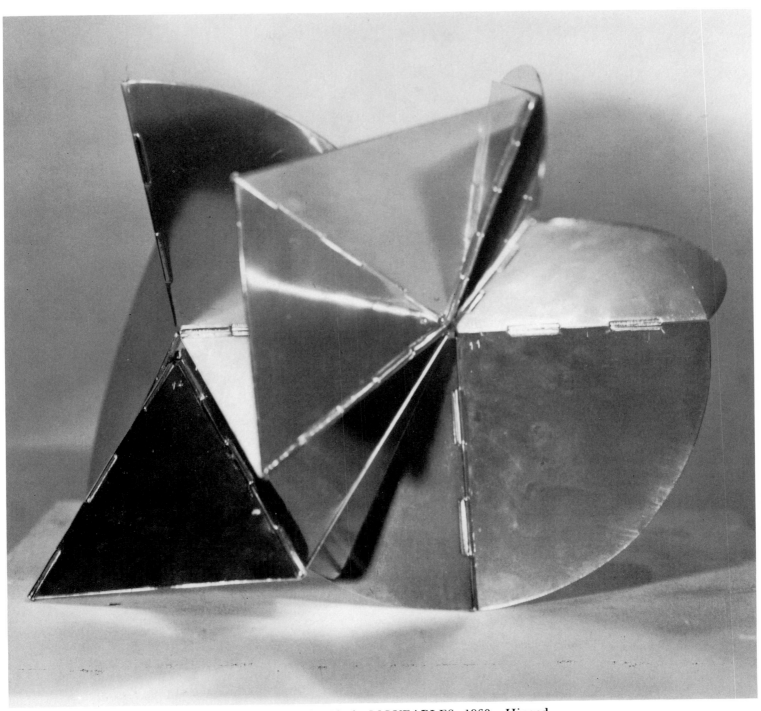

Figs. 92, 93 Ligia Clark. MOVEABLES. 1960s. Hinged
aluminum. *Courtesy Galeria Bonino, Ltd., New York*

A relative to the kinetic stream is witnessed in Ligia
Clark's MOVEABLES, which requires the viewer to
move the work from one static position to the other.

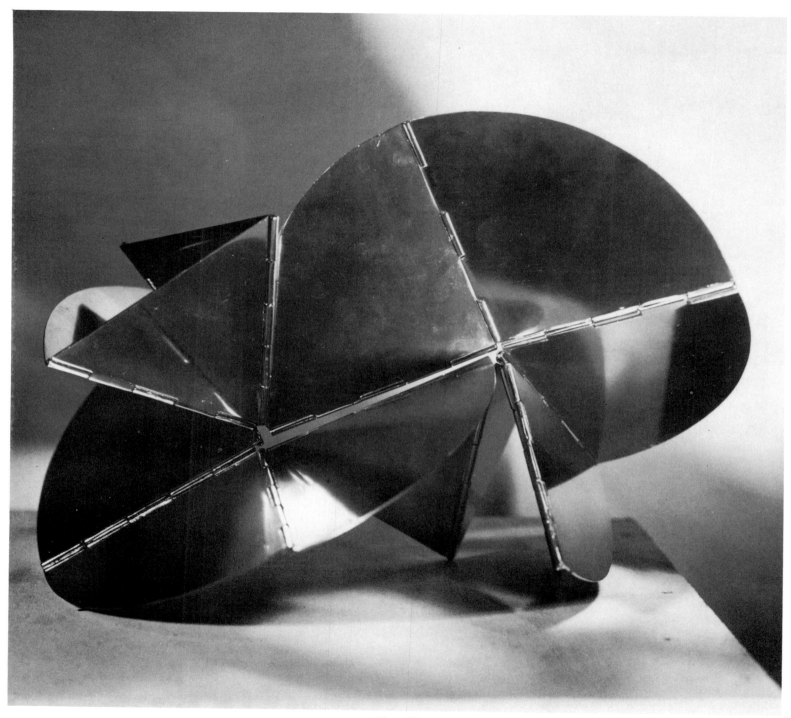

Fig. 93

Fig. 94 Charles R. Frazier. THE UNDERGROUND
TUBE CO. Begun fall 1966. 5 pieces of inner tubes and
vacuum cleaner motors, that, using air, bounced, juggled,
inflated, deflated, made music, and danced. (This is
their original state.) *Photography by Charles R. Frazier.
Courtesy of the artist*

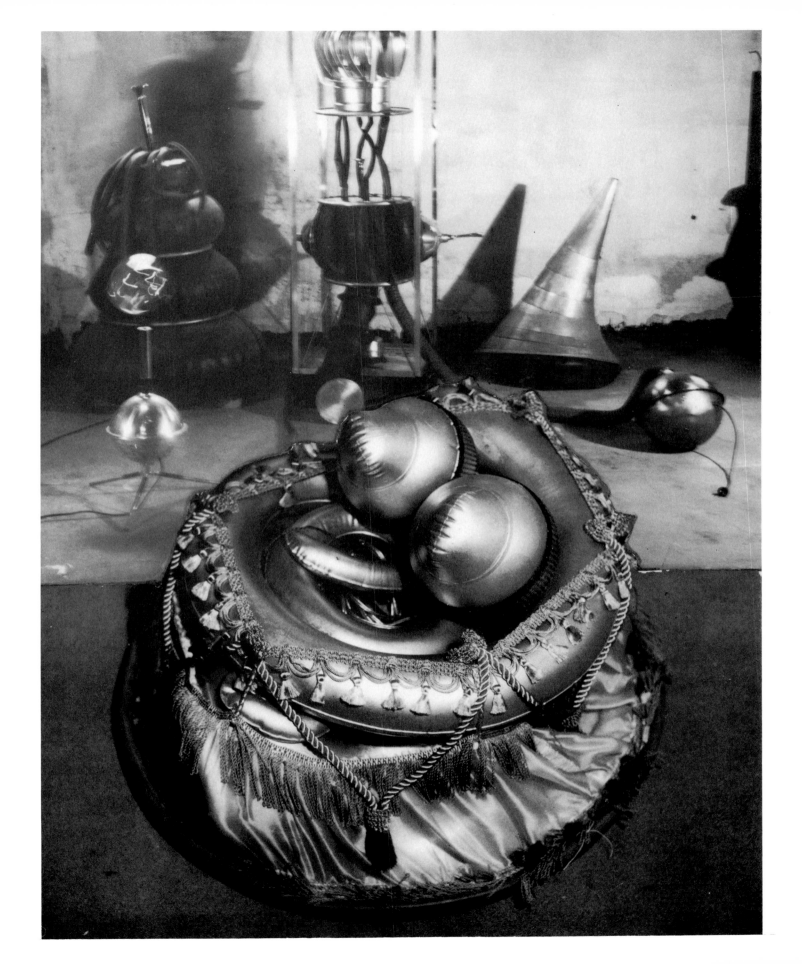

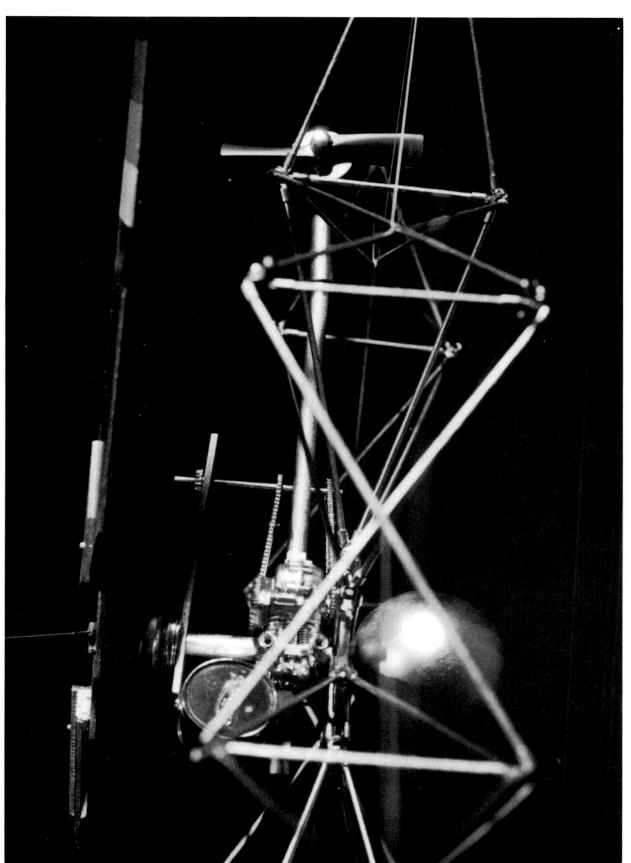

Fig. 95 Charles R. Frazier. PACIFIC ELECTRIC. Begun 1967. Close-up of model for THE PACIFIC ELECTRIC, a 28 h.p., 22′ diameter flying light system. Following the configuration of a helicopter but designed only to move a system of lights through a predetermined flight plan and program. *Photography by Charles R. Frazier. Courtesy of the artist*

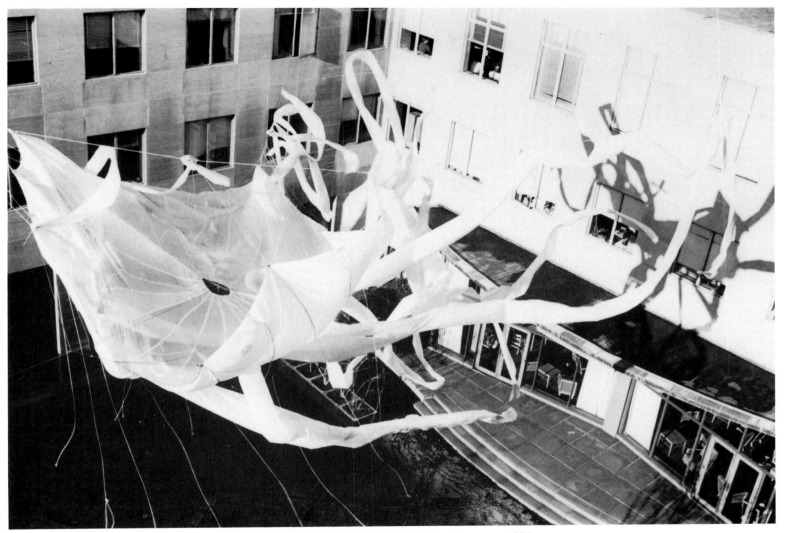

Fig. 96 Charles R. Frazier. ISADORA. January 1970.
Single 24'-in-diameter parachute with strings plus 12/40'
wind socks. Rigging in courtyard of Hayden Art Gallery,
M.I.T., "Exploration" Show. "Piece was snow white at
rigging time. Became dark grey from pollution of Boston
and Cambridge in two days. Was buffeted by 90 mph
winds." Charles R. Frazier. *Photography by Charles R.
Frazier. Courtesy of the artist*

I have emphasized the communications aspect of the
development of machines to clarify the change from
simple visual observation to the move beyond human
sensory involvement in gathering information, and
to suggest that art could be involved with more than
aesthetic information. Charles R. Frazier, *The Paper
Museum,* 1969.

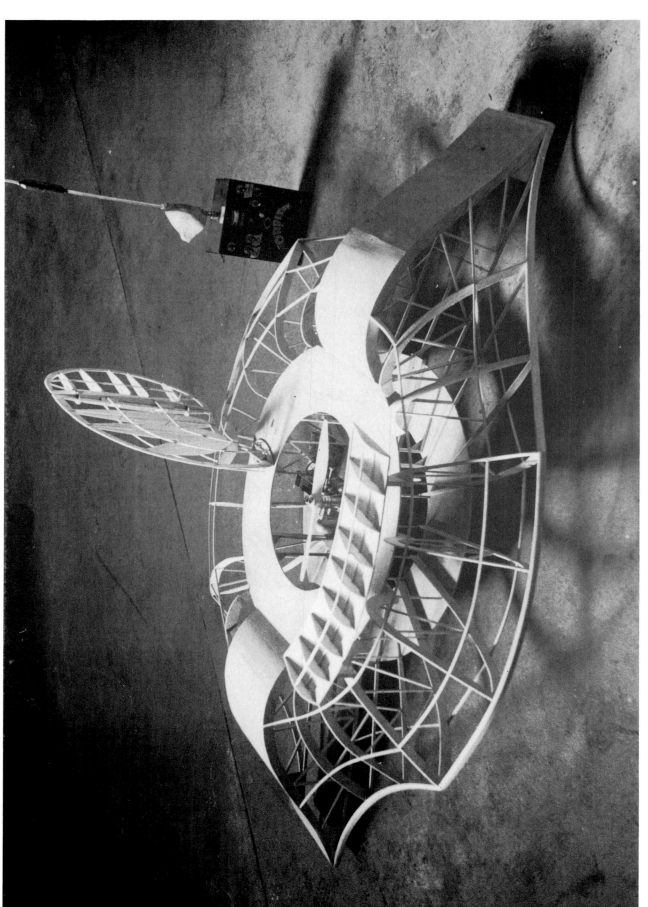

Fig. 97 Charles R. Frazier. 5' diameter ducted fan sculpture. Wood, silk. Powered by 1hp engine. 4-channel radio control. *Photography by Charles R. Frazier. Courtesy of the artist*

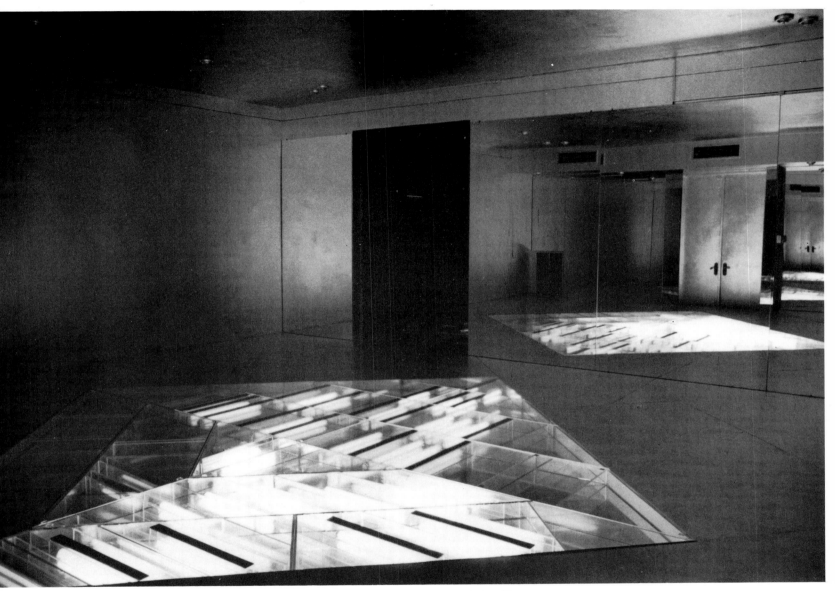

Fig. 98 Lila Katzen. LIGHT FLOOR. Transparent plastic, dull mirror, geometric arrangement of tubes of yellow, purple, and ultraviolet light. *Courtesy max hutchinson gallery, New York*

Lila Katzen's LIGHT FLOOR causes the sensation of weightlessness for the viewer. As he walks across the floor in his stocking feet, the feeling is that of transparency and giddiness because the floor seems to fall away.

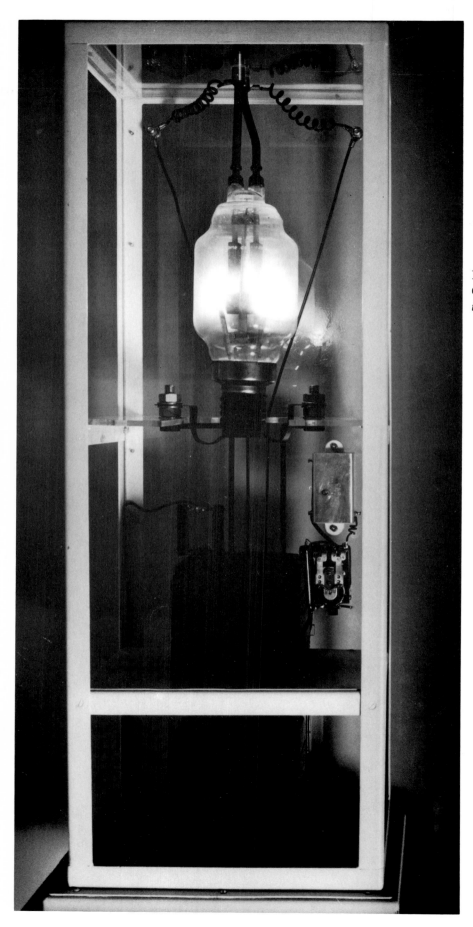

Fig. 99 Takis. TÉLÉLUMIÈRE. 1963–67. Collection C.N.A.C., Paris. *Photography by Michel Nahmias. Courtesy of the artist*

Figs. 100, 101, 102 Fletcher Benton. 1984 WITH ZONK. 1968. (Three views: Fig. 100, closed position; Fig. 101, back view; Fig. 102, open position) Kinetic work. 22″ x 26½″. *Photography by Rudy Bender-Eye Now. Courtesy Galeria Bonino, Ltd., New York*

My work at this time is involved primarily with controlled motion and in most cases transformation of one simple shape to another. I am working with purity of form and its relationship to motion. Fletcher Benton, from Peter Selz, *Directions in Kinetic Sculpture* (Berkeley, California: University of California, 1966), p. 19.

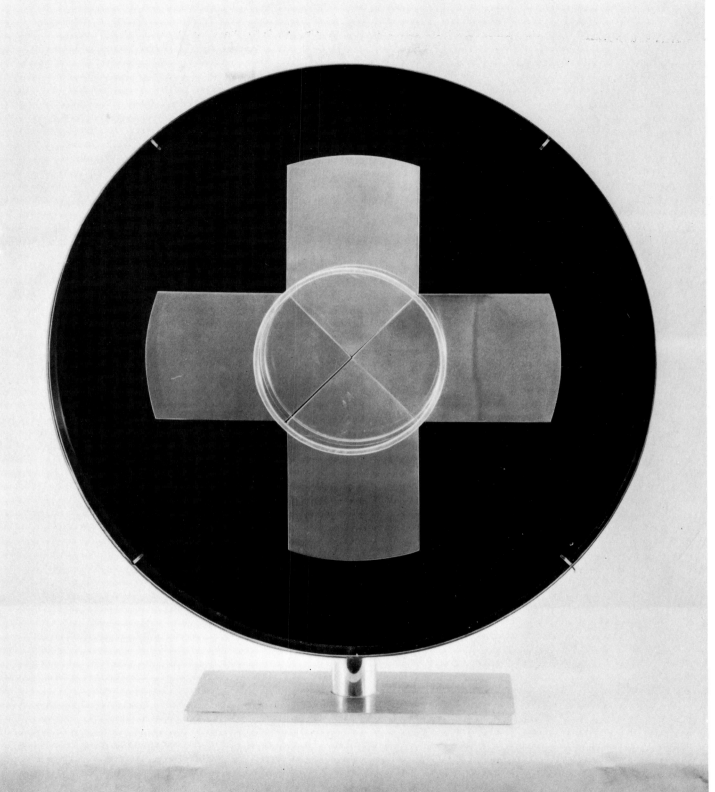

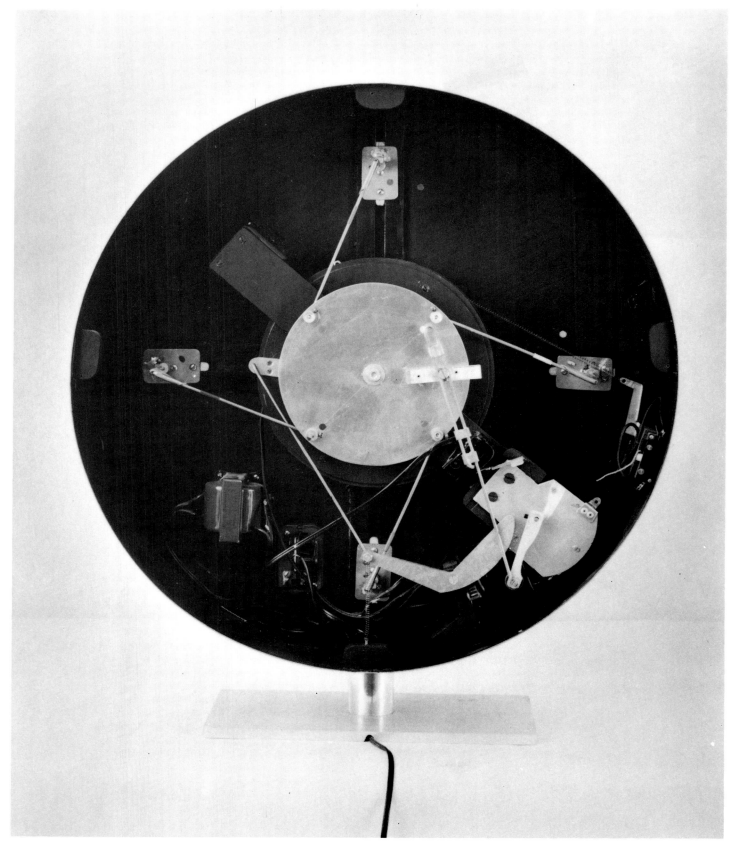

Fig. 101

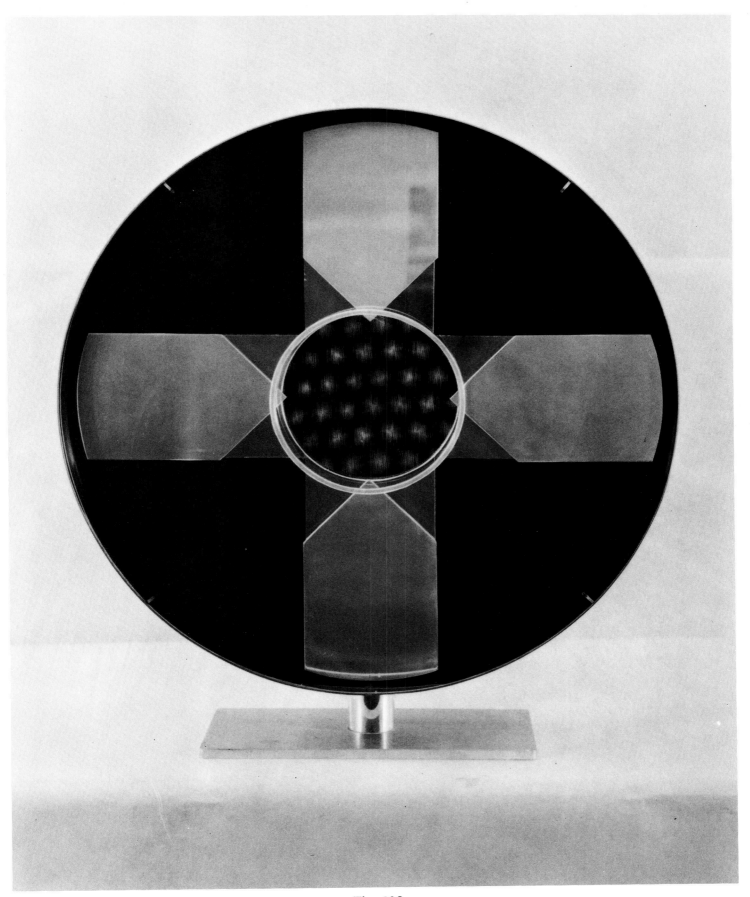

Fig. 102

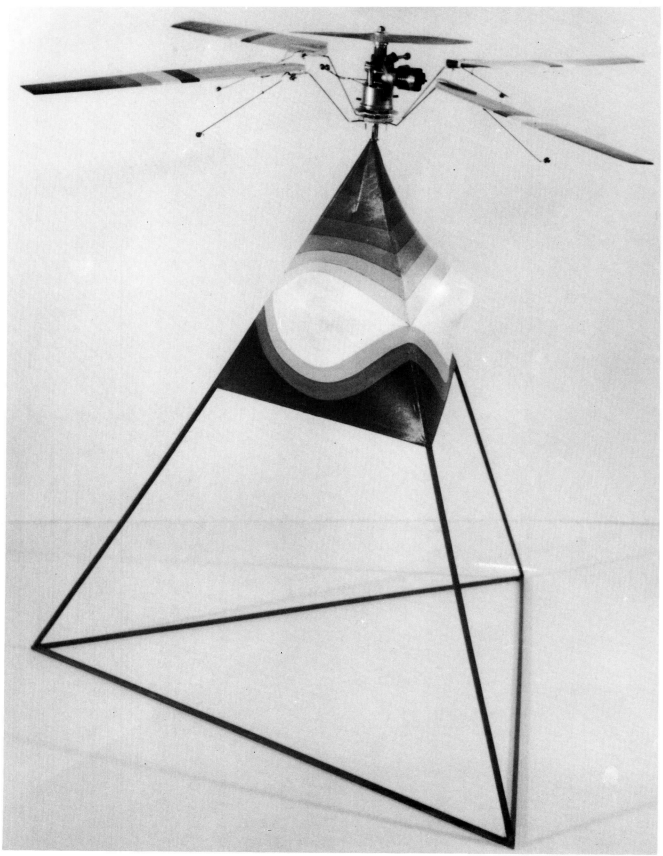

Fig. 103 Charles R. Frazier. HELI-SCULPTURE.
EARLY RADIO CONTROLLED FLYING SCULP-
TURE. 1966. Balsa wood, sild, airplane motor, helicopter
blades. *Courtesy of the artist*

This is a 3-foot working model for a 6-foot sculpture
that will be radio controlled.

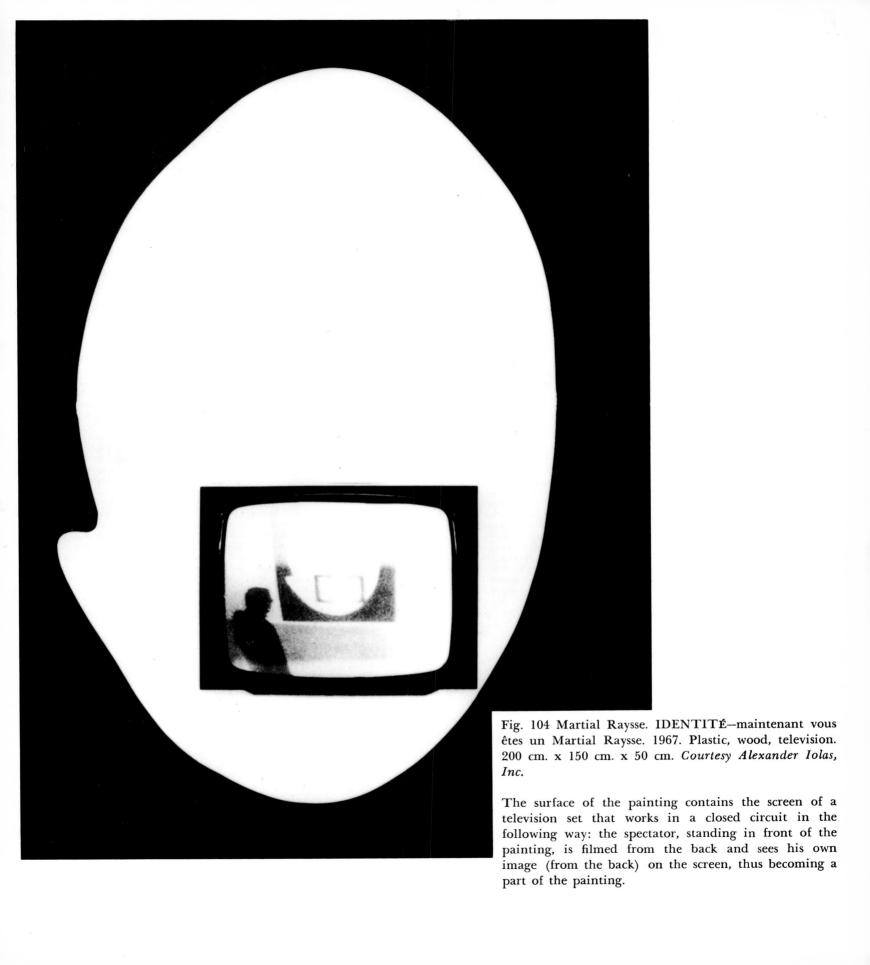

Fig. 104 Martial Raysse. IDENTITÉ—maintenant vous êtes un Martial Raysse. 1967. Plastic, wood, television. 200 cm. x 150 cm. x 50 cm. *Courtesy Alexander Iolas, Inc.*

The surface of the painting contains the screen of a television set that works in a closed circuit in the following way: the spectator, standing in front of the painting, is filmed from the back and sees his own image (from the back) on the screen, thus becoming a part of the painting.

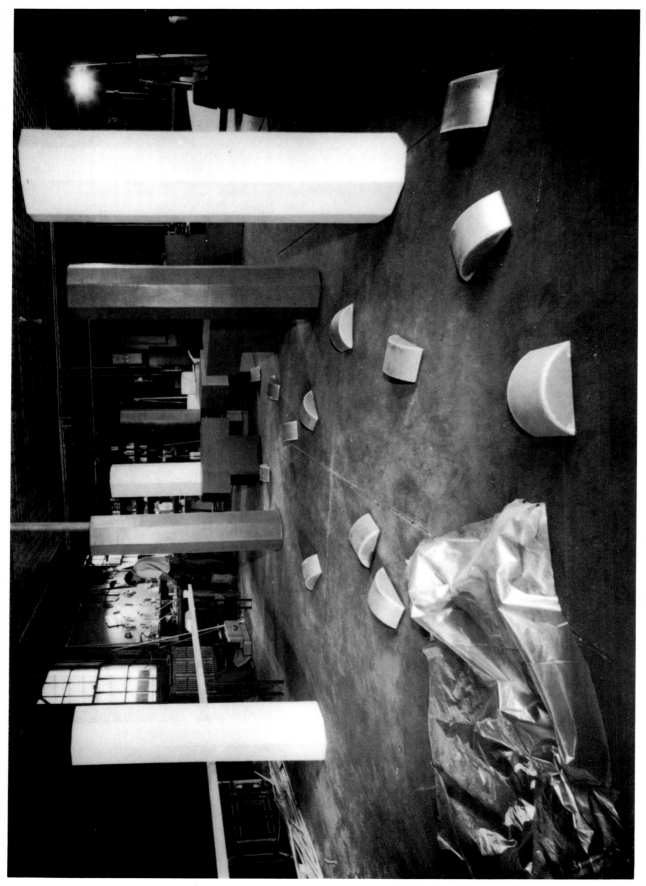

Fig. 105 Robert Breer. View of the Studio, with columns that are motorized and move at random across the floor. *Photography by Peter Moore. Courtesy Galeria Bonino, Ltd., New York*

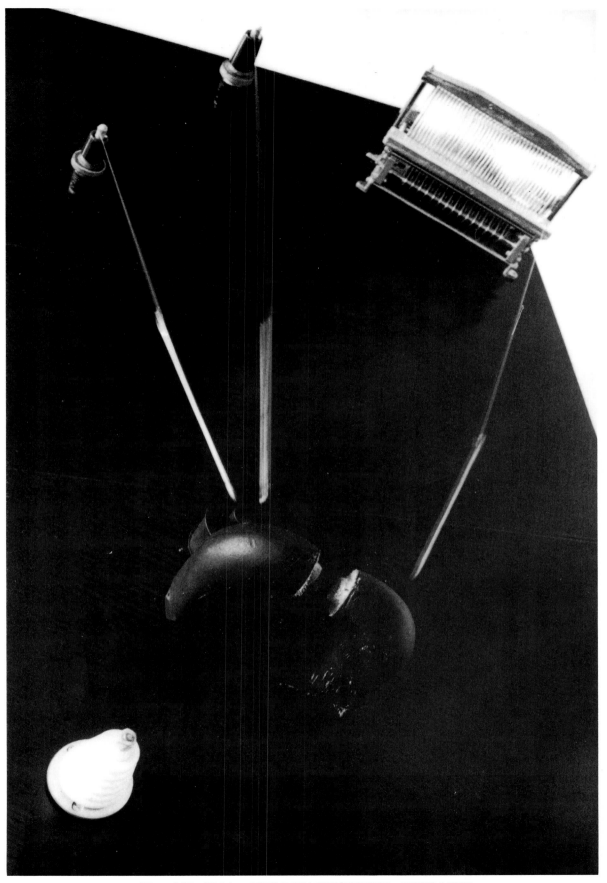

Fig. 106 Takis. **TELE-MAGNÉTIQUE VIBRATIF.**
1962. Paris. 120 cm. x 80 cm. *Photography by Holger*
Schmitt. Courtesy of the artist

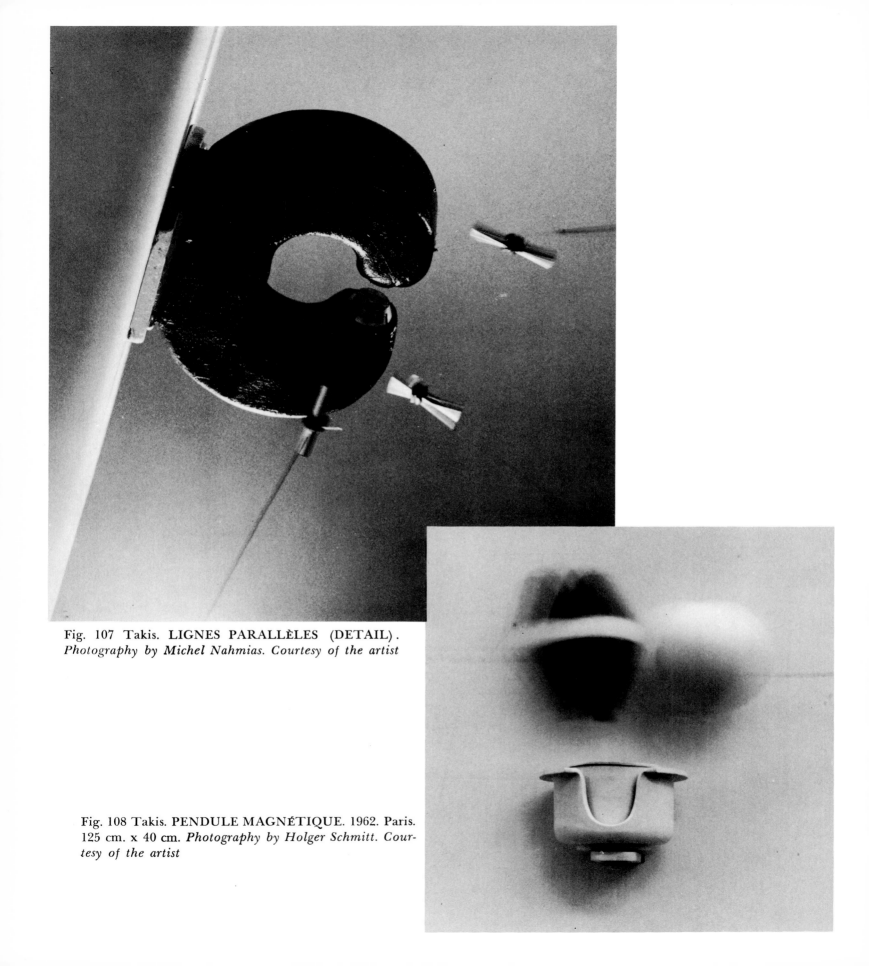

Fig. 107 Takis. LIGNES PARALLÈLES (DETAIL).
*Photography by **Michel Nahmias**. Courtesy of the artist*

Fig. 108 Takis. PENDULE MAGNÉTIQUE. 1962. Paris.
125 cm. x 40 cm. *Photography by **Holger Schmitt**. Courtesy of the artist*

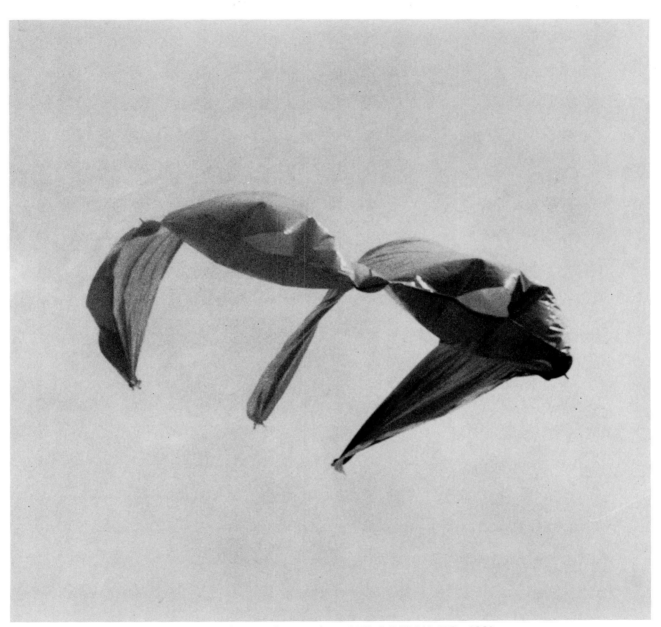

Fig. 109 Charles R. Frazier. AERO-DYNAMIC. 1968.
Inflatable kite. *Photography by Charles R. Frazier. Courtesy of the artist*

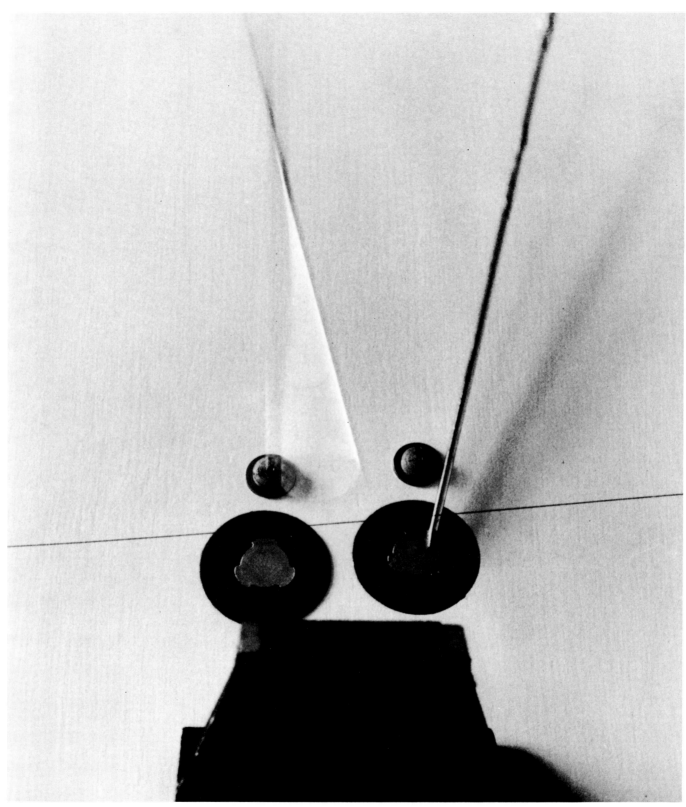

Fig. 110 Takis. MUSICAL. 1964. Paris. *Photography by Holger Schmitt. Courtesy of the artist*

Fig. 111 Takis. LIGHT SIGNAL. 1966. Athens. *Courtesy of the artist*

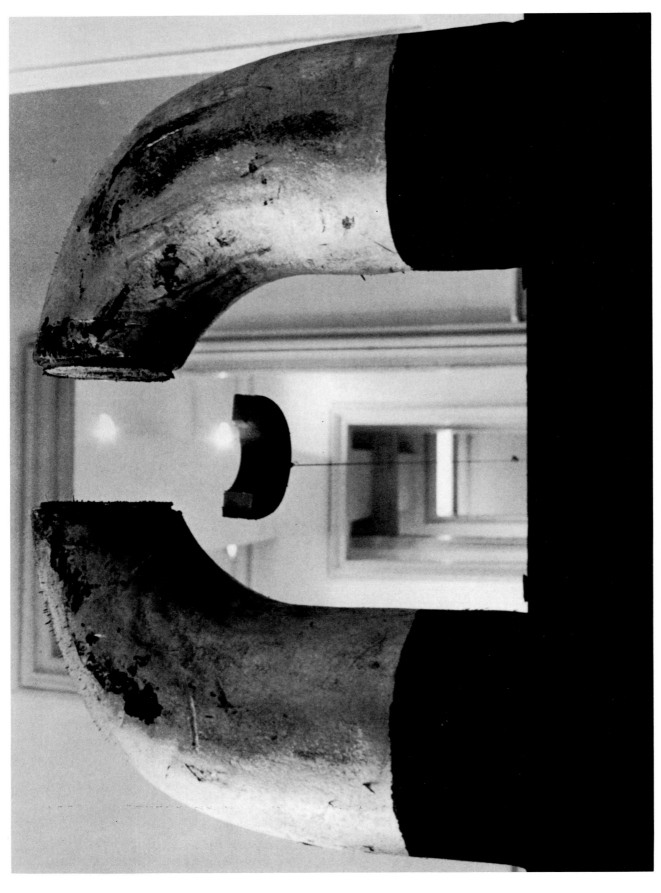

Fig. 112 Takis. 2 OSCILLATING PARALLEL LINES (DETAIL). 1970. 30 m. long. *Photography by Holger Schmitt. Courtesy of the artist*

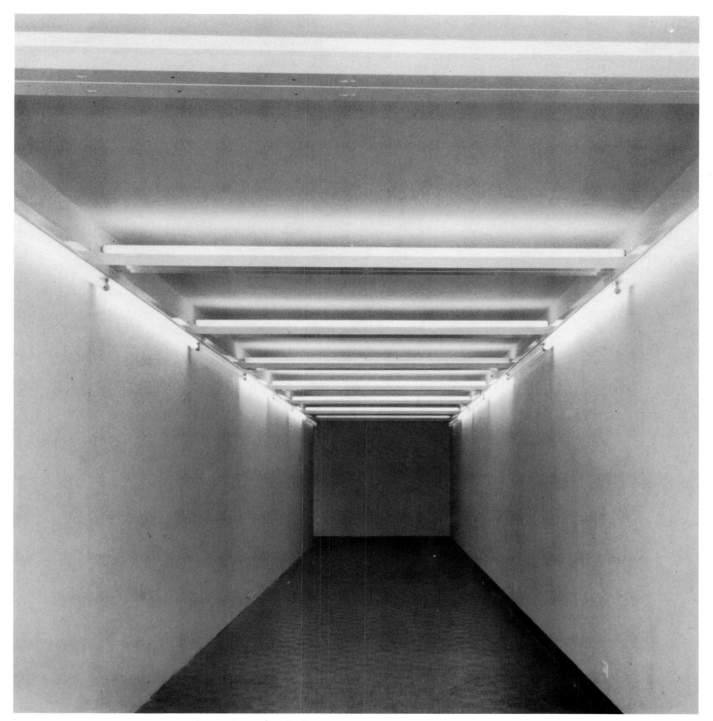

Fig. 113 Dan Flavin. UNTITLED (TO S.M.). 1969. Red, yellow, pink, and blue fluorescent light. 8′ high, 64′ long. Edition of three. *Courtesy Leo Castelli Gallery*

Regard the light and you are fascinated—inhibited from grasping its limits at each end. While the tube itself has an actual length of eight feet, its shadow, cast by the supporting pan, has none but an illusion dissolving at its ends. This waning shadow cannot really be measured without resisting its visual effect and breaking the poetry. Dan Flavin, ". . . In Daylight or Cool White," *Artforum* 4, no. 4 (December 1965) :24.

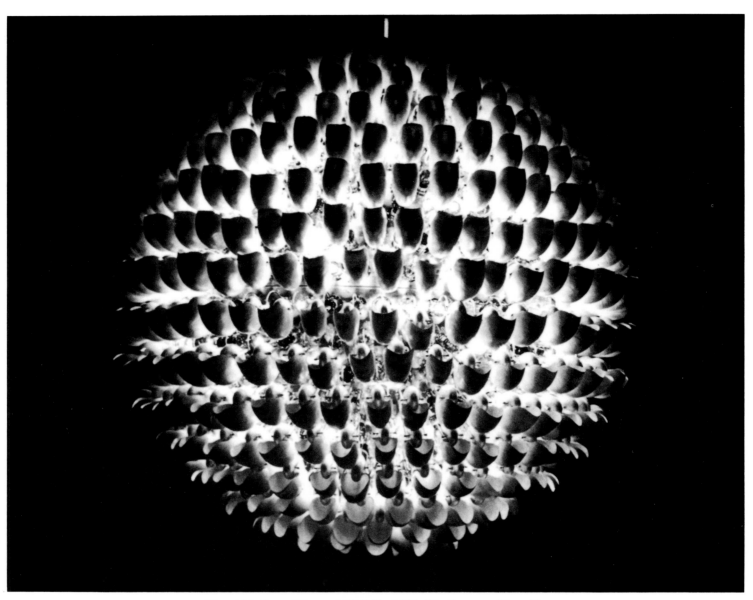

Fig. 114 Otto Piene. MOON. 1969–71. Senate. Hawaii
State Capitol. Honolulu, Hawaii. *Photography by Nor-
man Shapiro. Courtesy of the artist*

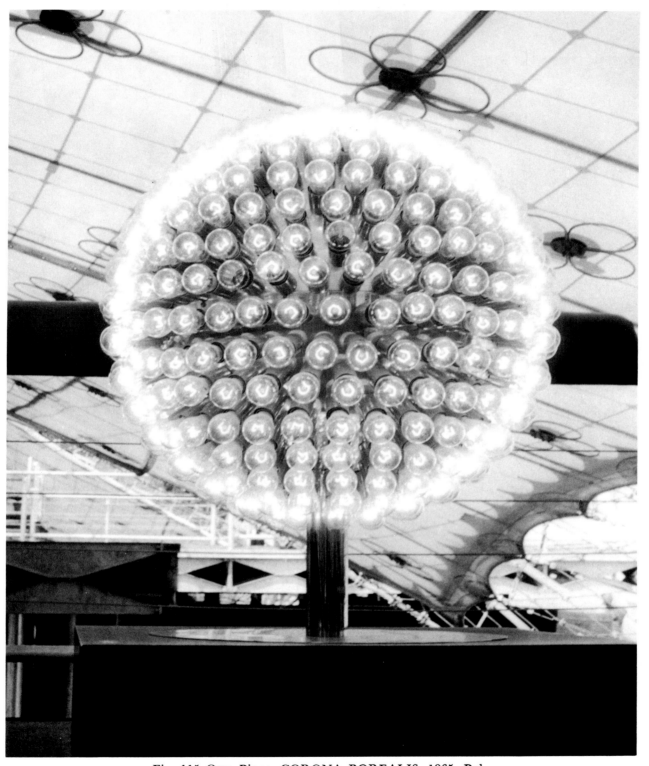

Fig. 115 Otto Piene. CORONA BOREALIS. 1965. Polished aluminum globe covered with about 400 clear 15-watt bulbs, on chromed stand: 29½″ diameter x 47¼″ total height. Horizontally organized groups of bulbs timed to go on and off from top to bottom in eight phases. Howard Wise Gallery. This installation: German Pavilion, Expo '67, Montreal. *Photography by bernd d. blomenröhr. Courtesy of the artist*

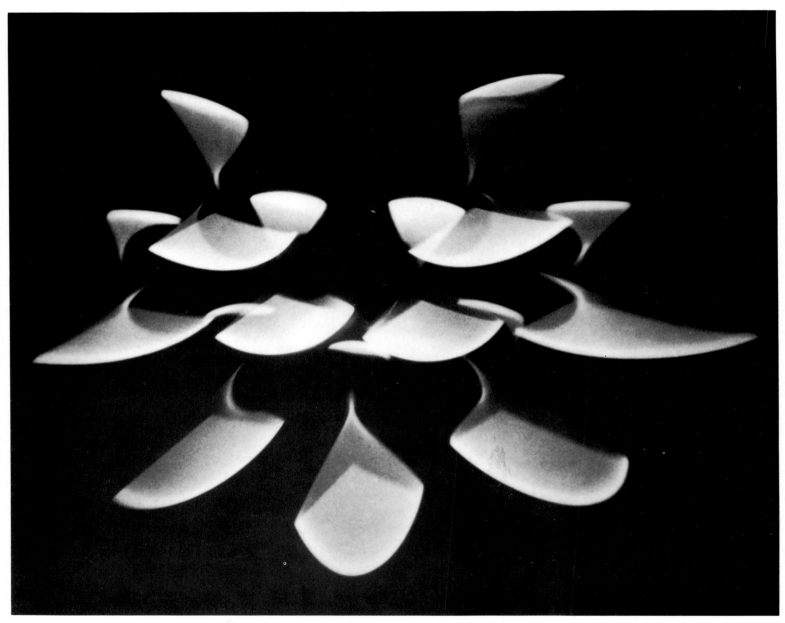

Figs. 116, 117 John Healey. BOX 3. 1967. 24" x 28".
Courtesy Waddell Gallery, New York

John Healey's luminous pictures utilize intricate boxed-
in mechanisms of light and lenses, patterns, discs, and
color wheels that project a series of forms onto a translu-
cent screen. It is moving sculpture, made entirely of
light.

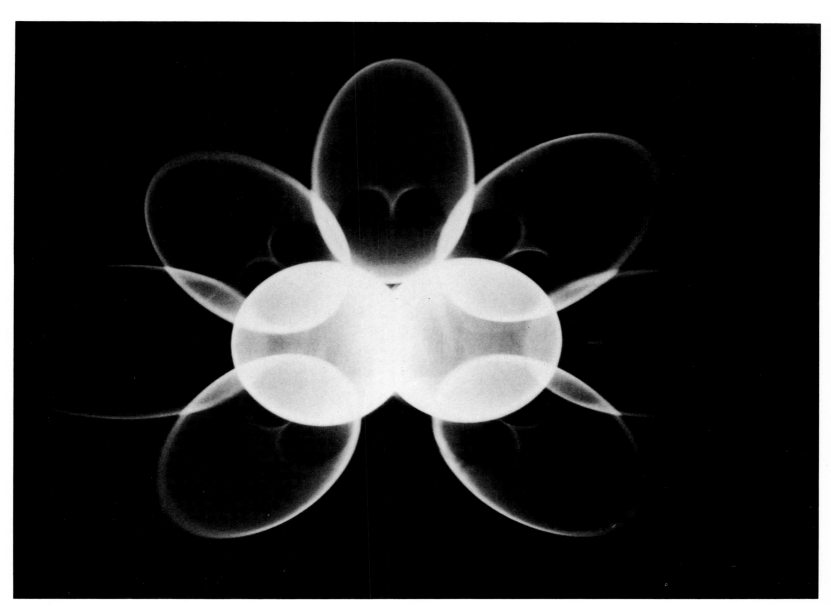

Fig. 117

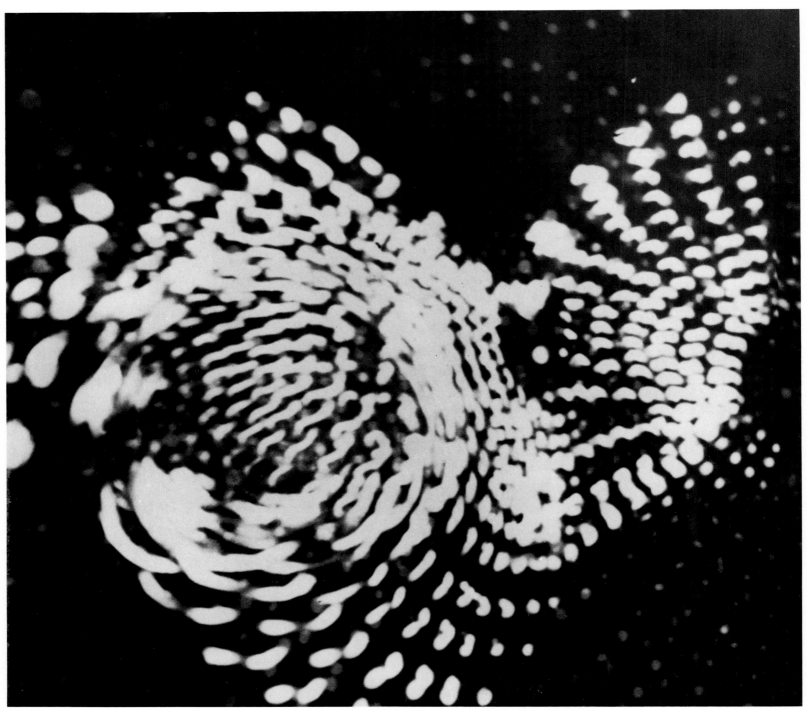

Fig. 118 Otto Piene. ARCHAIC LIGHT BALLET. 1959.
Light projections (phase). *Photography by Otto Piene.*
Courtesy of the artist

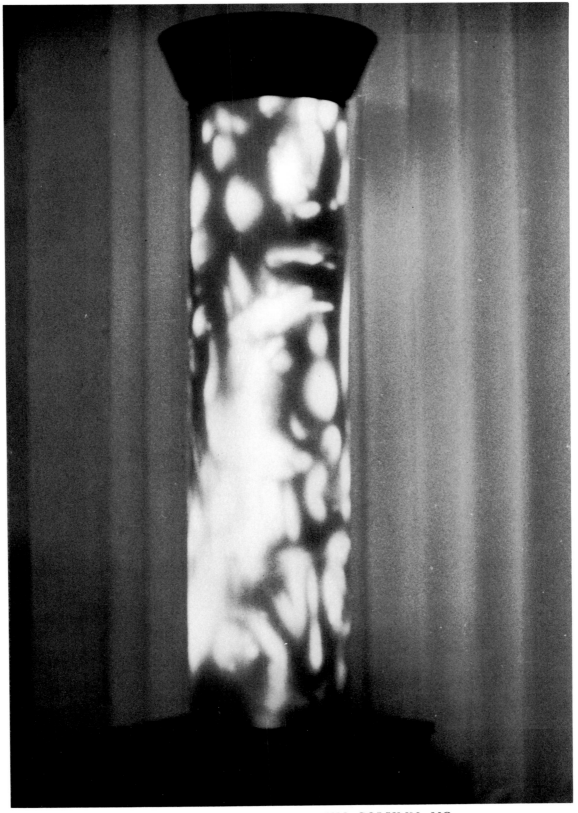

Fig. 119 Frank J. Malina. KINETIC COLUMN. NO. 925 A/1961. 41 cm. x 157 cm. Lumidyne System. *Photography by Frank J. Malina. Courtesy of the artist*

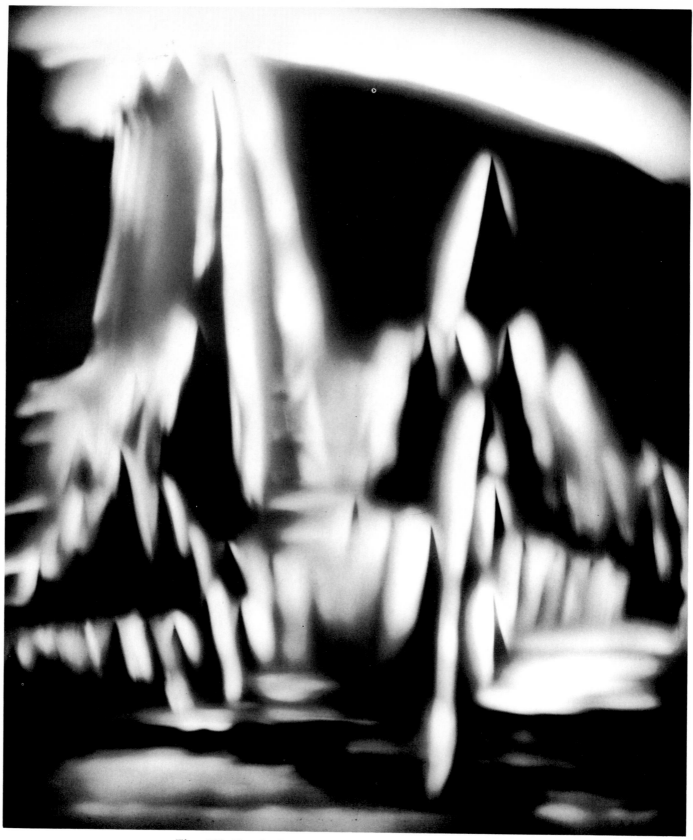

Fig. 120 Frank J. Malina. DARK MOON. 987/1966. Exter Series. 80 cm. x 60 cm. Kinetic painting—Lumidyne System. Collection of Dr. Jean Causse, France. *Photography by František Bartoň. Courtesy of the artist*

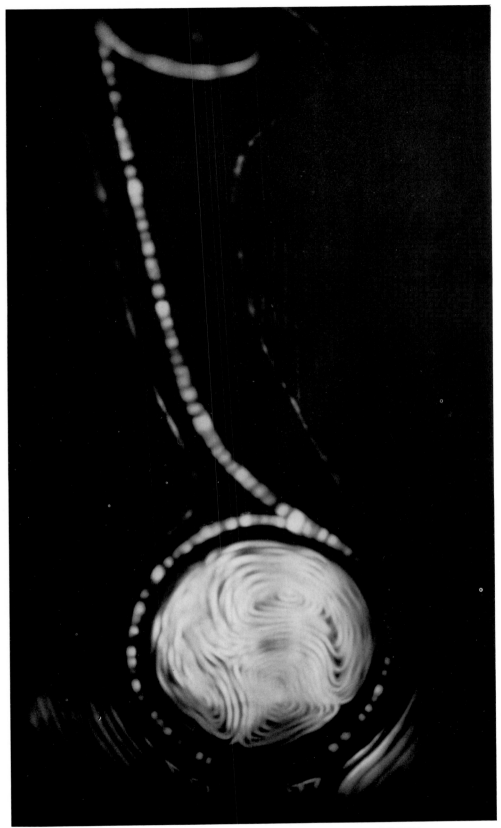

Fig. 121 Frank J. Malina. AWAY FROM THE EARTH
II. 991/1966. 100 cm. x 211 cm. Lumidyne System–5
discs. Kinetic painting. *Photography by František Bar-
toň. Courtesy of the artist*

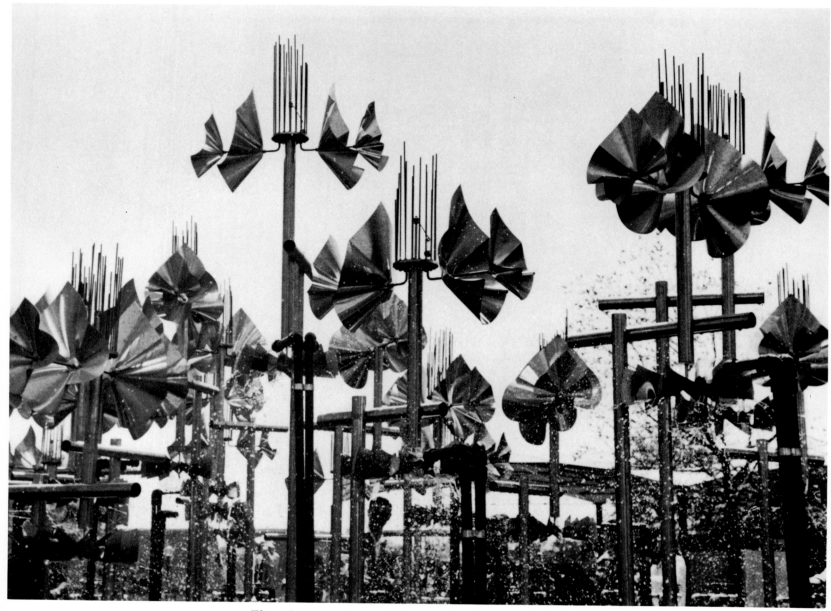

Fig. 122 François and Bernard Baschet. HEMISFAIR
FOUNTAIN. 1968. Stainless steel. Musical sculpture.
Courtesy Waddell Gallery, New York

their *atelier* looked more like a place where you shoe
a horse than create . . . sculpture. . . . The forge,
the stupendous array of files, the collection of forty-
seven ancient hammers—these were the tools of their
trade, and the solitary drill mounted on the work
table seemed a curious anachronism. R.H.W., from
catalogue of "Baschet Musical Sculptures," Waddell
Gallery, November 21–December 16, 1968.

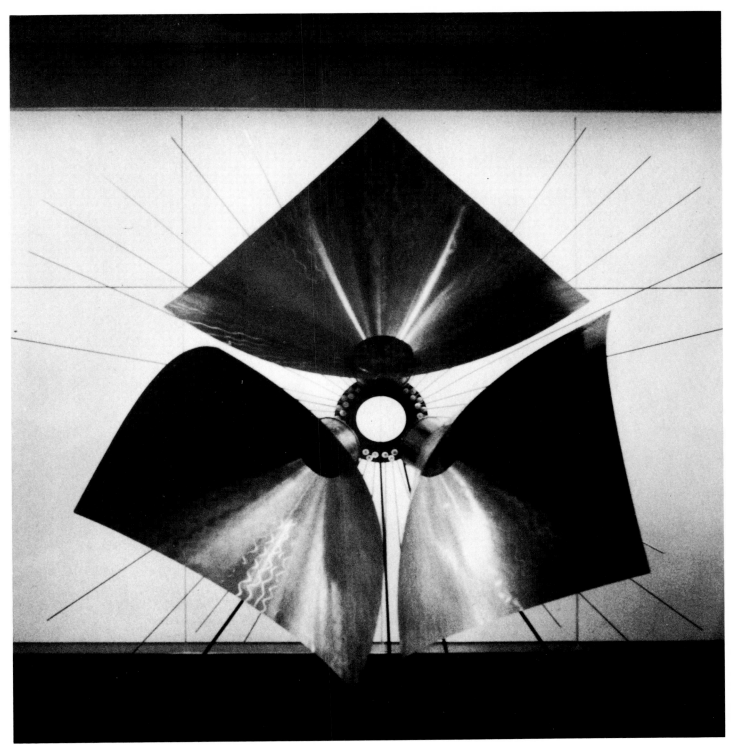

Fig. 123 François and Bernard Baschet. AMIENS MON-
UMENT. 1966. 126″ high. Musical sculpture. *Courtesy
Waddell Gallery, New York*

The Baschets never make scaled diagrams, relying
rather on rough sketches, and though a mock-up may
sometimes be made, it is during the actual construc-
tion that the "designing" is accomplished. R.H.W.,
from catalogue of "Baschet Musical Sculptures," Wad-
dell Gallery, November 21–December 16, 1968.

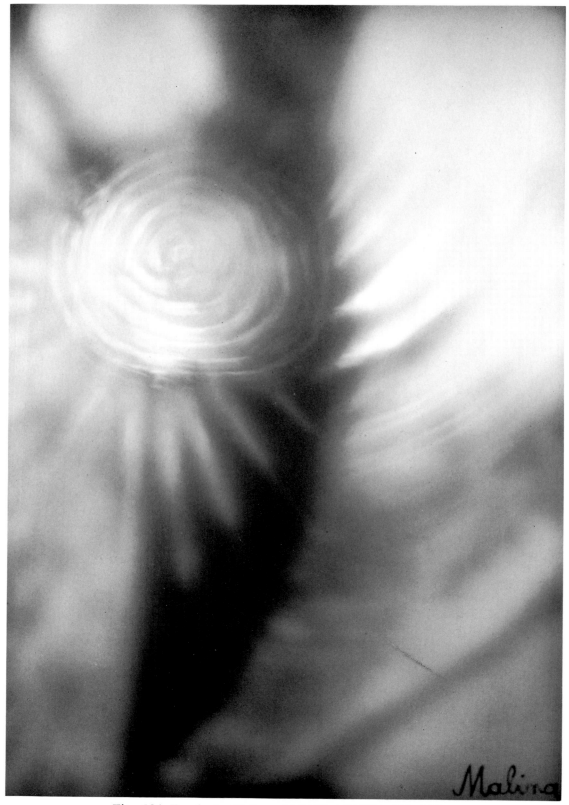

Fig. 124 Frank J. Malina. MOON WAVES III. 905/ 1961. Incandescent lights. 38 cm. x 25 cm. Lumidyne System. *Photography by František Bartoň. Courtesy of the artist*

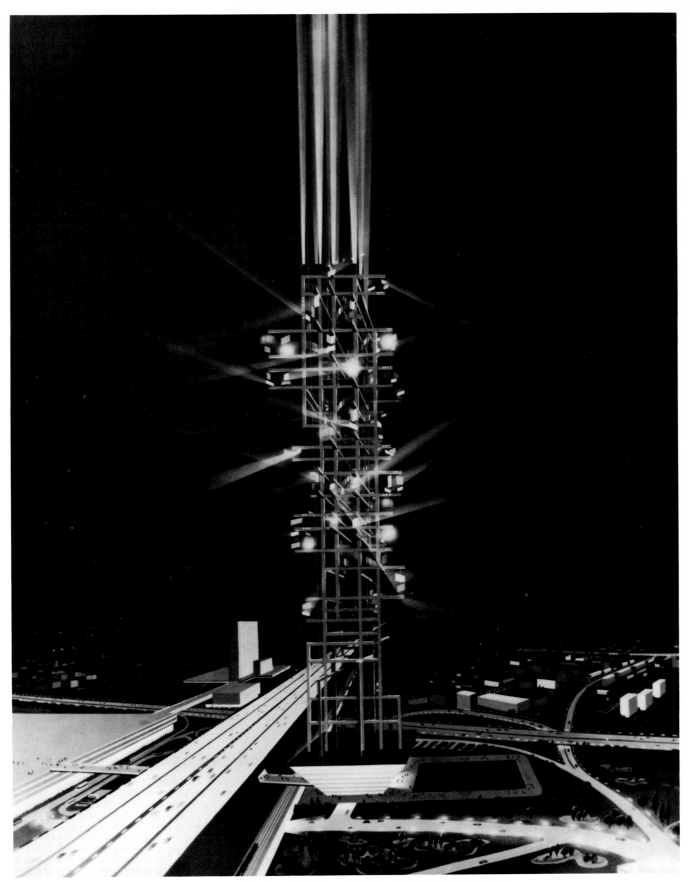

Fig. 125 Nicholas Schöffer. TOUR LUMIÈRE CYBER-
NÉTIQUE DE PARIS (MODEL). 340 meters high.
Projected for 1975. *Courtesy of the artist*

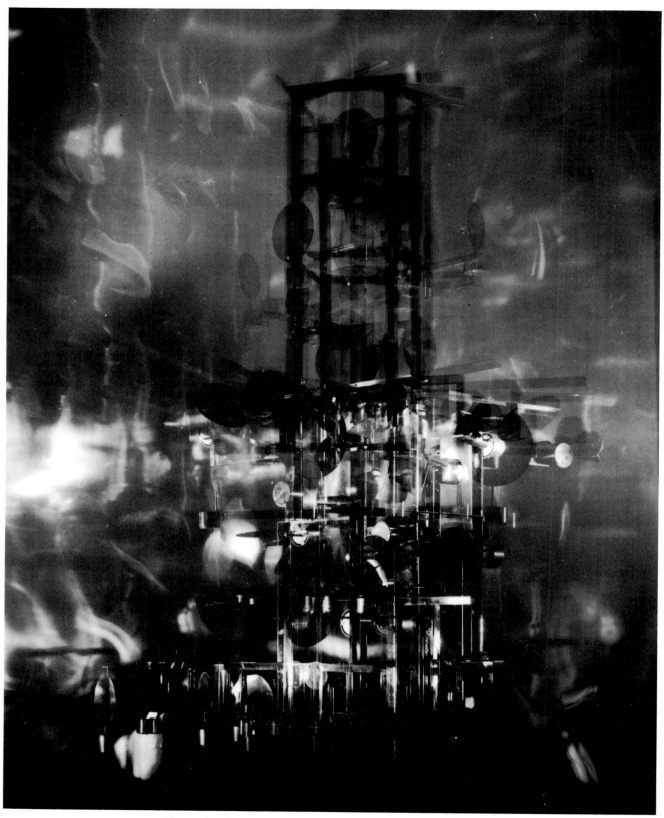

Fig. 126 Nicholas Schöffer. CHROMOS 8. 3 meters high.
Photography by Yves Hervochon. Courtesy of the artist

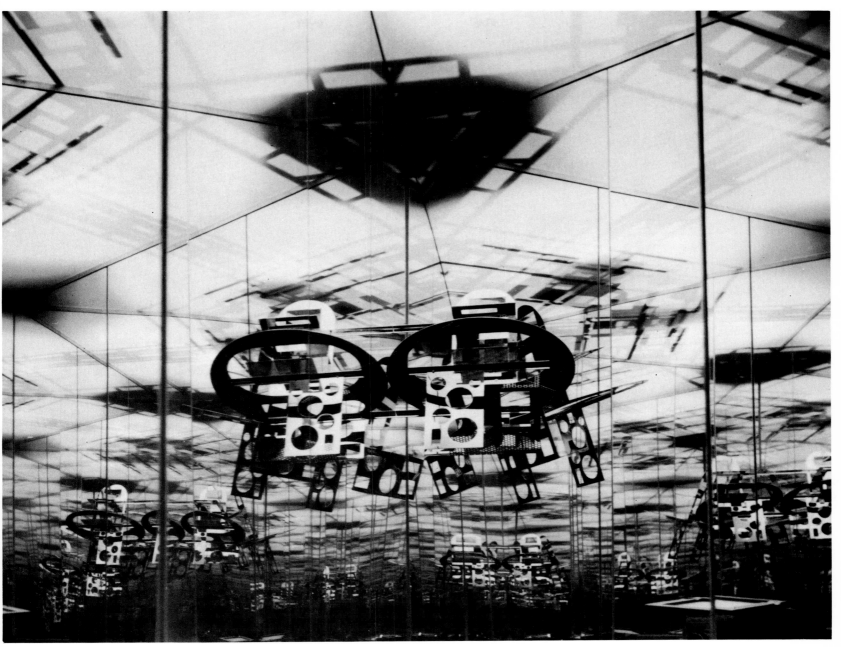

Fig. 127 Nicolas Schöffer. PRISME AVEC LUX II.
Photography by Yves Hervochon. Courtesy of the artist

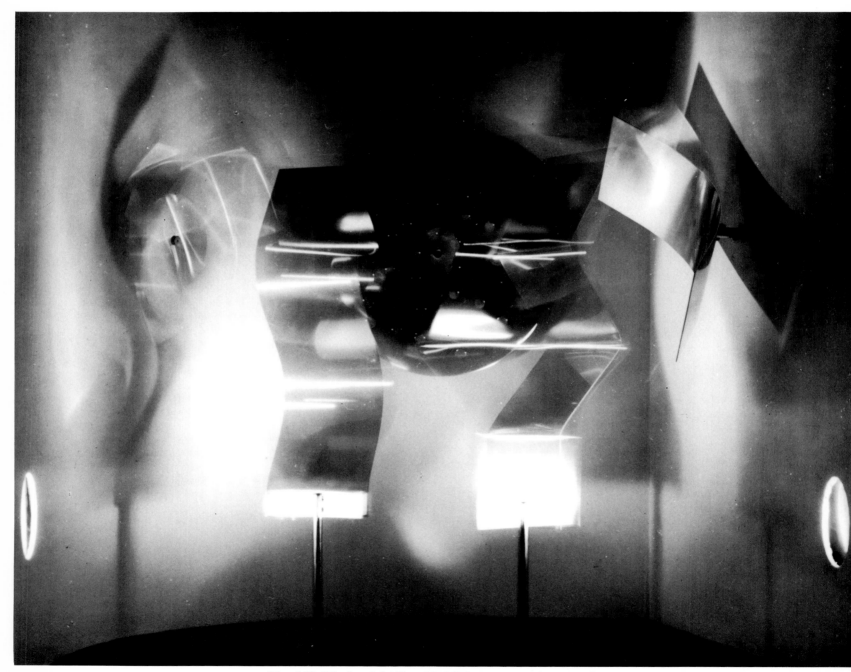

Fig. 128 Nicolas Schöffer. MICROTEMPS. *Photography by Yves Hervochon. Courtesy of the artist*

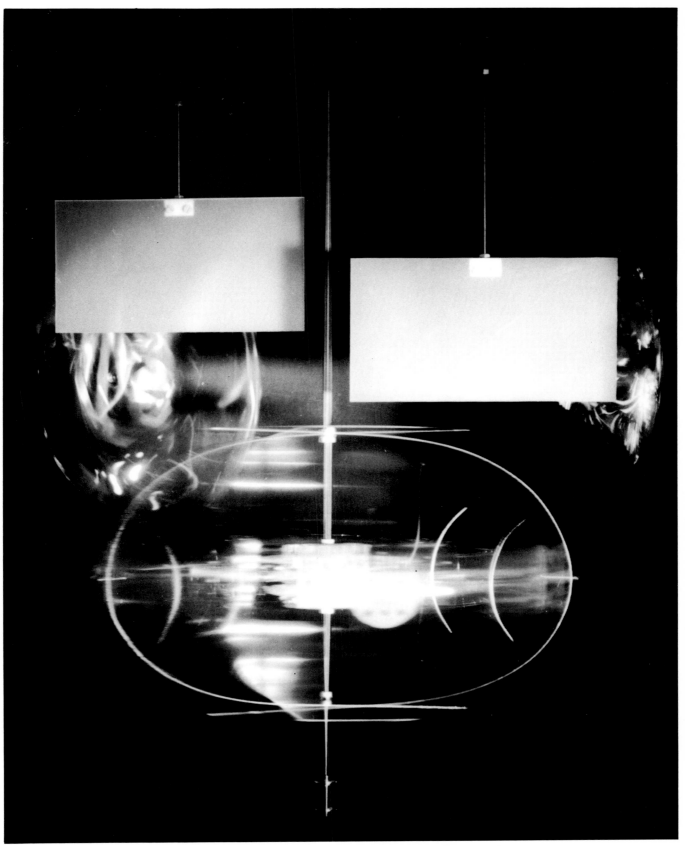

Fig. 129 Nicolas Schöffer. MICROTEMPS. *Photography by Yves Hervochon. Courtesy of the artist*

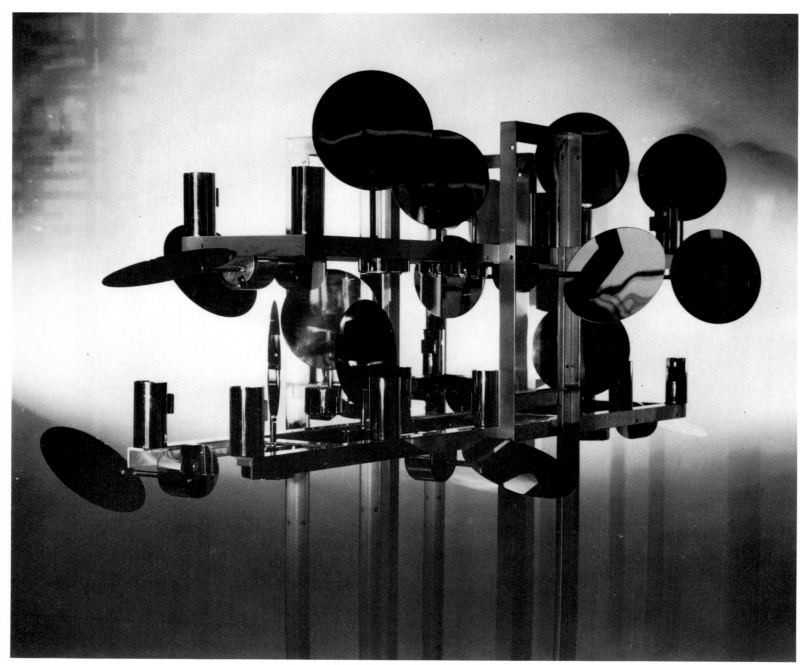

Fig. 130 Nicolas Schöffer. CHROMOS 10. 1 meter 80.
Photography by Yves Hervochon. Courtesy of the artist

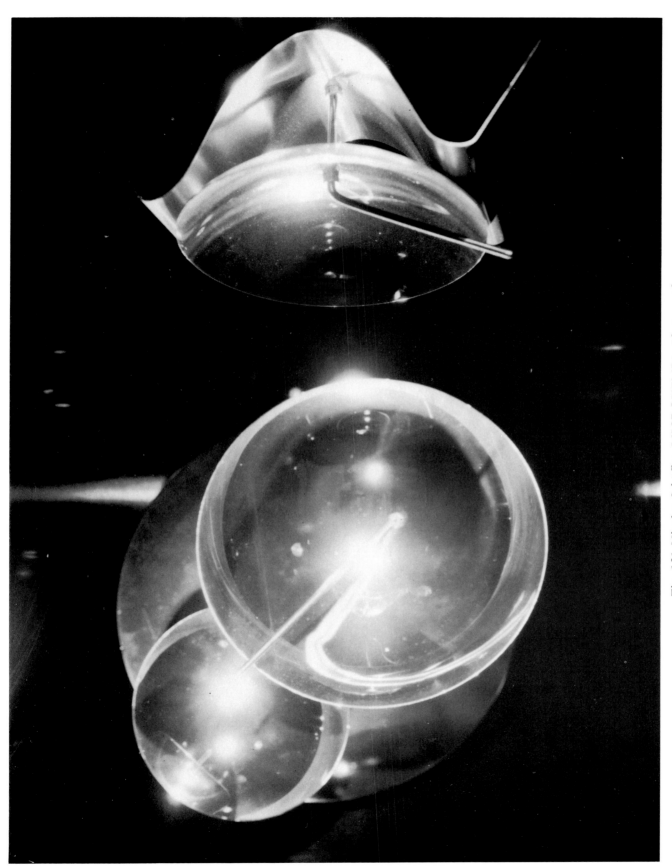

Fig. 131 Nicolas Schöffer. MICROTEMPS. *Photography by Yves Hervochon. Courtesy of the artist*

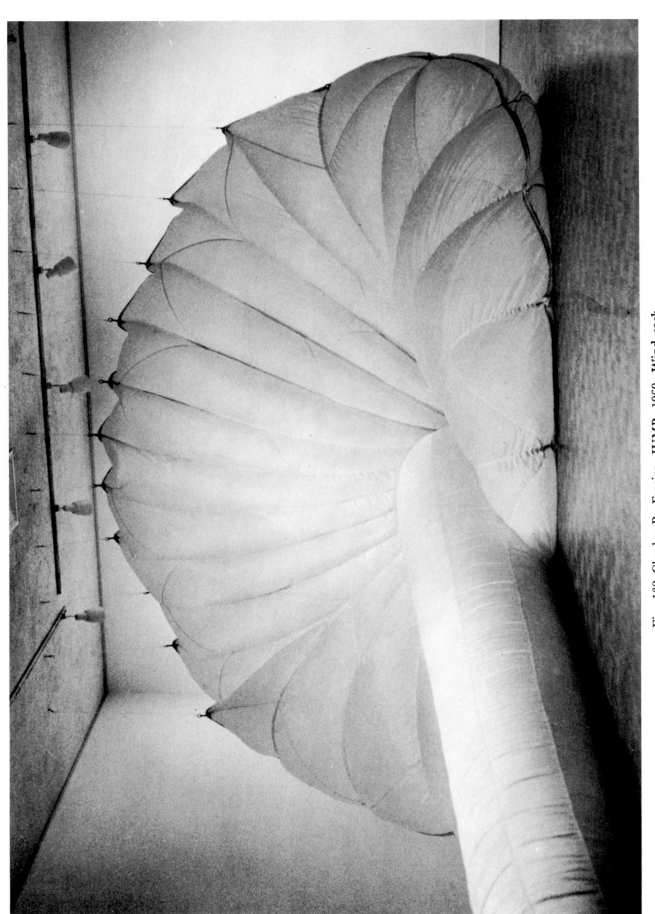

Fig. 132 Charles R. Frazier. JUMP. 1969. Wind sock, fan, double parachute; the piece inflated and deflated as the fan turned off and on. *Installation photograph at Jewish Museum. Courtesy of the artist, and The Paper Museum*

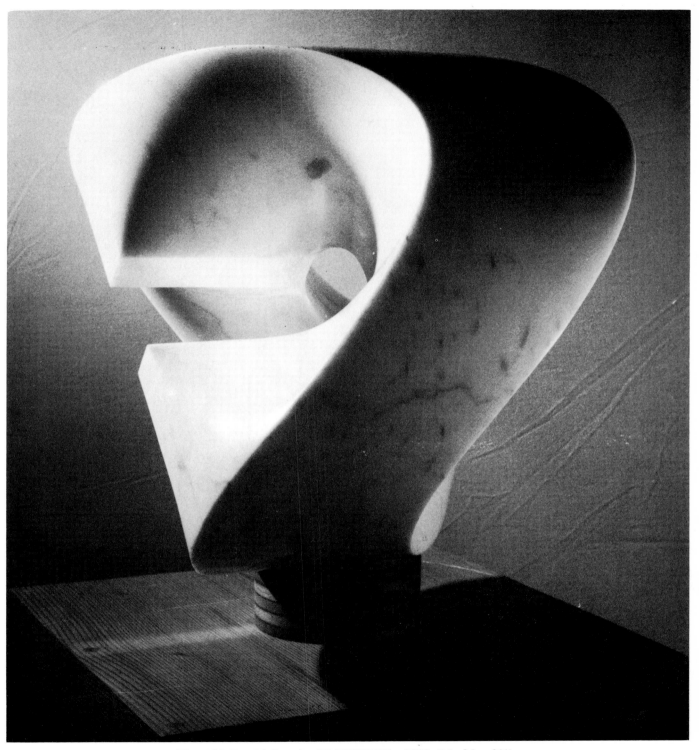

Fig. 133 David Dowis. UNTITLED. 1969. Marble. 30″ in diameter. Artist. *Photography by David Dowis. Courtesy of the artist*

I subject elementary forms to rudimentary incidents. This magnifies simple spatial truths to an intensification that demands the observer become aware of the complexities of simple visual happenings. David Dowis (in 1973 interview by the author).

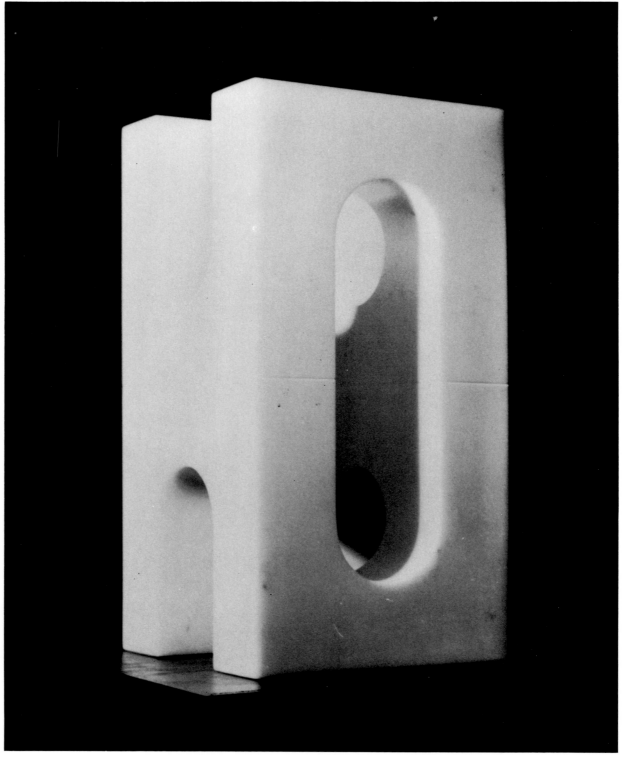

Fig. 134 David Dowis. SCULPTURE III. Marble. 18″
high. Collection of the artist. *Photography by David
Dowis. Courtesy of the artist*

My forms develop from essences of visual truths
that I see often enough to attract my attention.
Carving stone, my work, seems a selfish indulgence.
I do it because it makes my days joyful. David Dowis
(in a 1973 interview by the author).